PENGUIN BOOKS

THE PLANETS

Nigel Henbest is a science writer, broadcaster and consultant, specializing in astronomy and space. He is a columnist for the *Independent* and the *European* newspapers and *Focus* magazine, a consultant to many TV programmes, and presenter of the BBC World Service monthly programme *Seeing Stars*. His twenty-one books and hundreds of articles have been translated into twenty-seven languages. They include *The Exploding Universe* (1979), *The Mysterious Universe* (1981), *Comets, Stars, Planets* (1985), *The Stars* (1988, with Heather Couper), *The Universe* (1992) and *The Space Atlas* (1992, with Heather Couper). He has an MSc from Cambridge and is a director of Pioneer Productions, an independent TV and video production company, which has made programmes for BBC, ITV and Channel 4.

Past appointments include chairman of the Radio 4 science quiz *The Litmus Test*, astronomy consultant to *New Scientist* magazine, editor of the *Journal of the British Astronomical Association* and consultancies at both the Royal Greenwich Observatory and the Science and Engineering Research Council. He is a director of two companies that promote science through the media.

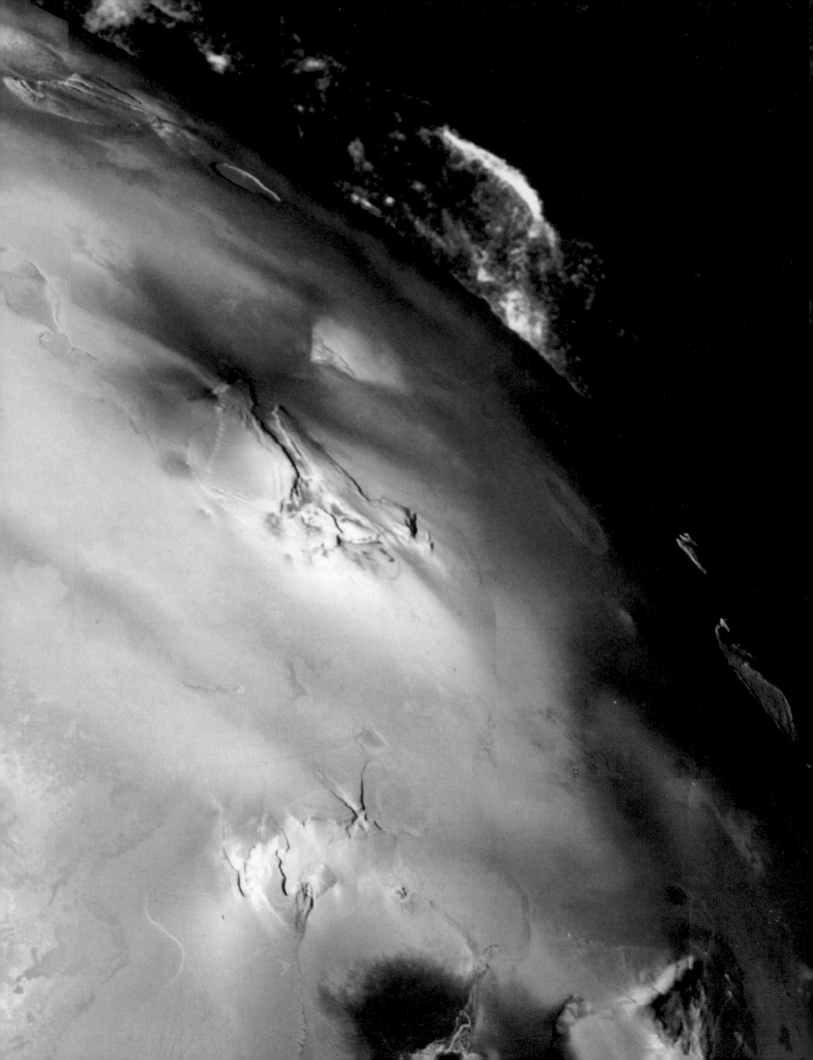

THE PLANETS

Nigel Henbest

PENGUIN BOOKS

By the same author

The Exploding Universe
The Mysterious Universe
The Restless Universe (*with Heather Couper*)
The New Astronomy (*with Michael Marten*)
Exploring the Universe (*ed.*)
Comets, Stars, Planets
The Stars (*with Heather Couper*)

PENGUIN BOOKS

Published by the Penguin Group
Penguin Books Ltd, 27 Wrights Lane, London W8 5TZ, England
Penguin Books USA Inc., 375 Hudson Street, New York, New York 10014, USA
Penguin Books Australia Ltd, Ringwood, Victoria, Australia
Penguin Books Canada Ltd, 10 Alcorn Avenue, Toronto, Ontario, Canada M4V 3B2
Penguin Books (NZ) Ltd, 182–190 Wairau Road, Auckland 10, New Zealand

Penguin Books Ltd, Registered Offices: Harmondsworth, Middlesex, England

First published by Viking 1992
Published in Penguin Books with revisions 1994
10 9 8 7 6 5 4 3 2 1

Printed in Great Britain by Butler & Tanner Ltd, Frome and London

Frontispiece: **Volcanic gases erupt 300 kilometres into space from a volcano on Jupiter's moon Io. The vent of this volcano, named Pele after the Hawaiian volcano goddess, lies at the tip of the triangle of rock in the centre of this picture from *Voyager 1*. The eruptions from Pele have covered a region 1,400 kilometres across: if Mount Vesuvius produced an eruption of this size, its ejecta would bury the whole of Italy, Sicily, Sardinia and Corsica – and most of former Yugoslavia as well.**

Contents

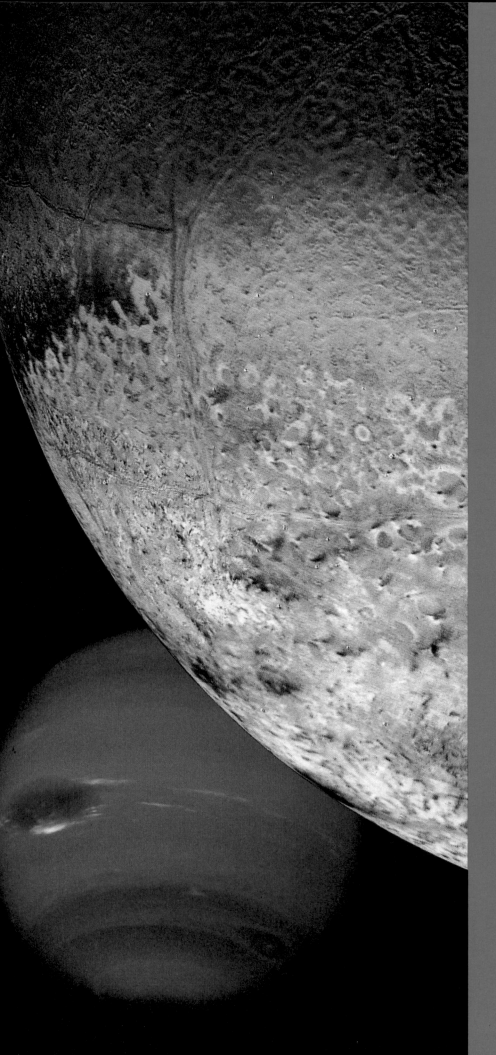

Pink ice and dark
streaks of volcanic ash cover
the polar regions of Triton, the
largest moon of the blue planet
Neptune. Triton has some of
the strangest geology seen on
any solid world. Watery
Neptune, too, is enigmatic, with
powerful winds and a tipped-
up magnetic field. Neptune and
Triton were the last ports of
call for the unmanned
spacecraft *Voyager 2* as it
swept towards the edge of the
Solar System in 1989,
concluding Phase One of our
exploration of the other
planets.

Acknowledgements

Many people have kindly provided images for this book. I must thank in particular those friends and colleagues who have uncomplainingly answered my request for bulk orders of images: Jurrie van der Woude at NASA's Jet Propulsion Laboratory; Jody Swann and Kathy Hoyt at the US Geological Survey in Flagstaff, Arizona; Barbara Frasco and Debbie Byers at Newell Color Lab, Los Angeles, and Kevin Krisciunas of the Joint Astronomy Centre, Hilo, Hawaii. In addition, I am grateful to all those individual researchers – listed in the photographic credits below – who have sent me their latest results and images.

PHOTOGRAPHIC CREDITS

Preliminary pages: p. 3 NASA; p. 6 USCS
Introduction: p. 8 IBM Research and SAO/Leon Golub; p. 11 Hencoup Enterprises; p. 12 Jean Dragesco; pp. 13–14 Hencoup Enterprises; pp. 16–17 NASA; p. 18 William Liller/4-metre telescope of the Cerro Tololo; Interamerican Observatory; pp. 19–20 NASA; p. 21 USGS.
Chapter 1: p. 22 NASA; p. 24 Michael Ledlow; pp. 25–28 NASA; p. 30 Andrew Potter & Thomas Morgan/NASA; p. 32 NASA.
Chapter 2: p. 34 NASA; pp. 36–37 Carle Pieters; p. 38 USGS; pp. 39–43 NASA; p. 44 USGS; pp. 45–49 NASA; p. 50 William Sinton; p. 51 USGS; pp. 52–54 NASA.
Chapter 3: p. 56 Earth Science Corporation/Science Photo Library; pp. 58–60 NASA; p. 60 (bottom) NASA; p. 61 H. J. Melosh & M. E. Kipp/Sandia National Laboratories; p. 62 NASA; p. 63 Hencoup Enterprises; p. 65 Jack Finch/Science Photo Library; p. 66 Soames Summer-hays/Science Photo Library; p. 67 USGS; p. 68 ESA/Science Photo Library; p. 69 NASA; p. 70 NASA/Science Photo Library; p. 71 Hencoup Enterprises; p. 72 copyright © Tom Van Sant/Geosphere Project/Santa Monica/Science Photo Library; p. 73 (top) Gene Feldman, NASA GSFC/Science Photo Library; p. 73 (bottom) Doug Allan/Science Photo Library; p. 74 NASA; p. 75 NASA/Science Photo Library; p. 76 ESA; p. 78 Earth Satellite Corporation/Science Photo Library.
Chapter 4: p. 80 USGS; pp. 82–83 NASA; pp. 84–87 USGS; p. 88 NASA; pp. 89–90 USGS; pp. 91–92 NASA; pp. 93–94 USGS; pp. 95–96 NASA; pp. 97–98 USGS.
Chapter 5: p. 100 NASA; p. 102 Royal Observatory, Edinburgh; pp. 103–121 NASA.
Chapter 6: p. 122 NASA; p. 124 Royal Observatory, Edinburgh; p. 125 Space Telescope Science Institute; pp. 126–141 NASA.
Chapter 7: pp. 142–150 NASA; p. 151 USGS; pp. 152–156 NASA.
Chapter 8: pp. 158–170 NASA.
Chapter 9: p. 172 Mark Sykes/Univ. Arizona Steward Observatory; p. 174 Lowell Observatory; p. 175 US Naval Observatory; p. 176 STScI; p. 177 Marc Buie, Keith Horne, David Tholen/STScI/Univ. Hawaii; p. 178 Marc Buie, Keith Horne, David Tholen/STScI/Univ. Hawaii.
Chapter 10: p. 180 Ian Steele & Ian Hutcheon/Science Photo Library; p. 182 David Scharf/Science Photo Library; p. 183 NASA; p. 185 Hencoup Enterprises; p. 186 NOAO/Science Photo Library; p. 187 European Southern Observatory; p. 188 Steve Larson; p. 189 H. U. Keller/Max-Planck-Institut für Aeronomie; p. 190 NASA; p. 191 John Fletcher.
Chapter 11: p. 192 NASA/IPAC; pp. 194–195 NASA; pp. 196 USGS; pp. 197–198 NASA; p. 199 NASA/IPAC; p. 200 Colin Aspin & Dolores Walther/Joint Astronomy Centre, Hilo, Hawaii; p. 202 Anglo-Australian Telescope Board.
Endpage: p. 208 NASA

Introduction

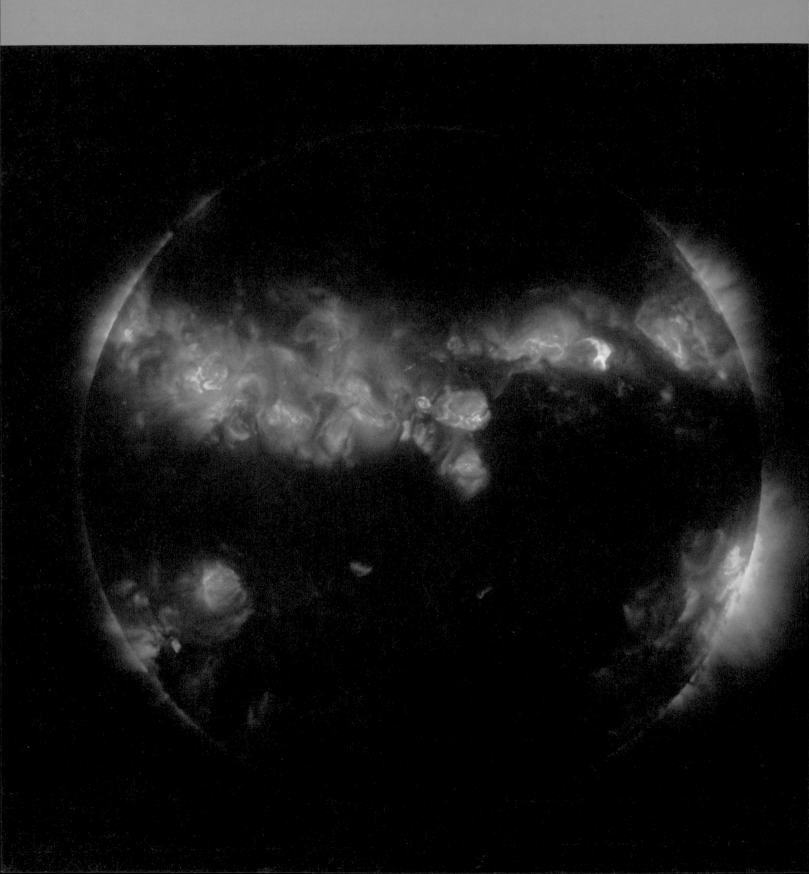

In August 1989 the spacecraft *Voyager 2* skimmed over the clouds of the remote planet Neptune. Despite its twelve years in space and a distance of 5 billion kilometres separating it from the controllers on Earth, *Voyager* operated flawlessly. The spacecraft's cameras sent back hundreds of images of Neptune, its rings and its moons, while the other instruments on board measured the magnetic fields, radio waves and other radiation that the planet generates. But *Voyager*'s fly-past of Neptune was more than an engineering triumph, more than another scoopful of pretty pictures and scientific data. August 1989 marked the close of an era. It was the end of Phase One of our exploration of the Solar System.

Phase One, to space scientists, was the period during which we obtained our first close-up glimpses of the other worlds in the Solar System from spacecraft hurtling past them. Phase Two involves getting to know the planets more intimately by sending unmanned craft to orbit around them and to land on their surfaces. Phase Three – still some way off – is the exploration of our fellow worlds by human beings.

Our first reconnaissance of the Solar System has taken a remarkably short period of time when we consider the millennia that passed before we gleaned even a passingly accurate idea of the geography of our own planet. The first planetary encounter occurred less than three decades before *Voyager* passed Neptune. Until the 1960s we had only a vague and blurred view of even the nearest planets – rather like medieval maps of the Earth with blank areas marked 'here be dragons'. Within thirty years the planets have become real worlds, mapped in as much detail as some parts of the Earth today.

Now that spacecraft have shown us the real characters of the other planets we can marvel that earlier astronomers managed to find out anything at all. We can see the five nearest planets quite easily with the naked eye. Mercury and the much brighter Venus shine in the dawn or dusk twilight as 'morning stars' or 'evening stars' – Venus appearing as the brightest object in the sky after the Sun and the Moon. The outer planets, Mars, Jupiter and Saturn, also appear as brilliant 'stars', often hanging high in the sky in the midnight darkness. But the unaided eye shows us these planets as no more than points of light.

Uranus, the planet beyond Saturn, is so distant that it is only just visible to

Storms on the Sun, seen here in X-rays, consist of ultra-hot gas that can sweep outwards in a powerful wind through its family of planets. The Sun is the centre of the Solar System. Its gravity keeps all the planets in orbit and its energy provides them with light and heat.

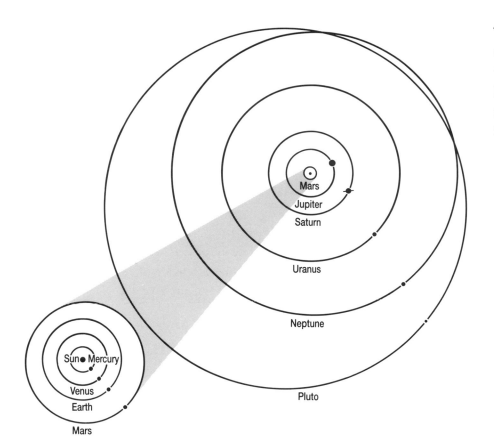

The orbits of the planets, shown to scale. Most planets follow an almost circular path, but Pluto's elliptical orbit can sometimes bring it closer to the Sun than Neptune.

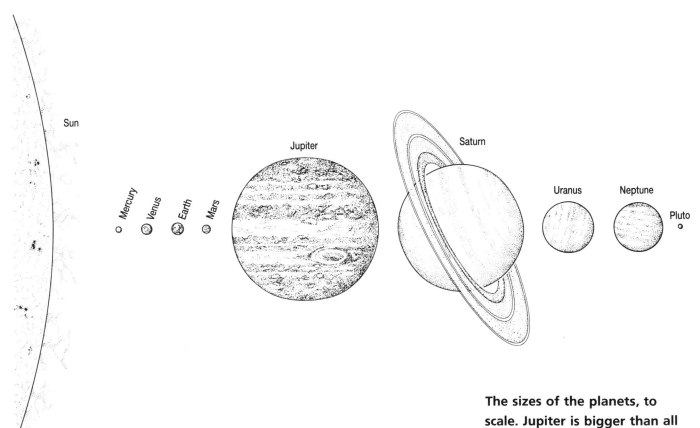

The sizes of the planets, to scale. Jupiter is bigger than all the other planets put together.

The nearest planets are among the most brilliant lights in the night sky. Venus (top) is the brightest object after the Moon. Little Mercury (just above the horizon) is often difficult to see in the twilight glow, but its brightness can rival any of the stars.

the naked eye, and it remained undiscovered until 1781, when the amateur astronomer William Herschel found it while scanning the sky with a powerful telescope. It certainly requires a telescope to show the most remote planets, Neptune and Pluto.

Even with a large telescope, however, astronomers have been limited in what they can see on the other planets. The Earth's atmosphere is constantly jumbling the light that comes from space. Shifting currents of air make the magnified view of a planet as unsteady as our view of the bottom of a busy swimming pool. In long-exposure photographs these air currents blur any fine details we might hope to see.

Astronomers have had some allies, however, to assist the telescope. They can use a spectroscope to split up and analyse the planets' light and look for tell-tale signs that reveal what a planet's atmosphere is made of. The law of gravity helps too. A telescope shows moons circling most of the planets, and by

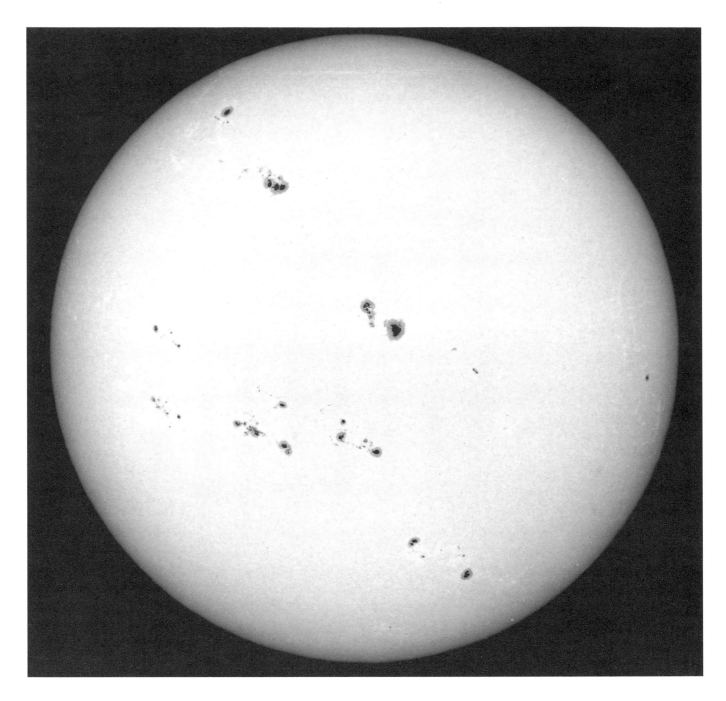

watching the motions of its moons astronomers can work out the strength of a planet's gravitational pull and, hence, how massive it is. Since a telescope shows, roughly at least, a planet's size, astronomers can calculate its density as well.

With these techniques astronomers on the Earth came up with some of the right answers even before the era of the space probes. They found that the four comparatively small planets closest to the Sun – Mercury, Venus, Mars and Earth – are so dense that they must be made of rocks with an iron core. The spectroscope showed that the beautiful clouds that cover Venus completely are made of corrosive drops of sulphuric acid.

The Sun is large enough to contain all the planets a hundred times over. Its gaseous surface is sometimes blemished by dark sunspots, where powerful magnetic fields cool the gases from 5500 to 4000 °C. The most prominent sunspot here is bigger than our planet Earth.

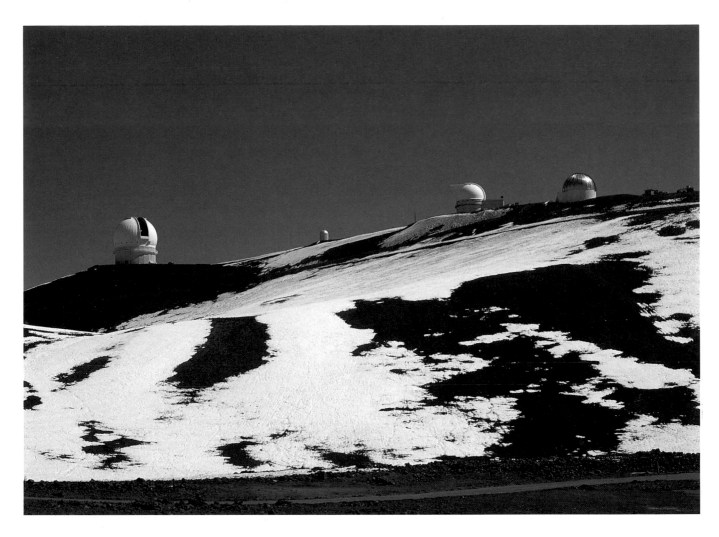

Many kinds of telescope on Earth are used to observe the planets. ▲ The 4,200-metre summit of Mauna Kea on Hawaii provides a clear view for the Canada–France–Hawaii optical telescope (dome open) and the UK Infra-red Telescope (aluminium dome): it is also the only place in Hawaii with a snowplough! ▶ Powerful radar signals from the giant Arecibo dish can map Venus beneath its clouds: this 'telescope' is a natural hollow in the wilds of Puerto Rico, lined with a dish of wire mesh 300 metres across.

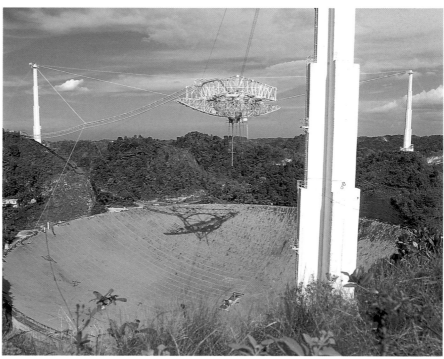

The telescope revealed that the next four planets – Jupiter, Saturn, Uranus and Neptune – are giants, each several times larger than the Earth. But their densities turned out to be so low that they could contain only a small amount of rock or iron. Instead the giant planets must consist mainly of water and gases. The spectroscope supported this supposition, showing signs of gases like ammonia and methane. Saturn has the lowest density of any planet – so low that it would float in water, given an ocean big enough!

Radio telescopes attached to the Earth have also had a hand in unravelling the secrets of the planets. Even before spacecraft arrived at any other planet radio astronomers found that Venus rotates backwards under its clouds and that Jupiter has a magnetic field thousands of times stronger than the Earth's. This information about Jupiter was vital to the designers of spacecraft. They were able to design special electronic circuits that could survive as the spacecraft went past Jupiter through a region of intense magnetic field and radiation belts that would have crippled ordinary electronics.

But much of our 'knowledge' of the planets gained from the Earth has been proved to be entirely wrong. Astronomers thought that our two neighbours in space would have climates rather similar to the Earth's. But Venus, slightly nearer to the Sun, has turned out to be no amorous paradise: its surface is hot

The Parkes radio telescope in New South Wales can receive natural broadcasts from the planets: astronomers have also used it to pick up the weak transmissions from spacecraft as they have passed distant planets and travelled through Halley's Comet.

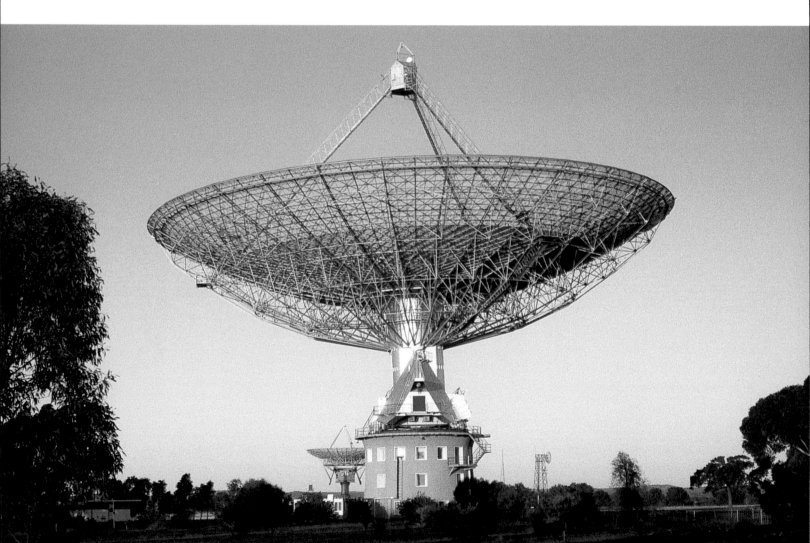

enough to melt lead. And although Mars lies only slightly farther from the Sun than the Earth, it is a frozen world where, even at the planet's equator, the temperature scarcely, if ever, rises high enough for its icy surface to melt.

As our near neighbours in space, Venus and Mars have become the targets for many of our space probes. Here Phase Two has already begun.

Spacecraft orbiting Venus have used radar equipment to pierce its all-enveloping clouds and reveal the broad details of the surface beneath: mountains, lava plains and volcanoes that are probably active. The heavily armoured *Venera* landers even sent back close-up shots of Venus's rocky surface before they succumbed to the heat.

The orbiters around Mars have photographed its surface in fine detail, showing canyons and extinct volcanoes far larger than any on the Earth. The *Viking* landing craft have survived for years on Mars's icy surface, watching the chilly seasons come and go. These robots have dug into the planet's soil to test for any life that may be deep-frozen there – so far without success.

When we venture beyond Mars we come upon planets so different from the Earth and so distant that it is not surprising that each spacecraft visit has resulted in a cornucopia of surprises. Even the nearest of the 'giant planets', Jupiter, never comes closer to the Earth than 590 million kilometres, a distance so great that a commercial airliner would take seventy years to fly there. The Earth's churning atmosphere spoils the view of these planets to the extent that all we can see is some cloud markings on Jupiter and Saturn and a blurred view of the glorious rings surrounding Saturn. The two *Voyager* spacecraft showed that we are missing some of the most stunning sights ever seen in the history of mankind.

Here we are dealing not with single planets but with whole systems of multitudinous moons and rings that resemble miniature Solar Systems in their own right. While the Sun retains only nine planets in orbit, Saturn has a retinue of at least twenty-four moons. Jupiter's family of sixteen moons includes four that are bigger than the planet Pluto and one that is larger than Mercury as well. The Sun has one 'ring' – the asteroid belt between Mars and Jupiter – but all of these planets have a complex set of rings, in the case of Saturn running into literally thousands.

Astronomers expected the moons of these planets to be pretty boring. Until the 1970s the only moon we knew anything about was our own – and even the expensive *Apollo* manned missions had shown that the Moon was a dull and uninteresting place. It has not changed for over 4 billion years and shows only the craters blasted out when debris crashed into it soon after its birth, plus a few flat plains of lava that seeped out shortly afterwards. Since then the Moon has been dead and airless.

But the *Voyagers* have found that the Earth has been dealt one of the least interesting moons in the Solar System. Jupiter has a moon, Io, that is roughly the same size as our Moon but is racked by volcanic eruptions that eject sulphurous gases 300 kilometres into space. The largest moon going around

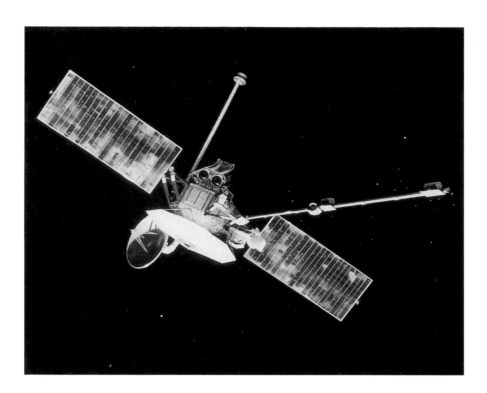

Unmanned spacecraft to the planets come in a variety of designs. ◄ Visiting the inner planets Venus and Mercury, *Mariner 10* needed a sunshade to protect its delicate electronics from the Sun's heat. The two solar panels converted the copious sunlight into electricity. ▼ At the outer limits of the Solar System sunlight is too weak to provide power, so the far-ranging *Voyager* spacecraft has a small nuclear-powered generator (left). It needs a huge dish to communicate with the distant Earth.

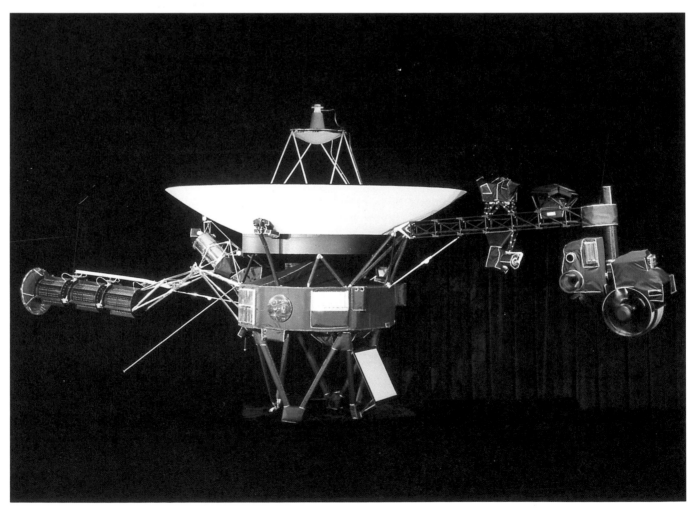

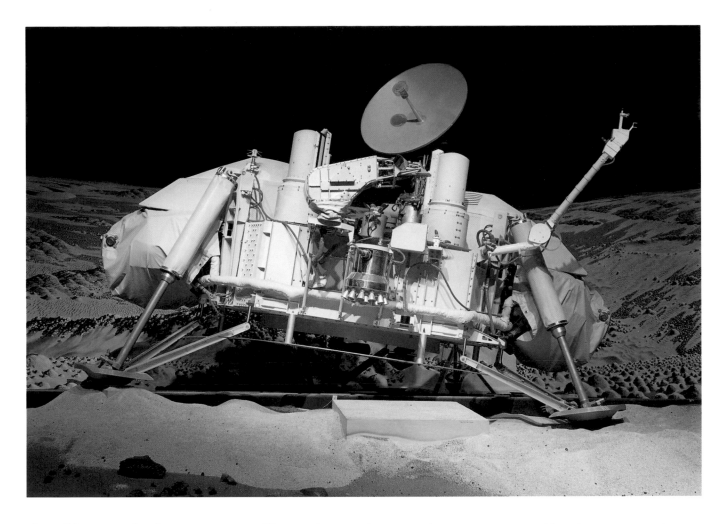

The *Viking* Mars-lander – here photographed against a painted backdrop on Earth – had two cameras, an extended boom to measure weather conditions and a scoop (folded under the antenna) to sample the Martian soil. Inside the lander was a fully automated laboratory to test the soil for signs of life.

Neptune has eruptions too, giant geysers powered by nitrogen gas and carrying soot high into the air. Saturn's biggest moon, Titan, has an atmosphere that is even thicker than the air on the Earth and has orange clouds that may contain the precursor molecules for life.

Even the smaller moons out here have their interest. Uranus's Miranda displays huge oval scars, looking like racetracks, which geologists have yet to explain satisfactorily. Two of the small moons of Saturn follow the same orbit and are almost certainly the halves of a moon that was broken in half by a giant cosmic collision.

The small moons also corral the tiny fragments of rock and ice that make up the rings of the outer planets. When the *Voyagers* were planned scientists knew of only one ringed planet, Saturn, whose glorious display is visible even with Earth-based telescopes. As the probes were prepared and launched astronomers on Earth began to suspect that Uranus and Neptune also had rings because they occasionally blocked out the light from distant stars, but these rings were too faint and thin to be seen by telescopes on Earth. The *Voyagers'* high-quality photos portrayed these rings in intricate detail and showed a gossamer ring around Jupiter as well. We now know that all four giant planets have rings, albeit very different in character.

At the frontier of the Solar System lies tiny Pluto, the only planet that has not yet felt the light touch of a passing spacecraft. And beyond is the homeland of the comets. Here, astronomers believe, there is a swarm of icy bodies. Occasionally one falls in towards the Sun and briefly grows a huge, shining head and, possibly, an elongated tail to appear as a fully fledged comet in our skies.

For scientists our new knowledge of the Solar System involves many measurements – of magnetism, of radio waves, of heat radiation, of ultraviolet light, of detailed spectra. But the most important way in which the spacecraft have enriched our knowledge is by sending back images. Although we sometimes depend on other types of image – for example, radar in the case of Venus – almost all of these are simply the view that we would have if we could visit the planets in person. They are 'photographed' by a camera that is very similar to an ordinary television camera but takes stills instead of moving images.

The images are so important that scientists have carried on 'improving' them

Long-range views from Earth can tell us very little about the other planets and their moons. In one of the best Earth-based photographs of Uranus, the five 'stars' close to the planet itself are its largest moons, blurred to many times their actual size by the Earth's atmosphere. Miranda is immediately to the right of Uranus.

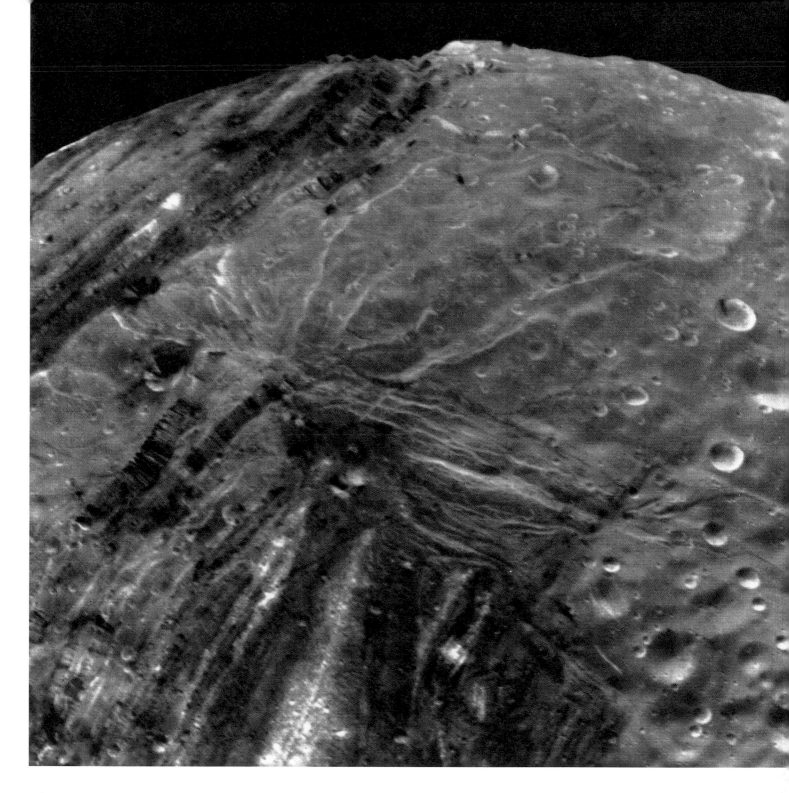

When *Voyager 2* swept past Uranus in January 1986 its cameras showed Miranda in close-up, revealing craters, grooves and strange markings as small as 500 metres across.

long after a fly-by spacecraft has passed its target planet or an orbiter has become defunct. With today's computer techniques there are many ways of cleaning up a picture to reveal details that might have escaped notice before, and it is possible to sharpen up the colour pictures of the planets by using a computer to add information from black-and-white images that show much finer details.

These 'new views' from old spacecraft are allowing geologists to study the surfaces of worlds such as Mars and the volcanic moon Io in much greater

detail than anyone expected when the *Viking* and *Voyager* spacecraft were originally designed. Both in the design of the spacecraft and in the subsequent processing of images, computer power and human ingenuity after the event have contributed as much as rocket power to our new understanding of what has emerged from Phase One – and the beginning of Phase Two – of our exploration of the other planets.

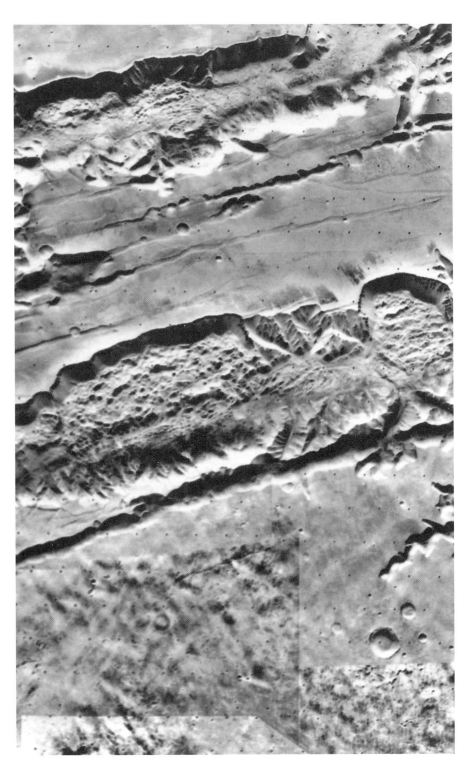

Computer-processing can bring out new details in our views of other planets, even many years after the images were returned to Earth. ◄ The original *Viking* orbiter pictures of the great Valles Marineris canyon on Mars were in black and white, revealed little detail and showed 'joins' where two images were abutted. Ten years on, Al McEwen of the US Geological Survey has used computers to stitch pictures together seamlessly, bring out fine details and add colour from other *Viking* observations. ► The result is a view showing details smaller than an average city dwelling: the dark colour of the valley floor and the patterns of erosion in the canyon walls are laying bare some of the earliest history of Mars.

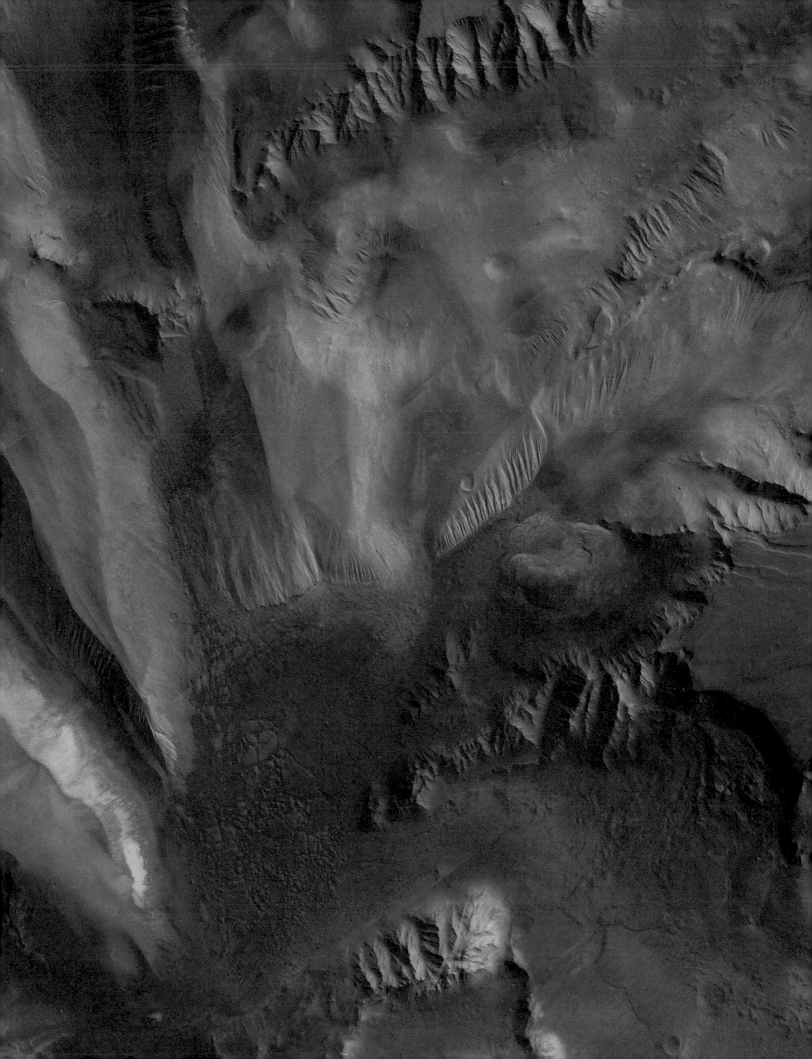

MERCURY

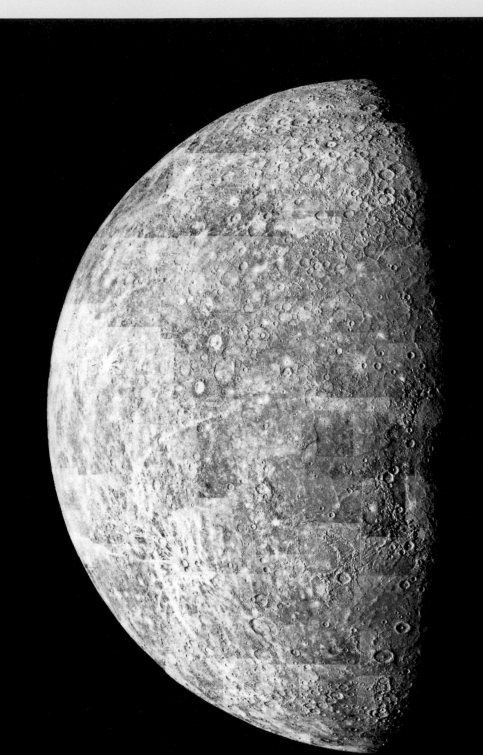

1

Throughout most of history astronomers dismissed Mercury as the least interesting of the planets. In recent years, however, they have begun to revise their opinion of the world closest to the Sun. Many astronomers now see Mercury as the vital 'missing link' that may explain how the other rocky planets, including the Earth, came into being.

The battered surface of Mercury is a fossil from the earliest days of the Solar System, unaltered by later geological activity. The largely airless planet has no erosion, no volcanoes and no recycling of its rocks. This view of Mercury incorporates both the planet's overall pinkish-brown colour and a mosaic of black-and-white close-up images from *Mariner 10*, the only spacecraft to have visited Mercury.

As seen from the Earth, Mercury never seems to stray far from the Sun. As a result we see it only in the bright twilight glow after sunset or before sunrise. Anyone with a clear horizon to the east or west should be able to see Mercury, two or three times per year, as a bright star that is visible when the sky is too bright for the real stars to show. But slight cloud or mist will hide this fleeting visitor to the sky, and many astronomers have never seen Mercury for themselves – including, it is said, Nicolaus Copernicus (1473–1543), the monk who first demonstrated that the planets go around the Sun rather than the Earth.

As the closest planet to the Sun, Mercury has the shortest 'year' of any planet, orbiting the Sun in only eighty-eight days. Its orbit is also the most elliptical, barring that of remote little Pluto. At its near point Mercury is only 46 million kilometres from the Sun's fierce heat, but the other end of its orbit takes it to 70 million kilometres away.

As it swings around its closest approach to the Sun, Mercury speeds through space at 200,000 kilometres per hour – a hundred times faster than Concorde. Here the Sun's gravity is so strong that Newton's simple laws of gravitation break down: in defiance of Newton, Mercury's whole elliptical orbit is gradually swinging around the Sun. In 1915 Albert Einstein produced a new theory of gravity, General Relativity, that could explain Mercury's odd motion. This theory has since spread its wings far beyond the Solar System to predict phenomena such as black holes and the Big Bang with which the Universe began.

Through a telescope we can see that Mercury is a small world, only 40 per cent larger than our Moon. It is the second smallest planet after Pluto and is smaller than the Solar System's largest moon, Ganymede, which circles the giant planet Jupiter. Because Mercury is so tiny, a telescope shows little detail on it, just a few dusky shadings.

For this reason we knew virtually nothing about Mercury until the 1960s, which saw the advent of the 'new astronomies' – techniques that go beyond ordinary telescopes. American astronomers used the world's largest radio

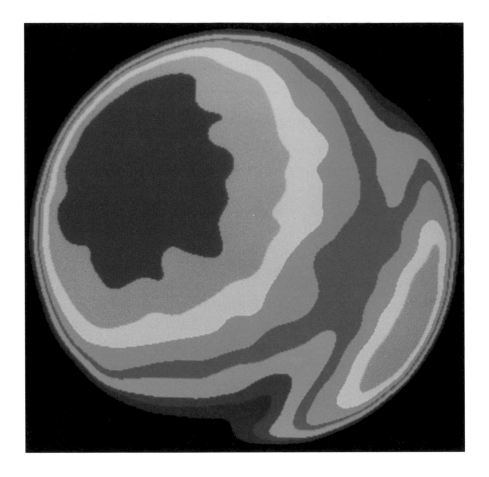

A heat map of Mercury shows that it has two 'hot poles' – regions with a much higher temperature than the rest of the planet. The hottest regions are here colour coded red, and the cooler parts of the planet are shown blue and purple. The hot poles mark the two regions that are alternately under the Sun's direct heat when Mercury is at its closest to the Sun. Mercury's temperature was here probed by a radio telescope, the Very Large Array in New Mexico.

telescope, a dish of metal mesh strung inside a vast limestone hollow at Arecibo in Puerto Rico, to 'bounce' radio waves off Mercury. This technique is a version of the radar used at airports and on board ships; just as terrestrial radar shows the locations of planes and ships, so astronomical radar pinpointed exactly where Mercury was and how far away. More important, the reflected radio waves showed how rapidly the planet was spinning: once in fifty-nine days.

This result came as a complete surprise to astronomers. They had thought that Mercury turned once in eighty-eight days, the same period as its 'year'. If the rotation period, measured relative to the stars, is the same as Mercury's year, then the planet turns on its axis at exactly the same rate as it moves around the Sun, so rotating the planet in such a way that the same side always faces the Sun. On this side there will be perpetual daylight, while the other side has eternal night. 'Daytime' or 'night-time' are infinitely long.

The rotation rate of fifty-nine days is exactly two-thirds of Mercury's year. This has a peculiar effect on the length of Mercury's 'day': as measured from noon to noon, the day on Mercury is twice as long as the year! Someone standing on the surface of Mercury would see the Sun apparently moving from east to west across the sky, because the planet is turning, just as we see the Sun appear to move across the Earth's sky as our planet turns during the course of the day. But Mercury is moving rapidly around the Sun at the same time, and this motion makes the Sun's position in the sky change too – in the opposite

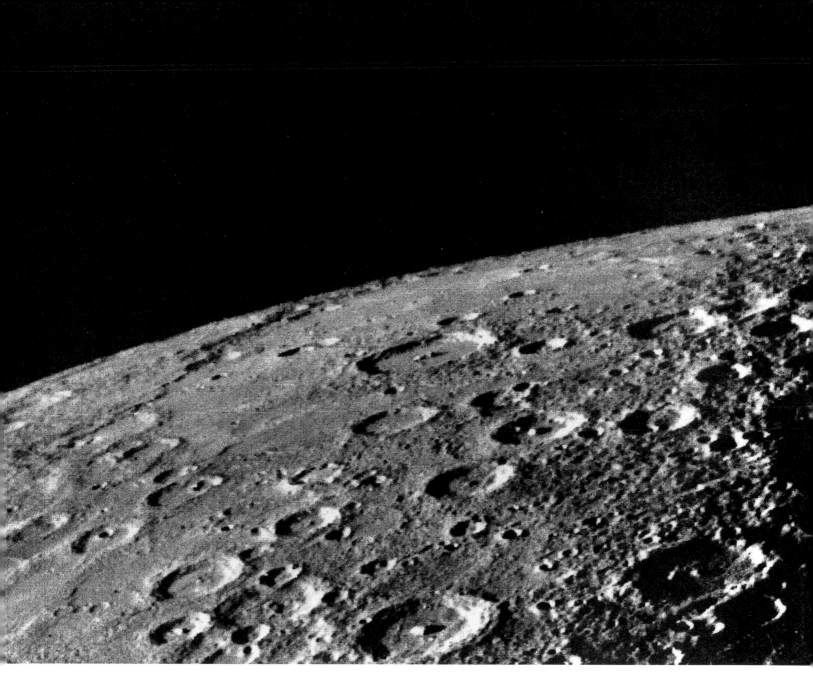

Looking at first sight like the Moon, Mercury is covered with craters blasted out by meteorites early in its life. Close-up views from *Mariner 10* show no sign of volcanoes or other geological activity that could have changed its surface: nothing has happened here for over three billion years.

direction. As a result the yearly motion of Mercury effectively slows down the daily movement of the Sun across the sky, so prolonging the length of 'daytime' and 'night-time', so that the period from noon to noon increases from fifty-nine Earth days to 176 Earth days.

Mercury's elongated orbit means that a Mercury-dweller would experience an unusual set of temperature changes. At night the temperature falls to −180 °C, and it naturally rises during the Mercurian day to an average of 350 °C. This is hot enough to melt lead – but, even so, it does not mark the extreme of Mercury's daytime temperature. When Mercury is at its closest to the Sun the region exposed can heat up to 430 °C. Because of Mercury's remarkable way of spinning there are only two regions (on opposite sides of the planet) that experience this extreme temperature; they are known as the 'hot poles'.

An equally surprising discovery came from much improved radar measurements made in 1991. They showed a small bright region near Mercury's north pole. It is probably a patch of ice, a smaller version of the frozen polar caps of the Earth and Mars. On the closest planet to Sun, this polar cap must live a precarious existence. With virtually no atmosphere above the ice, even the tiniest amount of heat would evaporate the polar cap into space as water vapour. The ice must be shaded by high crater walls from the Sun's heat. In addition, it probably lies under a thin layer of soil that provides protection from other sources of heat radiation, but is transparent to the probing radio waves from Earth.

Even with powerful radio telescopes there's not a lot more we can learn about Mercury from the Earth. Everything else we know about this planet has come from cameras and other instruments on board one hardy spacecraft, *Mariner 10*.

The American space agency NASA launched *Mariner 10* in November 1973. It was to be the first spacecraft to fly past two planets, taking in a close encounter with Venus on its way to Mercury. The long journey turned out to be a tense one for the controllers on Earth, as more and more problems beset *Mariner 10*. But the spacecraft successfully swept past Venus in February 1974 and reached Mercury the following month. *Mariner*'s orbit around the Sun was even more elliptical than Mercury's, and its path brought it back past Mercury every two Mercurian years. As a result the spacecraft was able to take two more sets of photographs of Mercury later in 1974 before it ran out of the propellant gas that kept it pointing in the correct direction in space.

To the disappointment of many astronomers, *Mariner 10* found a barren, cratered world, as pitted as the Moon and almost as lacking in atmosphere. Mercury has apparently been dead since soon after the birth of the Solar System. But first appearances turned out to be misleading: Mercury is bearing a message that has yet to be deciphered fully.

Although Mercury's battered surface looks at first glance like that of the Moon, geologists have found significant differences, including old lines of faults that break up the surface, the remains of a gigantic impact that covers a region larger than the British Isles and strange wrinkle ridges that wind for hundreds of kilometres across Mercury's surface. By analysing these various land forms and comparing them with the better-known surface of the Moon, geologists have been able to build up the story of Mercury's history from around 4,200 million years ago – some 400 million years after the birth of the Solar System.

The four rocky planets were built up from large chunks of rock, like the present-day asteroids, that came together under the influence of each other's gravity. At the point where we pick up Mercury's history the last of these fragments of rock were still falling on to the young planet and blasting out craters in a thin, solid crust. Beneath this thin layer of rocks the planet was molten, liquefied partly by the energy from the in-falling rocks and partly from

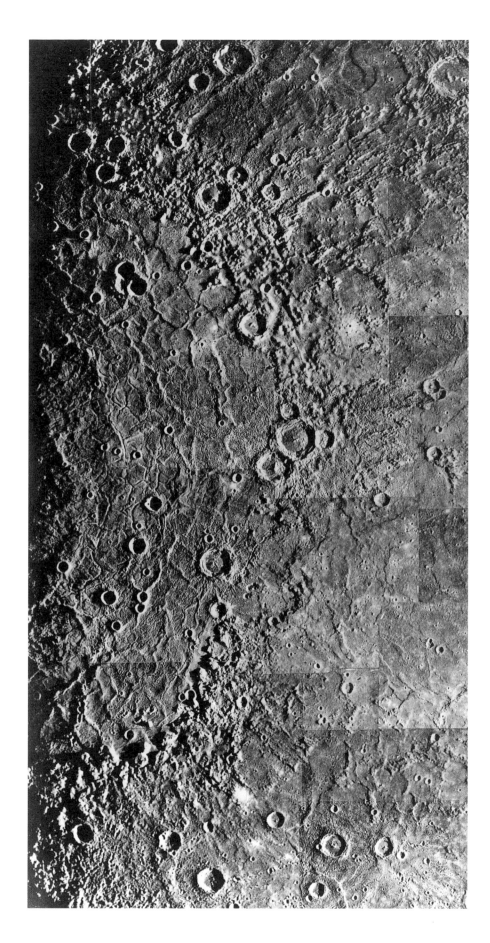

Curved mountain ranges, one inside the other, form part of the outline of a giant 'bull's-eye' on Mercury, the Caloris Basin. At the centre of this pattern (extreme left) is a flat plain. The plain was gouged out by a huge meteorite 3,850 million years ago: the impact also threw up the surrounding mountain rings.

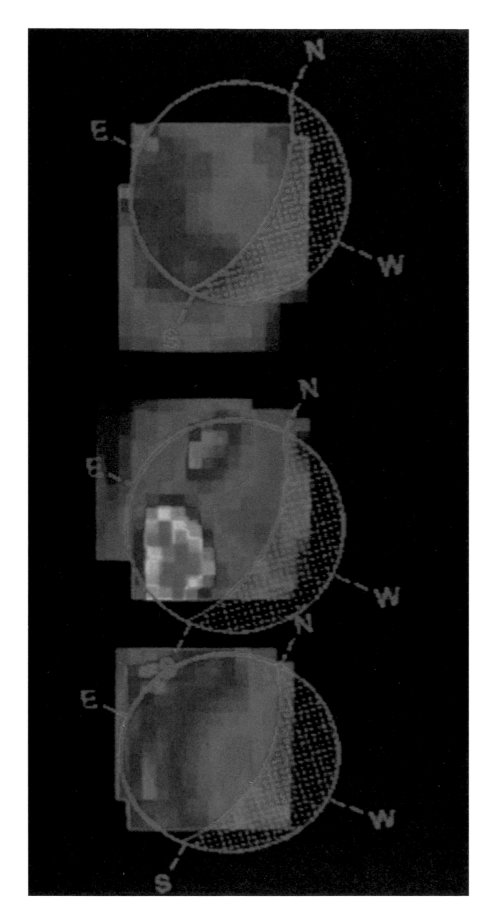

Mercury has a very tenuous atmosphere, which is patchy and impermanent. These three images show the distribution of the atmosphere on three consecutive days: the false colour highlights the densest parts in yellow and red. In the middle image, a dense patch of atmosphere has formed in Mercury's southern hemisphere, and it disappears during the next twenty-four hours. The planet's 'air' is made up mainly of sodium vapour (shown here) and helium.

volume to find its density. This turned out to be 5.44 times the density of water.

Mercury is the second densest planet after the Earth. A straight comparison is, however, rather misleading. The Earth is such a large planet that its inner regions are crushed to a higher density than they would normally have. If we allow for this squeezing in the larger worlds, we find that Mercury is made of material that is denser, on average, than the material of any other planet.

So what is Mercury made of? Assuming that it is basically similar to the Earth, which we know well, there is a simple answer: Mercury is made largely of iron. Geologists have worked out that the Earth's interior has two main regions. At the centre is a core that makes up about one-sixth of the planet's volume and is composed of the dense metal iron. Around it is wrapped a mantle of rock, which is much less dense. We can explain Mercury's high density quite easily by supposing that it has a dense iron core that makes up almost half of the planet's volume, with a correspondingly thinner layer of mantle rocks.

Mariner 10 provided some unexpected evidence to support this idea. The spacecraft carried instruments to measure the magnetic fields in space and also any magnetism that might be generated within Venus and Mercury. Because Mercury is so small and Moon-like astronomers generally expected that, like the Moon, it would have no magnetic field to speak of. But as *Mariner* rounded Mercury on its first encounter the magnetometers began to go wild. The subsequent meetings between spacecraft and planet confirmed this result. Mercury has a magnetic field rather like the Earth's but a hundred times weaker. The Earth's magnetism is generated within its liquid iron core, so the discovery of Mercury's magnetism confirms the idea that this planet too has an iron core.

But why should Mercury have so much iron – or, to put it another way, so little rock? At the time of the *Mariner 10* encounter most astronomers believed that it was because Mercury was formed so close to the Sun. Here, they argued, conditions were so hot in the earliest days of the Solar System that most minerals would not condense into rock. Iron had no such problem, so a planet that formed here would consist mainly of iron with relatively little rock around it.

New calculations suggest that this idea was too naïve. The interior of the next planet, Venus, is almost identical to the Earth's and very different from that of Mercury. It would be difficult for the temperatures of the regions where Venus and the Earth formed to be very similar, while Mercury was born in a region that was very much hotter than that of Venus.

Most astronomers now think that Mercury was originally very similar to Venus and the Earth, although smaller, and that it somehow lost most of its rocky covering soon after it was born. There are several possible theories.

According to one view, hot gases flowing out from the Sun may have boiled away the outer rocky layers of Mercury. More reasonable is the idea that

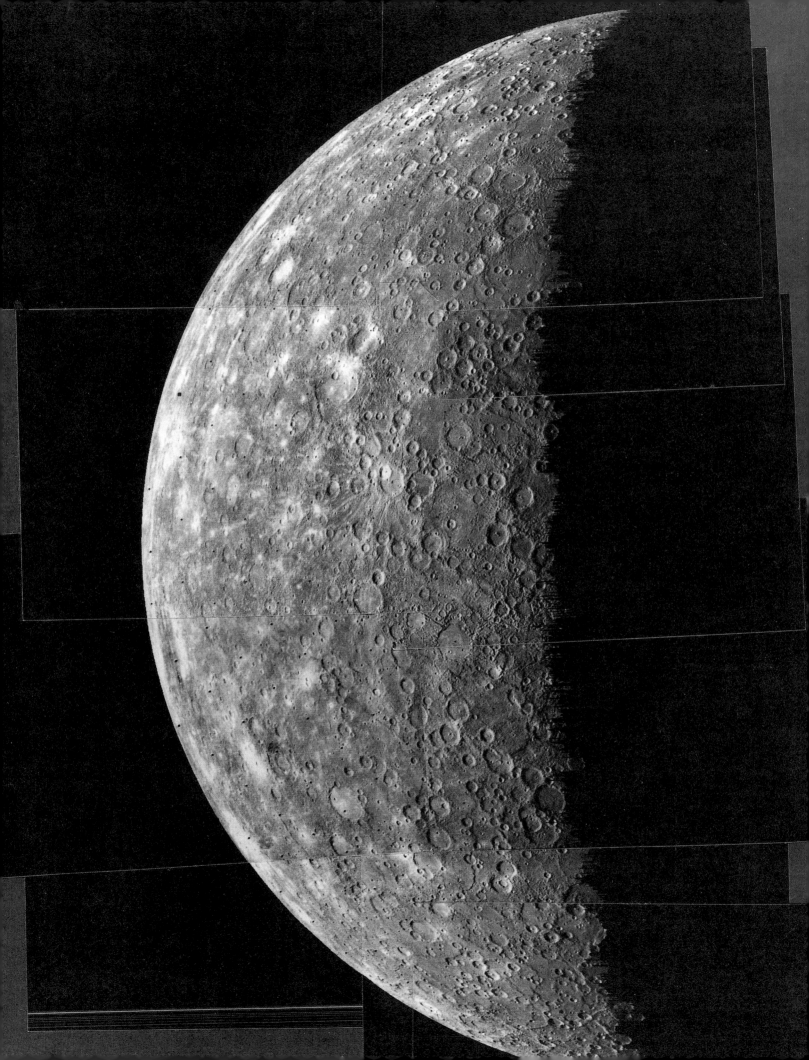

Mercury's rocks were blasted into space by the impact of giant asteroids. One theory contends that the space near Mercury was full of asteroids like the one that – much later – caused the Caloris Basin. At an early stage of Mercury's history a deluge of such asteroids sand-blasted away much of the planet's rocky covering. Another, and very popular, version of this idea is that a single impact was responsible. Mercury was, at that time, 30 per cent larger than it is today. Another planet, about half its size, hit the young world at a high speed. The immense explosion blew off most of the outer layers of Mercury and destroyed the other planet almost completely – apart, possibly, from its molten iron core, which combined with Mercury's own core. Bizarre though such an idea may seem, many astronomers believe that it has a parallel in the early history of the Earth, where a similar impact was probably responsible for 'splashing out' rocks that later solidified to make our Moon.

Astronomers now generally think that the birth of the four rocky planets – and our Moon – involved collisions between bodies that we can think of as either giant asteroids or small planets. On Venus, Mars and the Earth the evidence for these impacts has been destroyed by later geological processes, such as volcanoes and erosion. Only on Mercury do we have a preserved surface that dates back almost that far.

That is why astronomers are now becoming fascinated by this little world, for so long regarded as the runt of the Solar System, and why plans are now on the drawing-board for spacecraft to return to Mercury. If we can analyse carefully the most ancient parts of the surface, hidden below later craters, find out what Mercury is made of and investigate what lies within the planet, we can hope to open some windows on that remote epoch when worlds were, quite literally, in collision.

Intercrater plains – flat regions between the ubiquitous craters – show clearly in this detailed mosaic of *Mariner 10* images. They are solidified pools of lava that welled up during the planet's distant past. The largest craters here are 200 kilometres across. The small bright crater near the centre was excavated by a comparatively recent impact, which splashed rays of bright material around: it is named Kuiper, to honour the leading American planetary scientist Gerard P. Kuiper.

VENUS

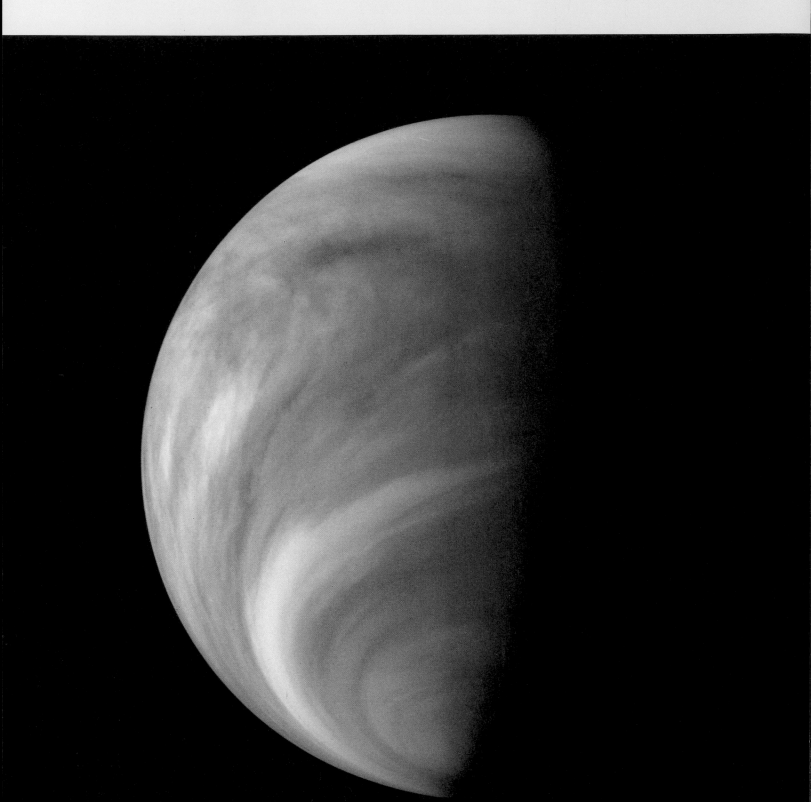

2

To ancient astronomers the brilliant planet that hangs in the twilight as the Morning Star or the Evening Star was naturally associated with the goddess of love. Yet a planet could hardly bear a less appropriate name. The gentle light of Venus is in fact the reflection of sunlight off clouds of concentrated sulphuric acid. Beneath, the entire surface is a hotbed of volcanic activity, laced by lava flows and dominated by vast volcanoes. The temperature is high enough to melt lead, and the pressure of the unbreathable 'air' is sufficient to crush a submarine. The modern astronomers' idea of Venus is not far from the medieval vision of Hell.

Layers of sulphuric acid cloud completely swathe our neighbouring planet Venus, hiding a hot volcanic surface that is reminiscent of images of Hell. The dark markings in the clouds – seen here in an ultraviolet view from the *Pioneer Venus* orbiter – reveal their rapid motion: the clouds race around the planet in only four days, while Venus itself rotates in a leisurely 243 days.

It is only in recent years that astronomers have learned what Venus is really like, even though this planet comes closer to the Earth than any other. The problem has been its all-encompassing clouds. On average the Earth is 40 per cent cloud-covered, so astronauts circling our planet can see most of the surface as time goes by. But the cloud cover on Venus is 100 per cent. Even the cameras on board the *Pioneer Venus* spacecraft that orbited the planet for fourteen years never showed any more than the tops of the cloud decks.

Scientists have been able, however, to use two ways in which to unveil the face of Venus. The brute-force approach is to send robot craft that can investigate on the spot. American space scientists have dropped small probes through the atmosphere to measure its composition, temperature and pressure.

The Soviets have pursued a more ambitious programme. They have dispatched balloons to float around in the planet's atmosphere and have landed several craft on the searingly hot surface. In the hour or so before they have succumbed to a pressure of 90 Earth-atmospheres, and a temperature of 465 °C, these *Venera* lander craft have measured the composition of the surface rocks and have even sent back colour pictures of their surroundings. These show mainly flat expanses of broken volcanic rocks.

While these spacecraft have revealed a few small patches of the planet in uncanny close-up, they have not given us a global view of Venus. We would, after all, have little idea of the Earth as a planet if our only information consisted of views of half a dozen randomly selected spots on its surface. By turning away from visible light to radio waves, however, astronomers can

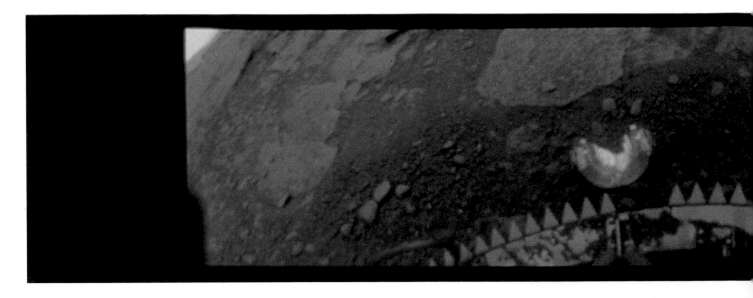

effectively 'see' through the clouds and so build up a picture of the entire planet with the clouds stripped away.

Radar astronomy involves sending out a beam of radio waves that are reflected off the target – say, a mountain on Venus – and then picked up by a suitable receiver, often simply the transmitting aerial working in reverse. One great advantage of radar, especially for investigating Venus, is that the radio waves can penetrate clouds with no problem at all.

Astronomers first made radar contact with Venus in the early 1960s, before any spacecraft reached the planet. The results showed that beneath the clouds there was indeed a rocky world about the same size as the Earth. With a diameter of 12,103 kilometres (as compared to the Earth's 12,756 kilometres), Venus is often called the Earth's twin, although in most other ways (apart from size) they show little family resemblance.

The real surprise of these early radar results was that Venus rotates much

The surface of Venus is paved with flat volcanic rocks, according to this view from *Venera 13*, which landed near the Beta Regio volcanoes in 1982. The camera scanned the landscape at an angle, so the horizon cuts diagonally across the upper corners, and parts of the spacecraft – including a discarded lens-cap – appear in the centre foreground. The dense clouds give an orange hue to the entire scene (top). If the colour balance is adjusted to show how the scene would appear in normal sunlight, the surface appears grey (bottom), as we would expect for basaltic rocks.

more slowly than any other planet, turning once on its axis in 243 days. Even more bizarre, it rotates from east to west, while most of the others, including the Earth, rotate from west to east. As seen from the surface of Venus (if we could strip the clouds away), the Sun would appear to rise in the west and set in the east. During the course of the long day Venus moves a significant amount along its orbit around the Sun. For this reason its 'day' – measured from noon to noon – is different from its period of rotation, and lasts for 117 Earth days.

Venus's rotation rate also means that the planet has a strange relationship with the Earth. Between one close approach to the Earth and the next, Venus rotates exactly five times, so at its closest approach it always presents the same side to the Earth. This fact was extremely galling for the pioneers of radar astronomy because they could produce good maps of Venus only when the planet was at its closest, and these always showed the same half of Venus.

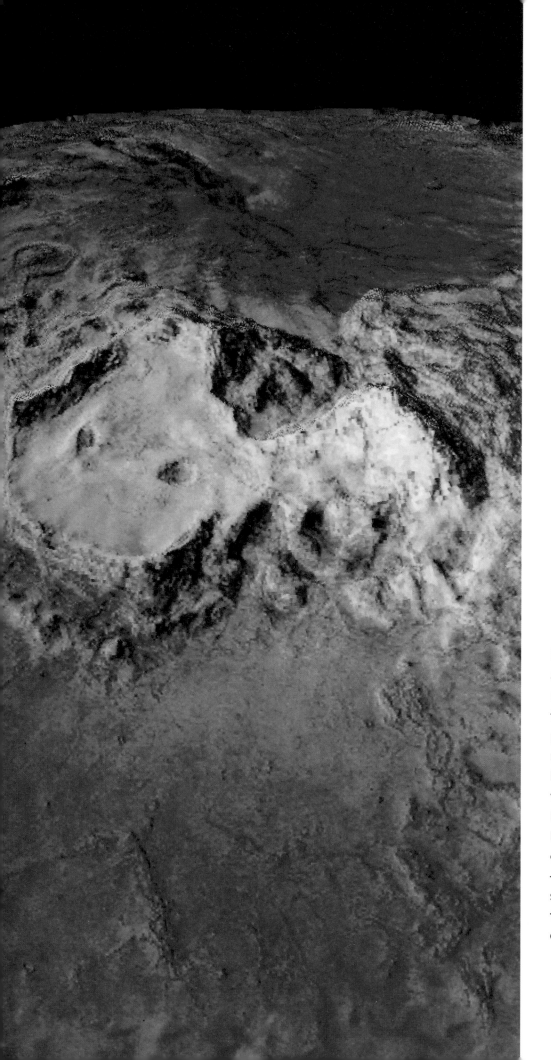

Beneath Venus's veils of cloud, a huge mountainous region rises from the flat plains near the planet's north pole. The plateau, Lakshmi Planum, is made of congealed lava that has poured from two large vents. The mountain (at right), Maxwell Montes, is higher than Mount Everest. This view was obtained by radar instruments – aboard American and Soviet spacecraft – that can 'see' through the all-enveloping clouds.

The contours of Venus – mapped by radar from the orbiting *Pioneer Venus* craft – indicate that most of the planet consists of low-lying volcanic plains (blue and green contours). The highland regions (yellow and red contours) include Aphrodite Terra, stretching halfway round the equator, and the two tall volcanoes that make up Beta Regio. Ishtar Terra resembles Tibet and the Himalayas on a larger scale: its vast plateau, Lakshmi Planum, is surrounded by folded mountain ranges that include the planet's highest peak (and the only feature on Venus named after a man!) Maxwell Montes.

None the less the first radar results showed some interesting details of Venus. Two regions, Alpha and Beta, were rough and reflected radar waves well. Near the north pole rose a tall mountain that was higher than Mount Everest and was named Maxwell Montes, after the scientist who predicted the existence of radio waves.

But the real breakthrough in astronomers' understanding of the geology of Venus had to await radar sets in orbit around the planet, patiently mapping the surface from just above the clouds. In 1978–9, the *Pioneer Venus* orbiter produced the first radar survey of the surface of Venus. The Soviet *Venera 15* and *16* craft provided more detailed views of the planet's north pole. But the breakthrough came from the American *Magellan* craft, which has been orbiting Venus since August 1990. Its radar can show features only 100 metres across on the hidden surface of Venus. With these images geologists can begin to unravel the history of our fellow planet.

Just as explorers have used their imagination freely in naming newly discovered rivers and mountains on Earth, so astronomers have had a field-day in giving names to mountains, craters and other features on freshly explored worlds. In the case of Venus, the only planet named after a goddess, the International Astronomical Union has decided that women only should be honoured. With the exception of the three features picked out first by Earth-based radar, the map of Venus thus bears names of women. They range from

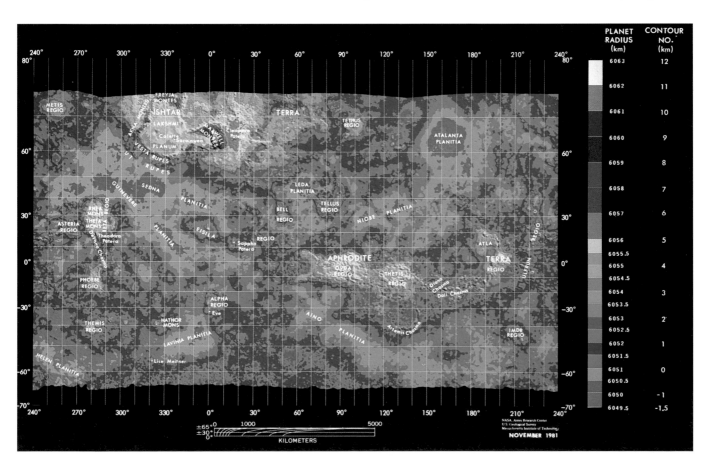

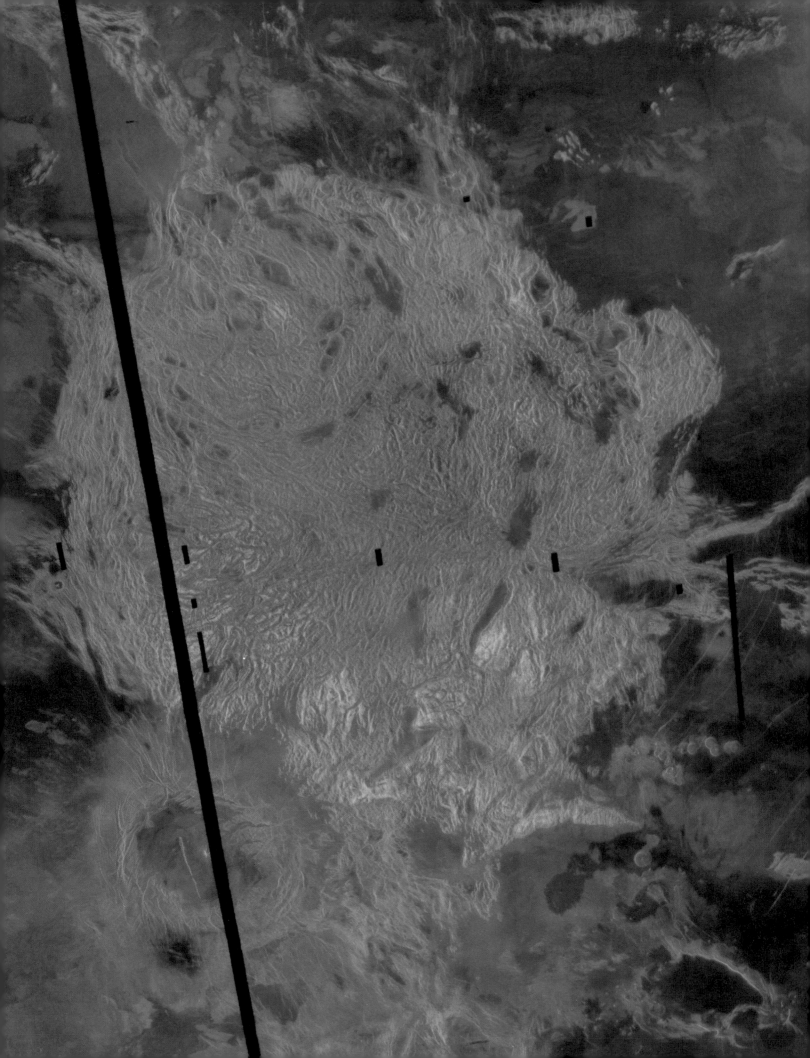

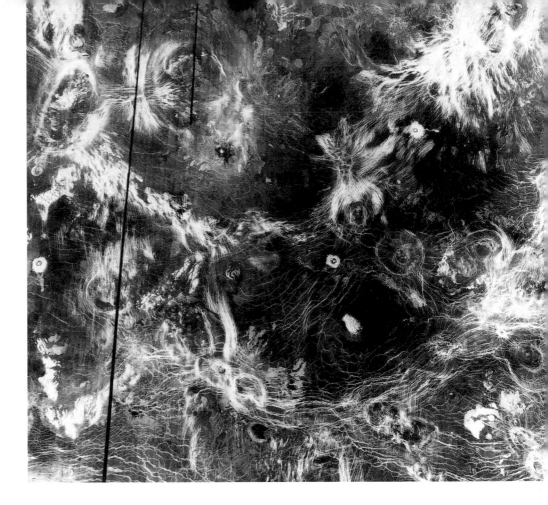

▶ The plains of Venus are cracked and scarred by volcanic activity. This *Magellan* view covers a 1,800-kilometre-wide section of the plains to the south of Maxwell Montes. It highlights spider-shaped systems of cracks and grooves called arachnoids. There are also lava flows and a few small bright craters caused by meteorite impact.

◀ A maze of intersecting ridges makes up Alpha Regio in this radar image from the *Magellan* spacecraft (black stripes are scans where the radar data is missing). Alpha Regio is roughly the size of Scandinavia, and it reflects radio waves so well that it was the first feature to be picked up by radar experiments based on the Earth. The pale circular ring to the lower left is Eve: the bright spot in its centre (next to the black stripe) has been chosen as the zero of longitude on Venus.

deities and mythological figures to heroines of our time. We find a mountain ridge named Aphrodite, the crater Cleopatra, the giant canyon Diana and plains called Helen and Guinevere. Eve is a strange circular feature surrounding a bright spot that astronomers have appropriately chosen as the zero for measuring longitude – the Greenwich of Venus.

The radar maps from *Magellan* show that Venus has a tortured volcanic surface. Covering practically every square kilometre are volcanoes of all sizes, enormous lava flows and weird igneous structures that have no counterpart on the Earth. Arachnoids are spider-shaped patterns of cracks that can stretch up to 250 kilometres across. Even larger are the coronae. A corona looks like a giant failed soufflé, and indeed it was formed the same way: it is a volcanic dome that rose and then, as the lava beneath it ebbed away, largely collapsed before it set solid. On a smaller scale are flattened 'pancake domes' the size of a city, where viscous lava has oozed on to the surface and congealed.

Most of these volcanic structures are broad and rather squat, and they are dotted over low-lying plains that cover much of the planet. Even the early results from *Pioneer Venus*, however, showed three regions that stand out because they are much higher than average.

Beta Regio is a pair of volcanoes with summits 5,000 metres high that make them among the tallest on the planet. They are composed of lava that has erupted from the centre of a sprawling system of cracks that stretches well beyond the volcanoes themselves. One of the Soviet landers settled on the

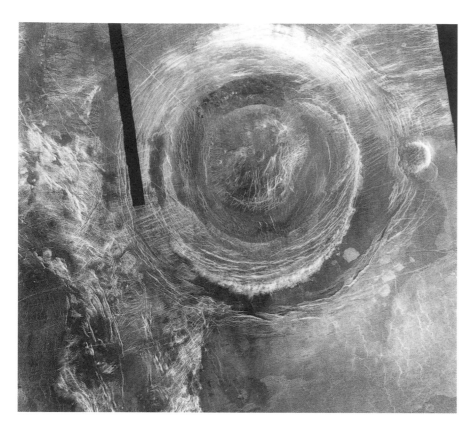

◄ This corona looks like a failed soufflé – and it formed in a similar way, as the centre of a giant volcanic dome collapsed. It is about the size of Ireland, and lies in the plains to the south of Aphrodite Terra. (The black stripe is due to data missing from this *Magellan* image.)

▼ Seven rounded hills rise from the plains near the edge of Alpha Regio. These pancake domes are about twenty-five kilometres across and less than one kilometre high. They consist of viscous lava that has welled up from the planet's interior.

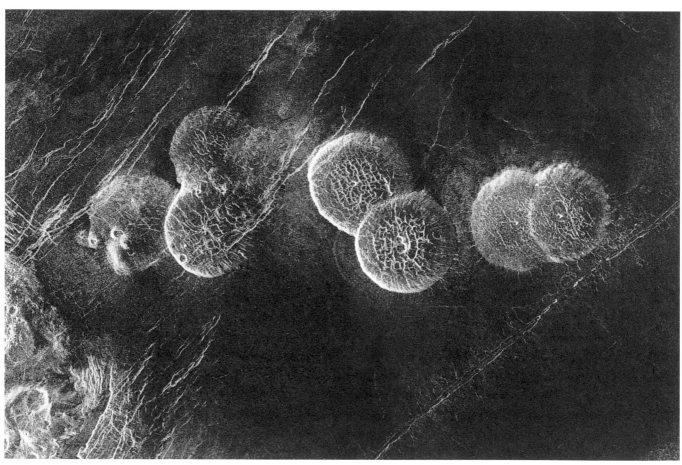

The double-peaked Sapas Mons is one of five large volcanoes making up Atla Regio, at the eastern end of Aphrodite Terra. The flanks of this shield volcano have a gentle gradient, rising to only 1.5 kilometres at the centre of a mountain 400 kilometres across.

edges of Beta Regio and recorded chunky rocks similar to some lavas on Earth. These sharp-edged stones are good at reflecting radio waves, thus making this region stand out brightly in the early radar images.

The volcanoes of Beta Regio are very similar to the shield volcanoes of the Earth – great volcanic piles like Hawaii that rise up to 10,000 metres from the ocean floor. A shield volcano on the Earth is fed by a single stream of molten rock – magma – rising from the planet's deep interior and forming a 'hot spot' at the surface. Beta Regio marks a hot spot on Venus where rising magma has cracked the surface and then heaped up a pair of shield volcanoes.

On the other side of Venus from Beta Regio we find a long mountainous ridge, Aphrodite Terra. Covering an area similar to South America, Aphrodite is shaped rather like a scorpion and winds along the equator to extend almost

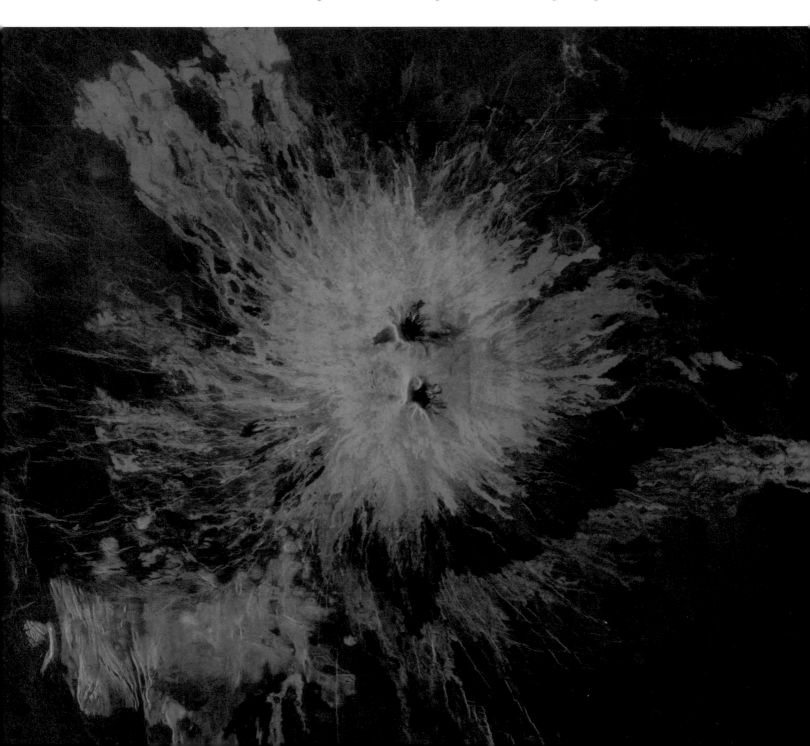

halfway around the planet. The body of the scorpion is currently one of the less active parts of Venus, but the region of its tail consists of a whole complex of troughs and ridges. The largest trough, Artemis Chasma, could swallow up one of the Earth's medium-sized mountain ranges. Some of the volcanoes here, such as Maat Mons and Atla Regio, resemble the peaks in Beta Regio and are probably fuelled by smaller hot spots of rising magma.

The third upland region of Venus lies near the north pole. Ishtar Terra consists of a plateau bordered on three sides by mountain ranges – in all, about the size of Australia. The southern edge is marked by a steep scarp, 3,000 metres high, where the plateau drops away to the lowland plains. The plateau itself, Lakshmi Planum, is very smooth. It is covered by the congealed lavas from two volcanic vents, that appear as large holes in the smooth plain.

To the east of the plateau towers Maxwell Montes. The highest mountain on Venus, it is 11,000 metres tall. Near the summit is a crater called Cleopatra. In early radar images Cleopatra looked rather like a caldera, the summit crater of a volcano, and many geologists thought that Maxwell was a mighty volcanic pile. But *Magellan* showed Cleopatra was formed by the impact of a large meteorite, and only by chance lies near the top of the mountain. Maxwell in fact consists of a series of parallel ridges, suggesting that it has been squeezed and crumpled in much the same way as the Earth's Himalayas were thrown up as India crashed into the Asian land mass.

Ishtar is the only part of Venus that looks like a continent. On Earth we usually think of a continent as a piece of the surface that happens to rise above sea-level. But there is a distinct geological difference between the ocean floor and the continents. The ocean floor consists of young rock – less than 250 million years old – that appears at mid-ocean ridges and eventually disappears back into the planet's interior. The continents consist of much older rock – up to 4,000 million years old. Ishtar rears above the plains of Venus in very much the same way as our continents rise above the ocean floor, but we cannot yet determine the age of its rocks, as much of them lie beneath the recent lava flows of Lakshmi Planum.

The rough and the smooth parts of Venus are contrasted in this false-colour image of the highland area Ishtar Terra. The shape of the terrain has been measured by orbiting spacecraft (*Pioneer Venus* orbiter and *Venera 15* and *16*) while the colours here show how well the surface reflects radio waves, as measured by the Earth-based Arecibo radio telescope. Generally, rough surfaces reflect radar better than smooth surfaces. The image shows that the plateau Lakshmi Planum is mainly smooth (purple and blue), with some rough patches (green): the high mountains, including Maxwell Montes (right), reflect even better (orange and red colour coding), probably because their rocks have been altered by weathering.

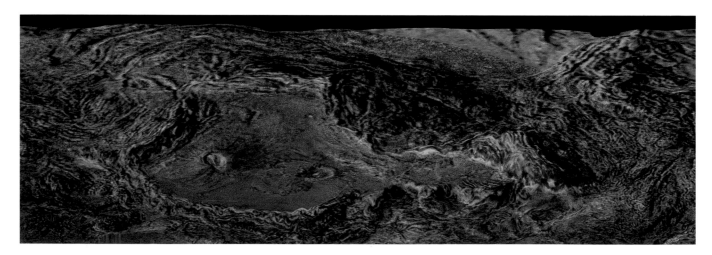

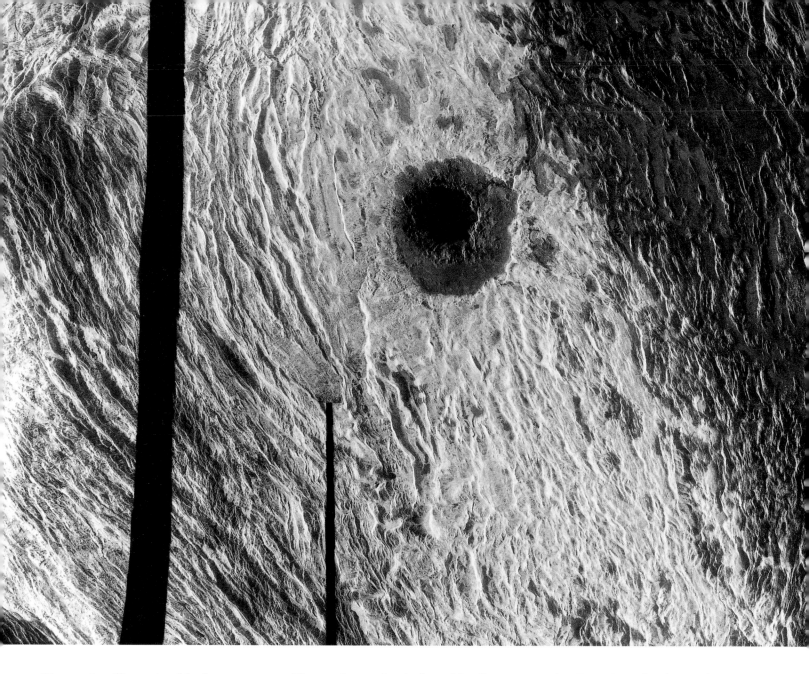

The crater Cleopatra (dark circle) was blasted out of the side of Venus's tallest mountain, Maxwell Montes, by the impact of a meteorite. This *Magellan* image convinced geologists that Cleopatra is not a volcanic caldera like Sacajawea; it also shows that the slopes of Maxwell are not part of a volcano but consist of folded bands of rock pushed upwards by powerful forces in the planet's crust.

The results coming in from *Magellan* suggest that Venus's surface has had a rather different history from that of its twin, the Earth. Because the two planets are similar in size and made of much the same material, radioactive elements within both worlds must produce about the same amount of heat. Much of the heat escapes through the surface in the form of molten rock from volcanoes. Some of this heat, in both planets, appears as hot spots where rising magma builds up huge volcanoes like those of Hawaii or Beta Regio.

But the rest of the heat emerges in different ways. On our planet, it comes up in distinct lines of volcanoes along the giant cracks that split our planet's crust into several rigid plates. The crust of Venus may be split into plates, but they are thin and flexible and easily pierced. Magma can well up all over, to create a planet-wide scattering of at least 100,000 volcanoes of all sizes.

The radar images cannot show if the Venusian volcanoes are still erupting, but geologists are convinced that many must be currently active. Detailed radar

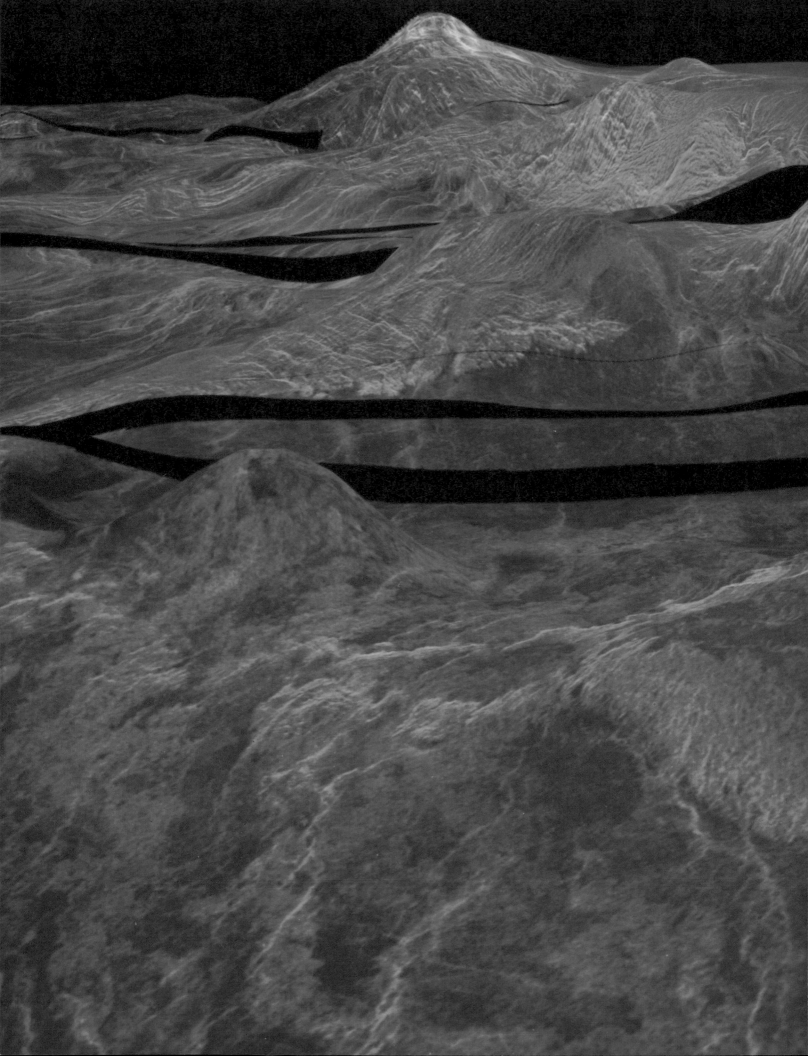

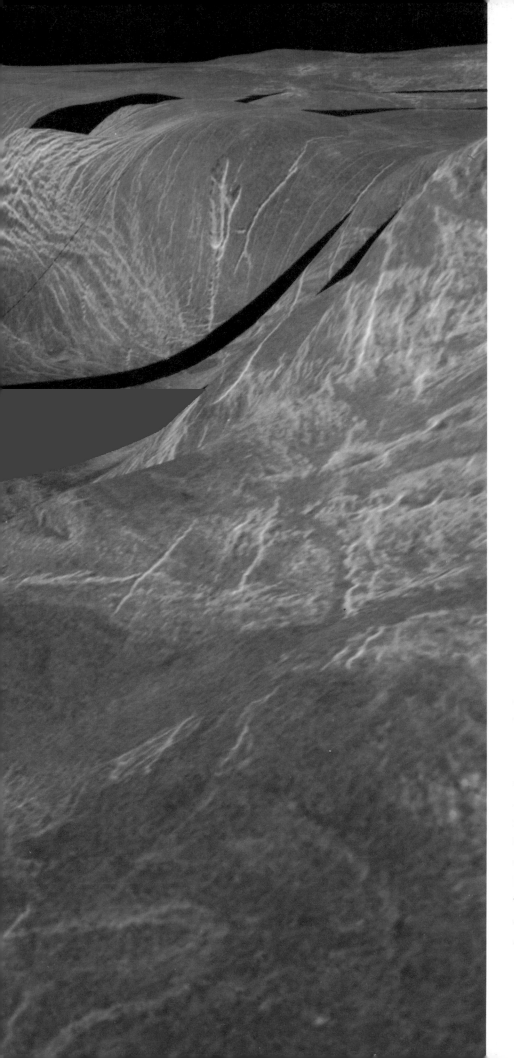

Mountain ranges and volcanoes
contort the surface of Venus
where a giant plateau, Lakshmi
Planum, drops down to the
plains. This view from the
cloud-piercing radar on the
Magellan spacecraft shows
solidified 'waterfalls' of lava
(top right), a small volcanic
cone (left) and the 5,000-metre
high mountain Danu Montes on
the horizon. The black stripes
are regions not covered by
Magellan's radar.

images show parts of Venus so rough that they resemble very fresh lavas on the Earth, including the peak of Venus's highest volcano, the 8,500-metre Maat Mons. In addition Soviet orbiting craft have found spots on Venus so hot that they may be active volcanic vents.

Planetary scientists have also been able to measure the age of many regions of the surface of Venus by counting the number of craters blasted out by meteorites. The radar images show only a thin scattering of impact craters over the surface of the planet – far fewer than the number we would expect from the continuous bombardment it must have suffered over the age of the Solar System. Most of the craters have evidently been wiped out by lava flows and other volcanic activity. The statistics show that the average age of the surface is only 400 million years.

But the surface is not all the same age. The oldest regions date back about

From this large vent, Sacajawea, flowed much of the lava that has covered the huge plateau Lakshmi Planum. After filling the plateau to overflowing, the supply of molten rock dried up and the floor of Sacajawea sank, cracking the plain around. Sacajawea now appears as one of two large holes in the smooth expanse of Lakshmi Planum.

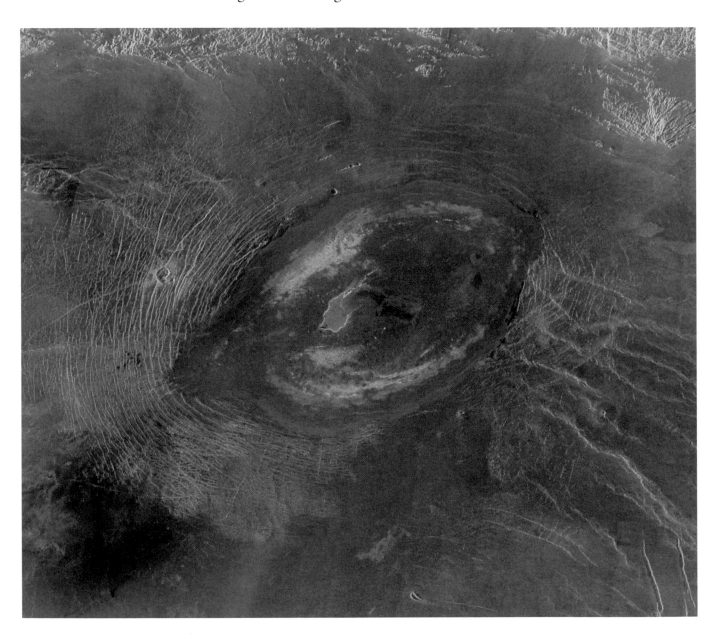

This forty-kilometre-diameter ring in the lowland region Lavinia Planitia is one of the few impact craters on Venus: the rest have been destroyed by volcanoes or buried under lava flows. The central peak, the crater walls and the surrounding ejecta appear brilliant in this *Magellan* radar image because they are made of jagged rocks that reflect radio waves well.

800 million years – an astonishingly short time on the geological scale – while other parts of Venus are progressively younger, suggesting that volcanic activity has been going on steadily all this time. It is presumably carrying on right now.

There is direct evidence of a massive eruption on Venus in the mid-1970s. When the *Pioneer Venus* craft arrived at Venus in 1978 it found a lot more sulphur dioxide in the atmosphere than astronomers on Earth had measured several years before. Over the next few years the amount of sulphur dioxide dropped again. Sulphur dioxide is one of the noxious gases released in volcanic eruptions, and the best explanation is that a major eruption ejected an enormous quantity of this gas just before the spacecraft arrived in orbit. Over the following years the amount of sulphur dioxide fell as chemical reactions turned it into sulphuric acid.

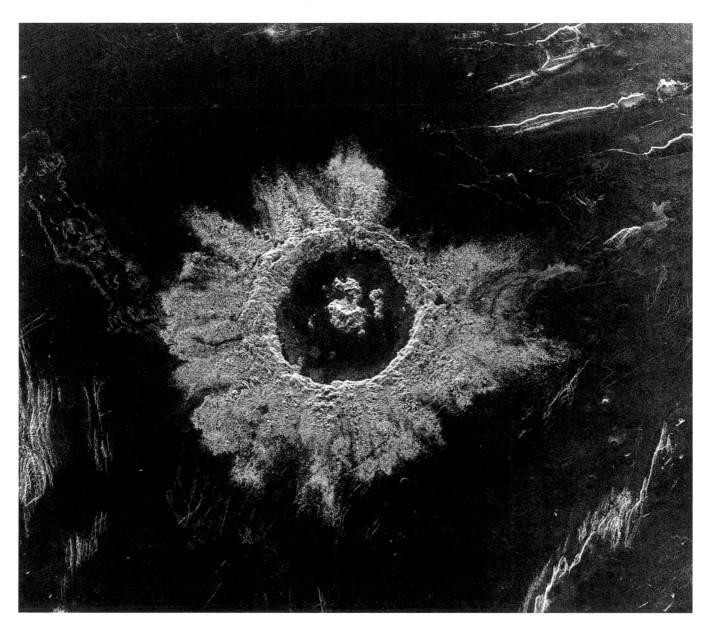

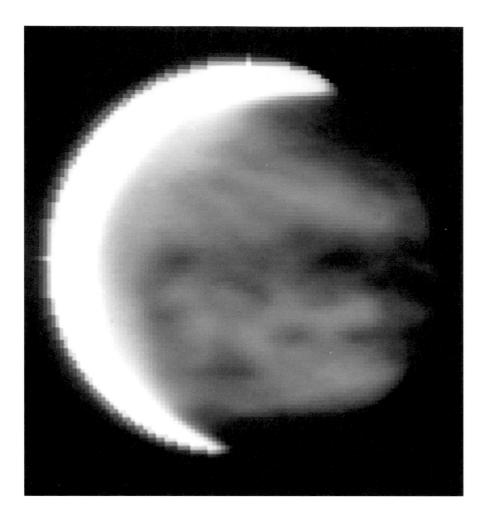

Over millions of years such reactions have produced the drops of sulphuric acid that now comprise the planet's continuous cloud decks. These clouds are actually not as dense as the water clouds of Earth: if we were foolish enough to hang about in the acid cloud layers of Venus, we would find ourselves in a haze rather than a pea-souper. Because the layers of haze are some 20,000 metres thick, however, they form an impenetrable veil over the face of Venus.

The clouds of Venus look bland when we observe them in ordinary light, but the view at ultraviolet wavelengths shows up an assortment of markings, in particular a large, dark Y-shape. *Mariner 10* took clear pictures of these markings as it swept past Venus on its way to Mercury in 1974, while the *Pioneer Venus* orbiter kept a continuous watch on Venus's changing weather from 1978 until it burnt up in Venus's atmosphere in 1992.

Because Venus rotates so slowly astronomers expected the winds on Venus to amount to just a gentle breeze. But nothing could be further from the truth: Venus lives up to its new fearsome reputation in its weather too. Although the planet turns once in 243 days, the clouds whip around once in only four Earth days, driven by winds that blow continuously at a speed of almost 400 kilometres per hour, well over twice hurricane force.

▶ The bare face of Venus: this is how the planet would appear if we could strip the clouds away. This image has been assembled from *Magellan* radar data, and tinted with the surface colour that was observed by the Soviet landers. Lying along the equator is Aphrodite Terra, its long cracks and curved fracture zones demonstrating where internal forces have stretched the planet's crust.

In 1985 meteorologists had their first inside information about Venus's weather. As the two Soviet craft called *Vega* sped towards Halley's Comet, they dropped weather balloons into Venus's atmosphere. The balloons floated around the planet within the main cloud decks, some 54,000 metres above the surface. And they experienced a bumpier ride than anyone expected. As well as tasting at first hand the winds whirling them around the planet at hundreds of kilometres per hour, the balloons were buffeted by strong gusts of wind

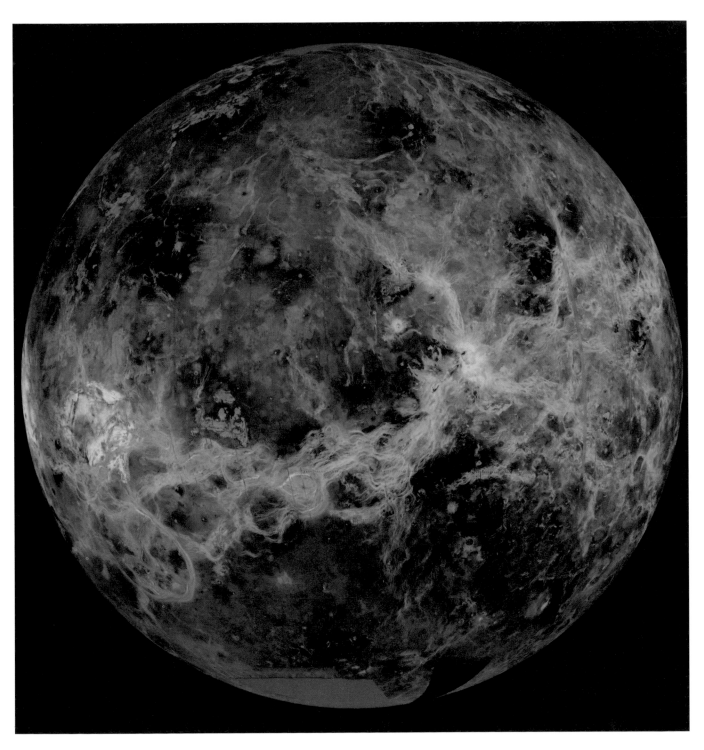

blowing vertically. As one balloon passed over the large volcanic swelling Aphrodite, a sudden squall sent it plunging precipitously downwards.

The weather on Venus is driven, as is the Earth's, by energy from sunlight. But, beyond this, any resemblance with the Earth's atmosphere ends. Venus's 'air' consists almost entirely of carbon dioxide, and it is so dense that the pressure at the planet's surface is ninety times the pressure at sea-level on the Earth – as crushing as the force on a submarine that has dived to 1,000 metres in the ocean.

In recent years everyone on Earth has become aware of the fact that carbon dioxide is excellent at trapping energy from the Sun and that the resulting greenhouse effect is increasing the temperature of our planet. With such a thick atmosphere, made up almost entirely of carbon dioxide, Venus suffers a greenhouse effect that makes ours pale into insignificance. While scientists argue whether the artificially produced increase of carbon dioxide will raise the Earth's temperature by one degree or three degrees, on Venus the greenhouse effect has raised the temperature by over 400 degrees. This makes it the hottest planet in the Solar System, even though it lies at twice Mercury's distance from the Sun.

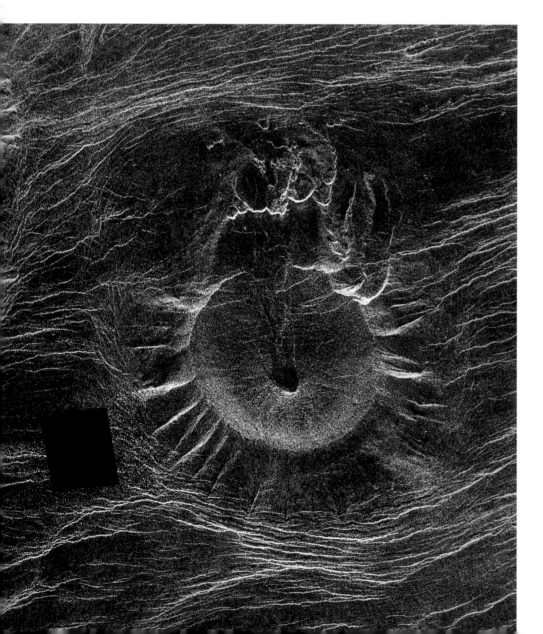

This volcano – nicknamed 'the tick' – lies near to the grooved region Alpha Regio. It is small by Venusian standards, sixty-six kilometres across at the base, and has unusual fluted sides. At one point the wall was breached by lava that flowed from a pit in the middle of the broad concave summit.

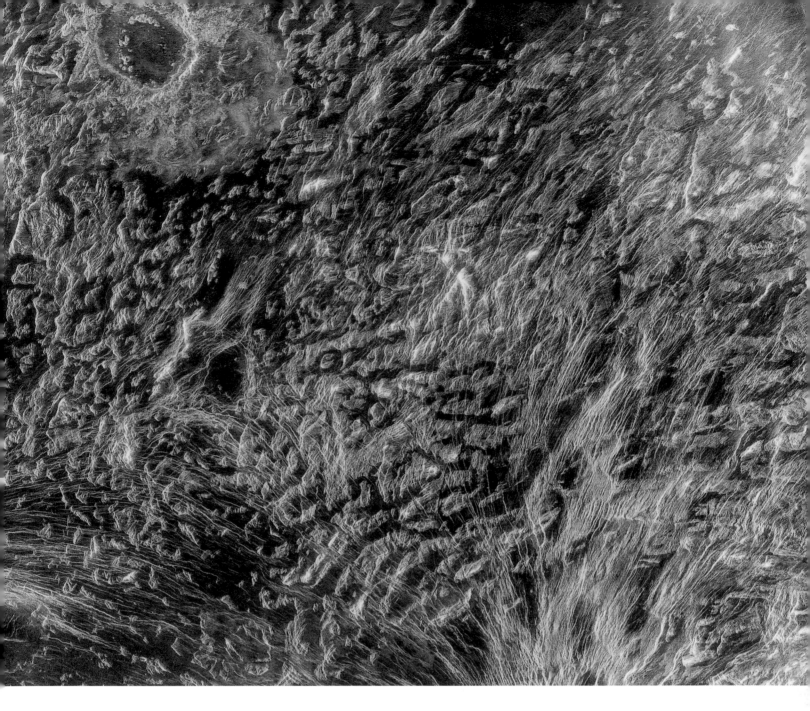

Most of the surface of Venus — like this part of Ovda Regio in the Aphrodite uplands — looks quite literally like nothing on Earth. Forces from within the planet have cracked, stretched and squeezed the surface rocks. A comparison of features on Venus, Mars and the Earth is improving our understanding of the processes that shape the faces of the planets.

The abundance of carbon dioxide on Venus is not a problem to explain. Carbon and oxygen are common atoms in the Universe, and, surprisingly enough, the Earth has an amount of carbon dioxide similar to Venus's. On our planet, however, it is locked up largely in carbonate rocks, like limestone, and dissolved in the oceans. For scientists the puzzling substance on Venus is water: the enigma is that Venus has virtually none.

Water is a common substance in the Universe. We find it aplenty in the planets Uranus and Neptune as well as on the Earth. Frozen water makes up the rings of Saturn and many of its moons and is incorporated into the soil of Mars. Neither ice nor liquid water could exist on the scorching surface of Venus, but scientists had expected the planet's atmosphere to be laden with steam. The spacecraft, however, have found only tiny traces.

Until further spacecraft have probed the surface and atmosphere of Venus in more detail, we will not know the definitive answer to the water mystery. Most likely the steam has risen to the top of the atmosphere, where the Sun's radiation has split the water molecules into separate atoms that have zoomed off into space, or the water may have reacted with the hot surface rocks and broken down into hydrogen. Being the lightest of gases, the hydrogen would have easily reached the top of the atmosphere and then escaped the planet's gravitational pull.

This brings us to the biggest question mark of all hanging over the veiled planet. Why is Venus so different from its twin, the Earth? Again we need future missions to answer this question to everyone's satisfaction. But the most plausible answer goes like this.

Golubkina, some thirty-four kilometres in diameter, was blasted out by the impact of a large meteorite. Within the circular mountain ring is a central peak, where the planet's rocks bounced back after the impact. Central peaks are more common in craters on a planet with higher gravity, like Venus, than on a small world like the Moon.

During the early days of the Solar System the Sun was slightly less bright, and slightly cooler, than it is today. At that time Venus would have been much like the Earth today, its closer distance to the Sun making up for the Sun's feebler power. Venus may then have been a wet and watery paradise, with an atmosphere composed mainly of nitrogen, as is the Earth's current atmosphere. Some kind of primitive life may even have evolved in its tropical seas.

But as the Sun grew hotter and brighter Venus became warmer and warmer. More water evaporated into the atmosphere – and water vapour is a better 'greenhouse gas' than even the infamous carbon dioxide. The water vapour trapped more of the Sun's heat, so heating up the oceans to produce more water vapour and also to release carbon dioxide dissolved in the seas. Eventually the temperature reached the boiling point of water. The oceans of Venus boiled away in thick palls of steam that trapped yet more of the Sun's heat. As the temperature rose higher it decomposed the carbonate rocks, and more carbon dioxide entered the atmosphere. Eventually the steam escaped from Venus to leave the carbon-dioxide-smothered Hell planet that we know today.

The case of Venus demonstrates clearly that planetary science is not an esoteric pursuit for ivory-towered academics. The 'runaway greenhouse effect' on Venus began with a rise in temperature of only a degree or two – just as we are seeing on the Earth today. That is not to say that our planet will inexorably go the same way as Venus, but if we can understand exactly how and why Venus experienced a runaway greenhouse effect, we will be in a much better position to prevent the same fate from overtaking the Earth. Venus stands as a dire warning of what can happen when a planet goes wrong.

EARTH

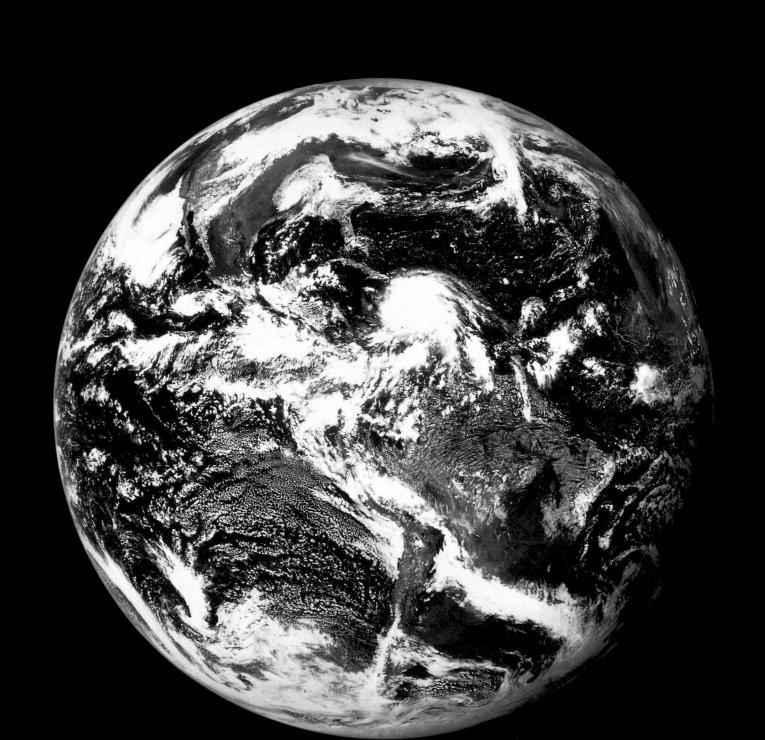

3

Third farthest from the Sun is the strangest planet in the Solar System. It is an active world, combining many of the most exciting features we find on the other planets – volcanoes, erosion, hurricanes, an outsized moon – with features that are unique to the Earth alone: drifting continents, liquid water and living beings.

The 'Blue Planet' of the inner Solar System, the Earth's colour is due to its unique oceans of liquid water. Beneath the ever-changing swirls of cloud – including a hurricane in the Caribbean – the Pacific and Atlantic Oceans dominate this view, taken by the GOES–East weather satellite. Separating the two oceans are the twin continents of North and South America. If we could watch our active planet for millions of years, we would see the continents gradually drifting around the world.

It is only in the past thirty years that we've been able to put our home planet and the other planets in context and hence learn how unusual – and fragile – our world is. The key has been the exploration of space. On the one hand, we now know the other planets as real worlds rather than fuzzy blobs in the sky; on the other, we have been able to look back at the Earth from space and see it as a whole planet. Until recently Earth scientists have been rather in the position of a group of blind people trying to describe an elephant by feel: the people handling the trunk, the tusks and the tail have all had very different ideas of the nature of the beast. So it is with the Earth: a global overview is now helping us to tie together the many measurements that Earth scientists have made of the surface of our planet and to understand the Earth as a whole.

Of the four rocky planets the Earth is the largest, slightly bigger than Venus and three times the size of Mercury. What we would notice first from space, however, is that the Earth is not alone. While Venus and Mercury have no moons, and Mars has a tiny pair of satellites that we would overlook at first sight, the Earth has a moon that is fully one-quarter of the Earth's own size. With their new extraterrestrial perspective on our own world, many astronomers now think of the Earth and the Moon as a 'double planet'. (This is not unique in the Solar System, however, as Pluto is also a double planet.) Certainly, we cannot think of the Earth's distant history in isolation. The birth of the Moon and of the Earth must have been closely related.

When the Americans planned the ambitious *Apollo* programme to the Moon in the 1960s they hoped that the mission would shed new light on the origin of both the Moon and the Earth. Ground-based telescopes had long ago shown that the Moon was the fossil of a world: devoid of air and water and scarred by craters caused by rocks falling in from space. The dark features of the 'Man in the Moon' are giant lava plains that solidified long ago, when the Moon was young. Nothing much has happened to change the Moon in billions of years. Here, astronomers reasoned, we would find rocks preserved from the birth of the Solar System, rocks that on the Earth have been destroyed by later volcanic activity and erosion.

The twelve astronauts who walked on the Moon's surface between 1969 and

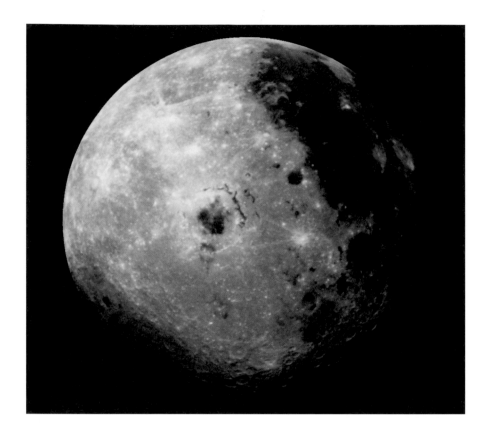

Our partner in space is as different from the Earth as we could imagine: the Moon is a dry, dead and airless world, unchanged for billions of years. Here the *Galileo* spacecraft has captured an unfamiliar angle as it swept past the Earth–Moon system in 1990 on its way to Jupiter. The bright regions are the lunar highlands, pocked with ancient craters. The smooth dark plains consist of lava that welled up and solidified almost four billion years ago.

1972 brought back one-third of a tonne of Moon rocks from six different places. Soviet robot craft also sent back to Earth samples of lunar soil from three more locations. Once these pieces of the Moon were in the laboratory, however, they caused more confusion than enlightenment: the analysis seemed to rule out all the current theories concerning the birth of the Moon.

One idea, current since the nineteenth century, was that the early Earth was spinning so fast that it split in two, the smaller fragment becoming the Moon. This was an attractive theory because the Moon is less dense than the Earth as a whole but has much the same density as the rocks that overlie the Earth's dense metal core. We can explain the Moon's low density if the Earth split into two after the core formed and the Moon was spun off from the rocky material of its outer layers. Unfortunately for this theory, the lunar rocks turned out to be very different from those of the Earth's surface: the Moon cannot be a lump of the Earth that has spun off into space.

Other astronomers had suggested that the Moon formed as a separate planet and was 'captured' by the Earth's gravity soon after both worlds were born. Most astronomers have abandoned this theory for the simple reason that such a gravitational capture is almost impossible: if the young Earth and the early Moon had passed close by one another, they would have swung about each other and headed off in different directions. There is an analogy with spacecraft here: *Mariner 10*, for example, swept past Venus without being captured even though it passed only a few thousand kilometres over the planet's cloud tops. To put a craft like the *Pioneer Venus* orbiter into orbit around a planet

you have to fire powerful rockets to slow it down and so allow the planet's gravity to take a firm grip.

And if the Moon *was* captured, where did it come from? The four planets out to Mars have a uniformly high density, much higher than the Moon's. They formed so close to the Sun that the temperature in the early days of the Solar System was sufficient to drive out much of the material with a low boiling point and leave high-boiling-point material – silicate rocks and iron – that are comparatively dense. Beyond Mars we find the asteroids, which contain rocks rich in water and compounds of carbon and have a density similar to that of the Moon. Following this argument through, astronomers in the 1960s suggested that the Moon came from the region beyond Mars and contained many of the 'volatile' (low-boiling-point compounds) that we find here.

When geologists looked at the composition of the rocks brought back by the astronauts they were amazed. The Moon actually contains much *less* in the way

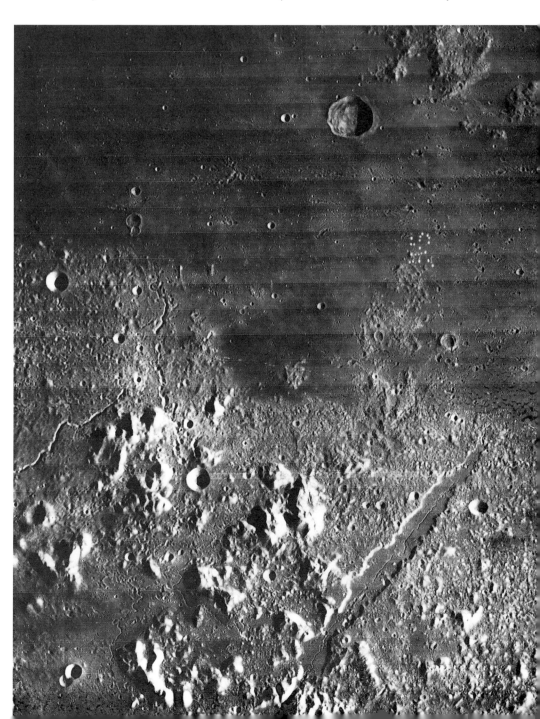

The lunar Alps are similar in height to their terrestrial namesake, but are in fact part of the rim of a huge ancient crater. Empty lava channels snake through the mountains and along the floor of a great rift, the Alpine Valley. Molten rock flooded the low-lying region adjoining the mountains to form the dark dry plain – Mare Frigoris, the Sea of Cold – that appears in the upper part of this view from the unmanned *Lunar* orbiter craft.

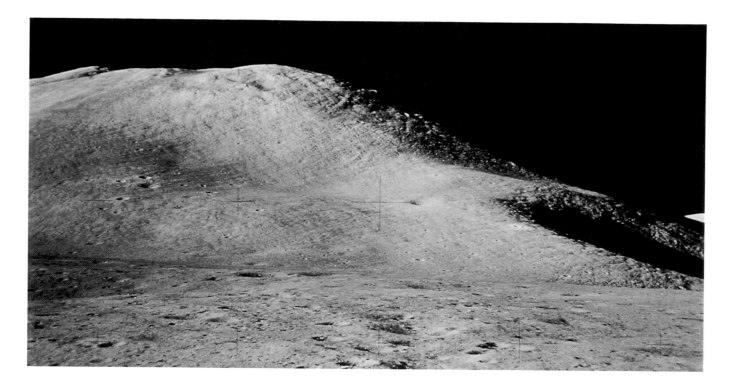

theory, the Earth did not at first have a moon at all. At this time the rocky planets were still assembling from smaller chunks of rock. In the inner Solar System there were several bodies the size of Mercury and Mars, along with the larger planets that would become Venus and the Earth. One of the Mars-sized bodies happened to run into the young Earth at high speed. The giant impact melted the upper layers of the Earth to form an ocean of molten rock 1,000 kilometres deep.

The effect on the incoming 'planet' was even more profound. The impact ripped it apart. Its dense core of molten iron flowed down through the Earth's molten rocks to merge eventually with the Earth's own iron core. The rest was splashed into space to form a cloud of incandescent fragments and hot gases surrounding the Earth. In this fearsome environment the more volatile substances, including water, boiled off into space. The other material eventually coalesced to form the Moon.

Although the Big Splash theory is so dramatic that it sounds more like science fiction than fact, it explains all the oddities of the Moon. According to the theory, the Moon formed from the rocky outer layers of the in-falling Mars-like planet, so it has little iron, and its composition, naturally, does not match that of the Earth's outer layers. The high temperature of the impact boiled away the volatiles before the Moon condensed from the matter orbiting the Earth. Because such an impact would be a rare event it has happened to only one planet, the Earth, out of the four planets in the inner Solar System. And an impact at an angle to the Earth's axis explains why our Moon – alone among the main satellites in the Solar System – orbits at a pronounced angle to the planet's equator.

▲ While the Moon's surface – typified by the Hadley Mountains – is barren and unchanging under a black airless sky, the Earth is a dynamic world. ▶ The Pacific island of Moorea is the tip of a giant volcano that has recently pushed its way up from the ocean floor; the abrasive power of rain is now wearing it down again. White clouds contrast with the blue sky as they condense over the mountains. Living plants grow up the slopes, while polyps form a mighty coral barrier that becalms the lagoon around the island.

The young Moon was almost certainly molten all through, but a crust of lighter rock soon solidified on top, like the skin on a jug of custard. We still see these rocks today as the bright, mountainous highlands of the Moon. Some of the smaller rocks still flying around the Solar System kept up the bombardment of the Moon for another few hundred million years. The most powerful of these impacts blasted out basins that are over 1,000 kilometres across.

By this time, around 4,000 million years ago, the Moon had largely solidified. But isolated hot regions just below the surface melted small local pockets of rock, which welled up as lava sheets that spread to fill the large impact basins. These are the dark plains that give the 'Man in the Moon' his distinctive features. Since then the Moon has been largely dead: in-falling meteorites have blasted out a few more craters, both in the highlands and on the lava plains, but nothing really exciting happened there until 1969, when the Moon had its first experience of visitors from another world.

By contrast, the Earth is an extremely active world. While virtually all of the Moon's surface is over 3,000 million years old – two-thirds of the age of the Solar System – only small portions of the Earth's surface are that old. These are the central regions of continents such as North America and Australia, and even here later geological activity has often masked their original form. Earth scientists have had to look very hard to find rocks on Earth as old as 3,900 million years, the average age of the lunar highlands.

The key to the Earth's geological activity is its comparatively large size – it is bigger than any of the other rocky worlds. When the Earth formed from the collision of asteroid-sized bodies the impacts generated more heat than was

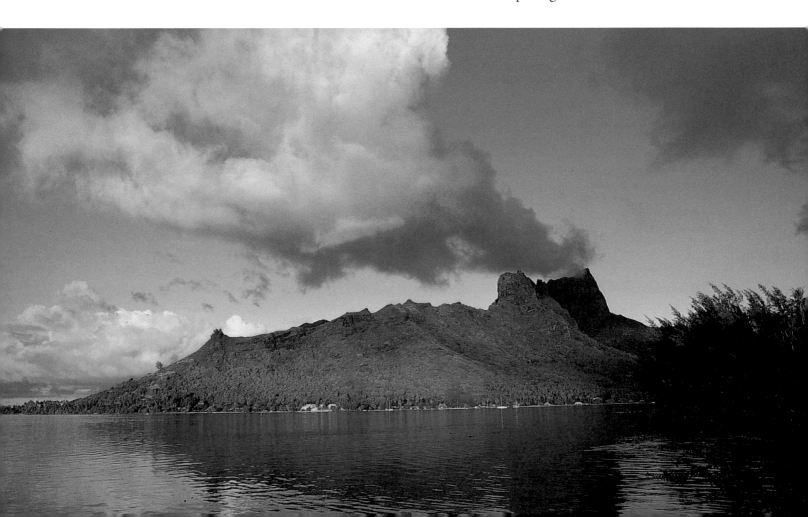

released in the birth of the smaller rocky worlds. Some of this heat is still trapped inside the Earth today. In addition, our planet contains more of the radioactive elements uranium, thorium and potassium, which are constantly breaking down and releasing heat. As a result, the temperature of the Earth's centre is about 5,000 °C – about as hot as the surface of the Sun. All known substances would normally boil away at this temperature, but the pressure of the overlying layers of the Earth keeps its centre compressed to a solid or liquid state.

In the middle of our planet is a large, dense core. Although they cannot study it directly, Earth scientists believe that the core must consist largely of iron because that would account for the Earth's high average density and would explain the way in which earthquake waves pass through regions near the centre of the Earth. This view is bolstered by the fact that some meteorites – presumably debris from disrupted minor planets – consist of pure metal, mainly iron with some nickel alloyed in.

The central part of the core is compressed so much that the iron here is solid. Surrounding this inner core is a region of liquid iron. As this molten metal sloshes around in our planet, it produces electric currents that in turn generate a magnetic field, the strongest on any of the rocky planets. This natural electromagnet is unstable. From the records of old magnetized rocks Earth scientists have found that every so often – after perhaps 100,000 or 1 million years – the direction of the Earth's magnetic field flips over. If the red end of a compass needle points north now, it would have pointed south 1 million years ago.

Most of the Earth, from the outer edge of the core up to the thin crust that covers the surface, is a large region of semi-molten rock called the 'mantle'. It is not liquid enough to flow easily, as does the iron in the outer part of the core, but it will flow slowly over a period of millions of years – rather like pitch at room temperature, which is solid enough to be shattered with a hammer but will flow gradually if left for years.

By analysing the paths taken by earthquake waves scientists are beginning to build up a three-dimensional view of hot and cold regions within the mantle. The waves travel more slowly through the hotter regions. The technique is similar to the medical 'tomography' that is now used to construct a three-dimensional image of, say, a brain from a set of X-rays taken at different angles. It turns out that the mantle contains 'plumes' of hot rock that are rising through the cooler (though still incandescent by normal standards) rock around.

Where a plume breaks the surface, we find a 'hot spot' – a region of continuous volcanic eruption. One of the best examples is the Big Island of Hawaii. This is a vast volcano that rises from the ocean floor to a height of 4,200 metres above sea-level. The total height from the volcano's own base to the summit is around 10,000 metres, which is more than the height of Mount Everest above sea-level. Given that Hawaii has gentle slopes, spreading its base

Shimmering curtains of colour – the aurora, or Northern Lights – are a familiar sight in regions near to the Earth's poles: in this case, Fairbanks in Alaska. The aurora is the most picturesque manifestation of the Earth's magnetic field. As electrically charged particles stream away from the Sun, our planet's magnetism channels some of them towards the magnetic poles and the particles make atoms in the Earth's upper atmosphere glow red and green.

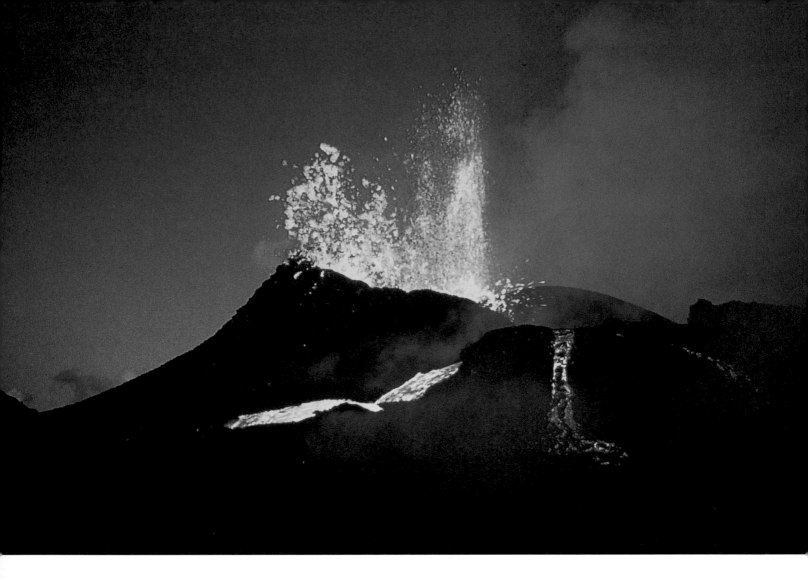

over 200 kilometres of the ocean floor, it is undoubtedly a greater mountain than Everest.

The Big Island of Hawaii lies at one end of a chain of islands stretching up to the north-west. Each of these islands has been an active volcano at one time but is now more or less extinct. As we go from the Big Island towards the north-west we encounter older and older peaks. The floor of the north Pacific comprises a large, thin 'plate' of the Earth's crust, and it is gradually moving north-west. The hot spot, however, stays put. As the moving plate carries the volcanic mountain away from the hot spot that is feeding it, the volcano's fires are extinguished. But the hot spot will eventually break through the new section of plate that has moved in above it and will erupt to form a fresh island.

Earth scientists now know that the 'Pacific Plate' is one of half a dozen large plates that cover most of the planet's surface. (There are also about a dozen much smaller plates.) The Pacific Plate is unusual in that it consists entirely of ocean floor; most of the others carry a continent on their backs. The continents are not merely parts of the Earth that stick up out of the oceans. If we could strip away the seas altogether, we would see the continents as plateaux that rise steeply for 5,000 metres (higher than the Alps) from the low-lying plains of

◀ Eruptions of lava from a hotspot in the mid-Pacific have built up the island of Hawaii. ▶ The island is composed of five volcanoes, the most active at present being Kilauea in the south-east, which emits lava continually. The snow-covered peak to the north of the island's centre is the highest mountain on Earth — as measured from its own base rather than from sea-level. From the ocean floor to its summit, Mauna Kea rises 10,200 metres.

the ocean floor. The continents consist of lighter rock that floats on the dense basalt that forms the base of the oceans.

The movement of the plates accounts for an idea that has been around, as speculation at least, since the last century: continental drift. If we could see the Earth as it was about 300 million years ago, we would find that all the continents formed a single, vast landmass, Pangaea. Moving currents of rock in the mantle below eventually broke Pangaea in two to create the 'super-continents', Laurasia and Gondwanaland. In turn, these also broke up. Laurasia split near its western edge to produce North America and Europe–Asia, separated by the North Atlantic Ocean.

◄ **The mountain ranges of Europe are the crumpled aftermath of a continental pile-up, as Africa crashed into the southern parts of Europe. The fold mountains extend from the Pyrenees through the Alps to the Apennines and the mountains of Greece. The pressure has forced parts of the Mediterranean floor down into the Earth's mantle, causing a succession of serious earthquakes in the eastern Mediterranean and igniting the Italian volcanoes Vesuvius, Stromboli and Etna.**

▼ **Deep trenches rim the western edge of the Pacific, where the surrounding continents are riding up over the floor of the ocean and forcing it down into the mantle beneath. These are the lowest parts of the Earth, dipping to 10,900 metres below sea-level in the Mariana Trench off the Philippines.**

Gondwanaland fragmented even more. One of the smaller pieces settled near the Earth's South Pole to become the continent of Antarctica. A similar piece went charging northwards in the shape of Australia – currently the fastest-moving continent, with a speed of 8 centimetres per year. Another small but fast-moving fragment of Gondwanaland shot off across what is now the Indian Ocean and ran smack into the side of Asia. That fragment of Gondwanaland is what we now call India: the collision raised the world's greatest mountain chain, the Himalayas, rising to 8,800 metres above sea-level in Mount Everest.

The largest part of Gondwanaland drifted north-westwards and eventually broke into two continents: Africa and South America. On a map today it is easy to see how the west coast of Africa can be matched across the South Atlantic with the east coast of South America. These two continents have moved so far north that they have met up with parts of the old Laurasia. The two Americas united, while Africa linked up with Asia through the Middle East. Africa's motion northwards is compressing the region of the Mediterranean, setting off the familiar earthquakes of southern Greece and the eruptions of Etna and Vesuvius. Less obviously, it is the push of Africa that has thrown up the Alps. One day Africa's inexorable northward path will squeeze the Mediterranean Sea out of existence altogether and raise in its place a range of mountains mightier than the Himalayas.

Where a piece of continent is running into the plate beneath an ocean, something different happens. Westward-drifting South America, for example, is trying to narrow the Pacific and is running against one of the smaller pieces of ocean floor, the Nazca Plate. In this collision the ocean floor is no match for the massive continent. South America rides up over the ocean floor, forcing the Nazca Plate down under the continent. As these rocks head downwards into the mantle, their cracking causes earthquakes above. The heat down here

The Earth's restless surface is still on the move. The Gulf of Suez and the Red Sea – photographed here from the space shuttle *Atlantis* – are parts of a widening crack where the Middle East is splitting away from Africa. A smaller split runs from the Gulf of Aqaba to the Dead Sea in the distance. The Nile meanders through the foreground of this shot.

boils off the water in the ocean-floor rocks, powering the volcanoes that erupt along the length of the Andes.

Continents are encroaching on the Pacific from all sides, so the Andes form just part of a volcanic 'Ring of Fire' that surrounds the world's greatest ocean. It includes the famous volcanoes of Japan and New Zealand as well as the fearsome but little known Alaskan volcanoes. Where a plate is overridden by a

The Grand Canyon in Arizona demonstrates the invincible power of erosion by running water. The Colorado River has etched its way down through the soft sandstone, so that it now flows 1,600 metres below the level of the surrounding terrain. In the process, it has carved a canyon over ten kilometres wide.

continent, it bends down under the load to form a steep trench in the ocean floor. As a result the floor of the Pacific is bordered by trenches that go deeper beneath the ocean surface than the Himalayas rise above it.

Just as the ocean floor disappears in trenches, so it is created where plates are moving apart. The classic case is the Atlantic, which is widening at the rate of one centimetre per year, taking the New World away from the Old at a rate equal to the growth of a finger-nail. Right down the centre of the Atlantic, and winding to match the coastal shape on either side, is a long ridge. Most of the Mid-Atlantic Ridge is hidden beneath the ocean, but occasional peaks protrude in islands such as Iceland and Ascension Island. At the mid-ocean ridges molten rock is welling up from below and cooling to form new ocean floor.

In the processes of plate tectonics the floor of the ocean is continuously recycled: created freshly at the mid-ocean ridges and squeezed back into the mantle by overriding continents at the edges of the oceans. As a result, no part of the ocean floor dates back more than a few hundred million years. Continents, on the other hand, are survivors because they always end up on top in any collision. Their oldest rocks therefore run back to ten times the age of the ocean floors. We find these ancient rocks in the centres of continents because collisions with other plates have confused their edges with mountain chains and volcanic mayhem.

The other force that has altered the continents during the life of the Earth has been erosion, the wearing away of the rocks by wind, by temperature changes and, most of all, by the cutting force of water, either as a liquid or in sheets of slowly moving ice.

While hot spots and plate tectonics raise giant volcanoes and great mountain

The living planet is revealed in an image of the Earth stripped of its clouds: this was assembled by computer from satellite images of cloud-free parts of the Earth. Half of our planet's land area is covered by vegetation dense enough to show up from orbit. The great rainforests around the equator – now under threat of destruction – are particularly important 'lungs', where plants convert carbon dioxide into oxygen.

► Plankton in the sea extends the range of plant life towards the poles, according to this false-colour view from the *Nimbus-7* and *NOAA-7* satellites. Areas of dense vegetation on the land are coded green. The most abundant regions of microscopic plants in the sea are shown in red and yellow. Plankton forms the basis of a food chain that stretches through fish to whales and people.

▼ The Earth is the only planet where the same substance – in this case, water – can exist in three different states: solid, liquid and gas (water vapour). The present ice-caps at the North and South Poles are the residue of frozen sheets that reached halfway to the equator during the great Ice Ages.

chains, erosion wears them down again. Tropical rainfall and waves have ground away the older Hawaiian islands until they now lie entirely below sealevel; rivers and glaciers have smoothed away the proud peaks of Scotland – probably once the greatest mountains on Earth – to a shadow of their former glory.

At the moment the Earth is unique in experiencing erosion of this kind – though dried-up water channels appear on Mars, and astronomers eagerly await future results from Venus to see if it too shows signs of a watery past. Our planet is the only world where conditions are currently benign enough for water neither to boil nor to freeze. The water may have originated as condensed steam from the Earth's early volcanoes. On the other hand, it may be melted ice, dropped in from space in the form of a bombardment of comets billions of years ago. Either way, there was enough to fill deeply the low-lying regions of the Earth's crust, between the continents, and so cover two-thirds of our planet with water. Reflection from the oceans makes our world appear from space as the 'Blue Planet'.

Water was responsible too for another of our planet's idiosyncrasies: living creatures. Most scientists believe that the first living cells formed from simple chemical compounds that dissolved in the early oceans to create a 'primordial soup'. From these cells evolved all the diversity of life – plant as well as animal – that we have around us today.

Plants have provided an essential pathway for life on Earth to progress. In the early days our 'air' was almost certainly a mixture of nitrogen and carbon

▲ **Dense clouds of water drops are unique to planet Earth – photographed here by the *Galileo* spacecraft on its way to the very different planet Jupiter. Clouds form an essential part of the water cycle, in which water evaporates from the oceans, condenses into clouds and falls as rain, either directly into the seas or on to land where it forms rivers that flow back to the oceans.**

▶ **A thin veneer of atmosphere is all that protects the surface of the Earth with its frail cargo of living beings from the harsh conditions of space: hard vacuum, temperature extremes and dangerous radiations.**

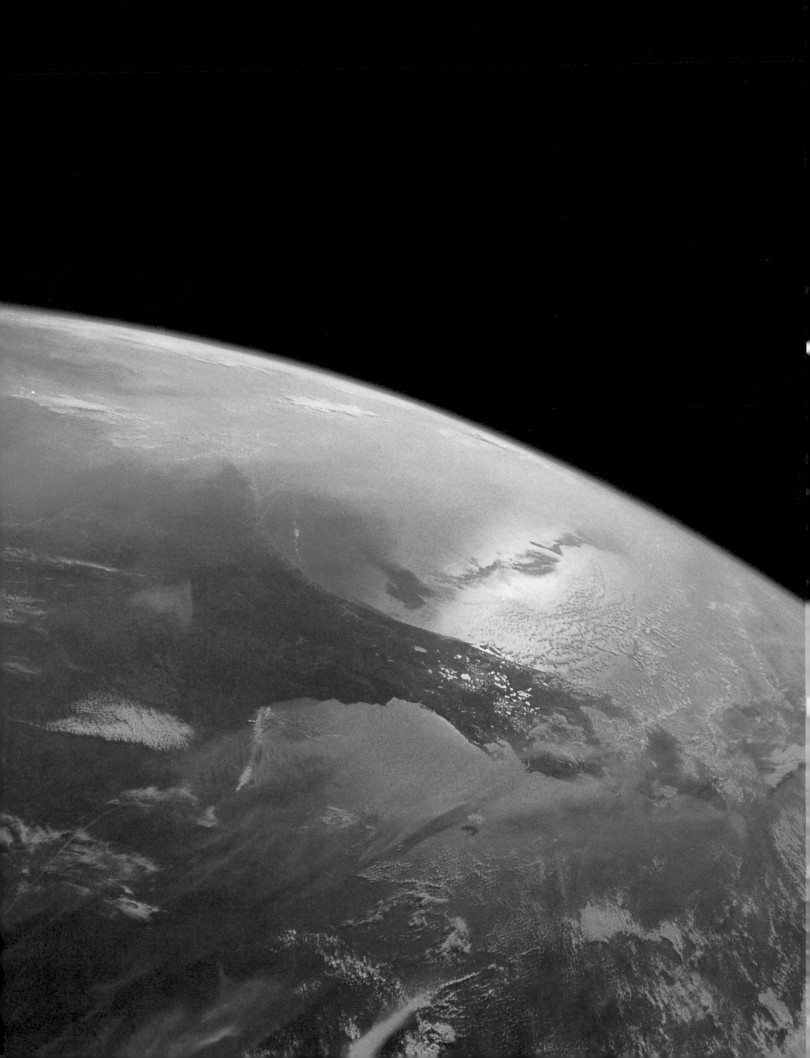

dioxide. Through the process of photosynthesis the plants used sunlight to feed off the carbon dioxide, exhaling the reactive gas oxygen. When animals evolved they could live by breathing the oxygen and eating the plants (or each other). So plants were responsible for providing us with an atmosphere rich in oxygen, a kind of air that is unique in the Solar System.

Scientists have discovered the remains of living cells in Australian rocks that were laid down 3,500 million years ago, some of the earliest rock known on the Earth. Since then life has evolved in a myriad different forms, and fossils show us many other kinds of creature that have turned out to be dead-ends. Sometimes these new variants on old creatures died out because they were unlucky in the struggle for survival; more often, changing conditions made life too difficult and tipped the balance in favour of a competing species.

Such circumstances arose, for example, when continents collided and destroyed much of the life that had existed in the shallow oceans around their rims. Changes in ocean level throughout the world had a similar effect, as did major changes in the climate – in particular the great Ice Ages, when half the planet was frozen solid.

Most intriguing to scientists who have investigated the Earth's past are the 'mass extinctions'. Half a dozen times in our planet's history the vast majority of species have disappeared overnight (in geological terms, if not literally). About 250 million years ago, for example, nine out of ten species on the Earth were wiped out. Better known is the 'death of the dinosaurs', the mass extinction of 66 million years ago that marked the disappearance not just of the great land reptiles but also of over half the plant and animal species.

The demise of the dinosaurs has led to a great debate between scientists holding rival theories. In 1979 an American team claimed to have proof that the dinosaurs were wiped out by a giant asteroid that crashed into the Earth. The impact raised a cloud of dust that blocked out the Sun's light, so killing plants and starving the animals that fed on them. The evidence was the discovery of a layer, rich in the element iridium, laid down at the time when the dinosaurs died. This element is rare on the Earth's surface but is common in meteorites.

The supporters of a cosmic cataclysm invoke the recently-discovered Chicxulub crater, on the north coast of Mexico, as the site of the impact that devastated the Earth. Oil prospectors found the first signs of this huge buried ring of disturbed rocks. Instead of a major reservoir of petroleum, however, this circular structure turned out to be a buried crater 66 million years old, blasted out by a wayward asteroid. The violent impact would have wreaked havoc on the Caribbean, and its force could have destroyed the dinosaurs that lived in North America.

Other researchers have suggested that the colossal impact also burned down most of the trees on Earth and scattered broken grains of quartz over our planet. Some scientists believe that mass extinctions happen regularly, every 30 million years or so, as a shower of comets hits the Earth.

Erosion by water and wind has shaped this landscape in a remote region of China, photographed by astronauts aboard the *Spacelab* laboratory on the space shuttle.

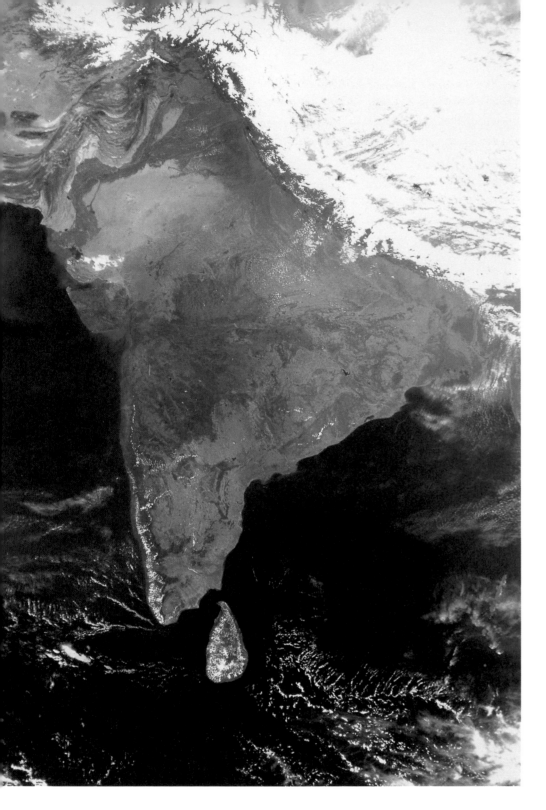

The 'smoking gun' that may have killed the dinosaurs: the Deccan Traps are a huge outpouring of lava that covers much of western India, showing up dark grey in this false-colour picture from a *Tiros-N* satellite. The huge eruption took place 66 million years ago, just when the dinosaurs perished. It may have been the climax of a rearrangement of rocks within our planet that altered the sea-level and the Earth's climate and so destroyed many species of plants and animals.

Exciting as this idea may be, it has yet to convince everyone. Geologists have pointed out that many creatures in the sea died off gradually in the million years before the dinosaurs met their *coup de grâce*. How did these animals know that the end was nigh? Some geologists have suggested an alternative execution scene for the dinosaurs. About 70 million years ago a giant blob of molten rock from the lower part of Earth's mantle began to make its way upwards. As it rose it distorted the Earth's surface and raised the sea-level, killing many of

the small animals that lived in the shallow waters. The changing sea-level cooled down the Earth's climate and weakened many animals, like the dinosaurs, that needed warmth. Eventually, some 66 million years ago, the hot rocks burst through the crust, bubbling with iridium gas brought up from the Earth's depths.

For these geologists, the 'smoking gun' is seen in the west of India, which is dominated by the remains of a giant eruption that occurred at exactly the right time. The Deccan Traps are a vast basaltic plateau where thousands of cubic kilometres of lava poured out of the ground 66 million years ago.

Whatever the outcome of this debate, it is evident that life on Earth has survived some major upheavals over the past 3,500 million years. However many species were wiped out, a few have survived, and have proliferated, to repopulate the Earth.

At the moment our planet faces at least one more mass extinction of this kind. Biologists fear that human activities on the planet, such as the destruction of the tropical rainforests, will kill off at least half the species on the Earth within the next century – and that's just the blink of an eye in a geological context. The other danger is the greenhouse effect, the gradual build-up of carbon dioxide that is warming the Earth's climate. The effect so far is small, a degree at most, but the consequences could be dire. The ultimate warning comes from looking at Venus, where a runaway greenhouse effect has boiled the planet dry.

But the more optimistic message from the Earth's past is that, despite ice and fire, life of some kind has always managed to survive and eventually blossom in new environmental niches. It is quite a safe bet that even if human folly wipes our own species off this planet, life of some kind will win through on the only planet in the Solar System that life can call home.

M A R S

4

As the unmanned spacecraft *Mariner 9* homed in on its target, the red planet Mars, the mission controllers on Earth were in for an unpleasant surprise. A swirl of cloud in the planet's dusty desert grew and grew until it became a giant dust storm that covered the planet, hiding its surface entirely from view.

In both size and appearance, the 'Red Planet' is a cross between the Earth and the Moon. From a distance, the ochre plains – such as Arabia, to the top right in this *Viking* orbiter view – resemble the Earth's desert areas, but in close-up they turn out to be peppered with craters like those on the Moon. The craters at the lower right, near Mars's south pole, are coated with a layer of carbon dioxide frost. Overlapping the frosty region is a large circular patch of fog and cloud, where evaporating carbon dioxide is filling the low-lying region Hellas.

If *Mariner 9* had been merely a 'fly-by' mission, the planet-wide dust storm would have put paid to the dreams that rode along with it – the first detailed photographs of Mars's surface. But *Mariner 9* was a different kind of spacecraft. It was to become a satellite of Mars: the first artificial moon of another planet. The mission was the first in Phase Two of the exploration of the other planets, a spacecraft that would rendezvous with another world and examine it in detail.

From its orbit the *Mariner* could watch the dust-shrouded planet below, waiting patiently until the winds abated and the dust began to settle. The weeks of waiting turned out to be well worth while, for the cameras of *Mariner 9* eventually revealed a world that was totally unexpected: a planet of giant volcanoes, huge canyons and old river beds.

These findings were the more astonishing because *Mariner 9* was not the first spacecraft to photograph Mars, and until then all the results had indicated that Mars was merely a cratered hulk as dead and as uninteresting as our Moon. Three earlier spacecraft from the *Mariner* stable had already paid flying visits. *Mariner 4* swept by the red planet in 1965 and sent back photographs showing a surface that was barren and scarred by innumerable craters. Its twenty-one black-and-white images are crude by comparison with the spectacular colour photographs from later spacecraft, but in their time they were epoch-making as the first close-up views of another planet. The unfriendly aspect of Mars was confirmed in 1969 by the views from *Mariner 6* and *Mariner 7*, the latter following a path that took it over the icy cap at the planet's south pole.

The first three *Mariners* found that Mars has only the thinnest of atmospheres, held by the weak gravity of a world containing scarcely one-tenth as much matter as the Earth. Lying 40 per cent farther from the Sun than the Earth's orbit and with such a tenuous atmospheric blanket, Mars turned out to be a frozen world where the temperature rarely rises above the freezing point of water. Bombardment from space has blasted out innumerable craters, so that the pictures from the early *Mariners* could easily be taken for photographs of the Earth's Moon. With no magnetic field to protect it, Mars is buffeted by storms of energetic particles that sweep out from the Sun.

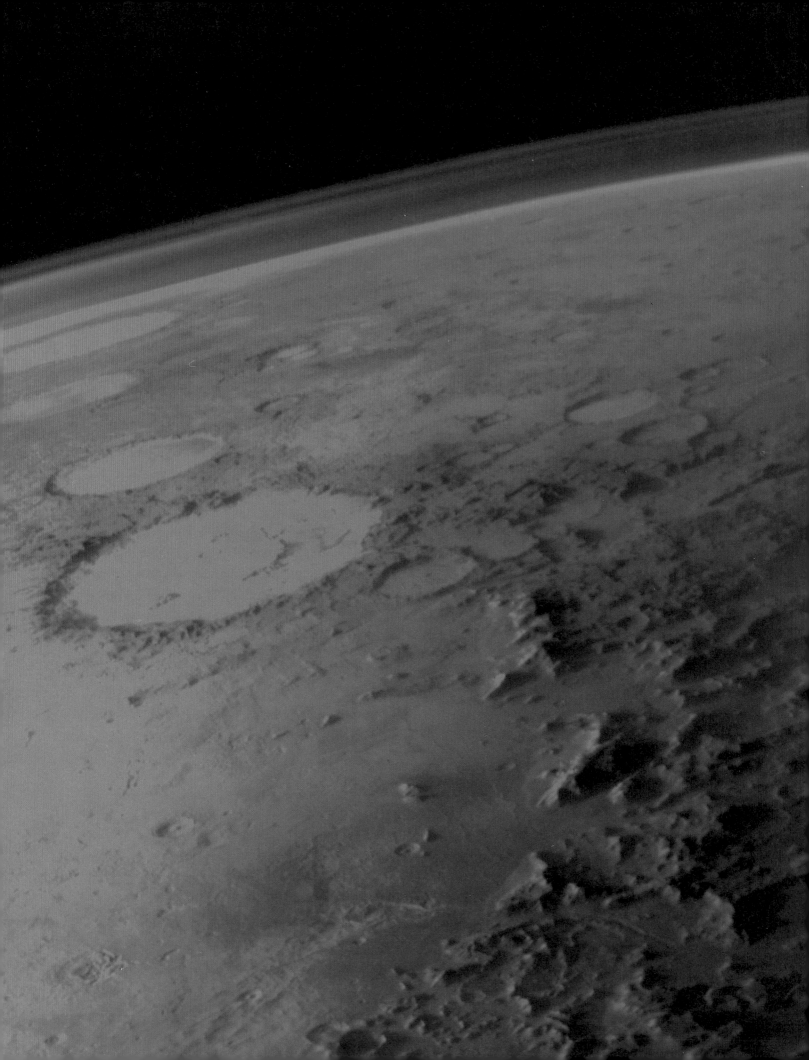

◄ This plain (lower left) is the lava-covered floor of the Argyre Basin, a 600-kilometre-wide hole blasted out of the surface of Mars by a giant meteorite impact. The mountains are part of the circular ring thrown up around the basin: in places they have been obliterated by smaller, more recent, impact craters such as Galle (left of centre). At the horizon, layers of carbon dioxide haze hang 25,000 metres high in the atmosphere.

These views of Mars destroyed once and for all the cosy Victorian idea that Mars was a second Earth, complete with water flowing in artificial 'canals' that had been built by intelligent Martians. This belief had been bolstered by two similarities with the Earth: the length of the day on Mars is very nearly the same as the Earth's, and Mars is tipped up in such a way that each hemisphere has 'winters' and 'summers' – although the seasons are much longer than ours because Mars takes almost two Earth years to travel around the Sun.

Even scientists who discounted the idea of intelligent Martians thought that large, dark regions in Mars's red deserts were composed of lowly vegetation or lichen. The first three *Mariners* put paid to that idea as well: Mars was too cold, and its air too thin, to support life of any kind. By the time the orbiter *Mariner 9* arrived astronomers had virtually written off Mars as a dead world.

When the veils of dust started to fall back to the planet's surface at the end of 1971 *Mariner 9* began to see the highest parts of Mars poking through. To the

► Rivers once flowed on Mars, geologists concluded in 1972 after studying this image of a 575-kilometre-long valley, taken by the *Mariner 9* spacecraft. Although Mars is now so cold that water would instantly freeze solid, the valley was evidently carved by running water – indicating that Mars was once a much warmer world, where life might have developed.

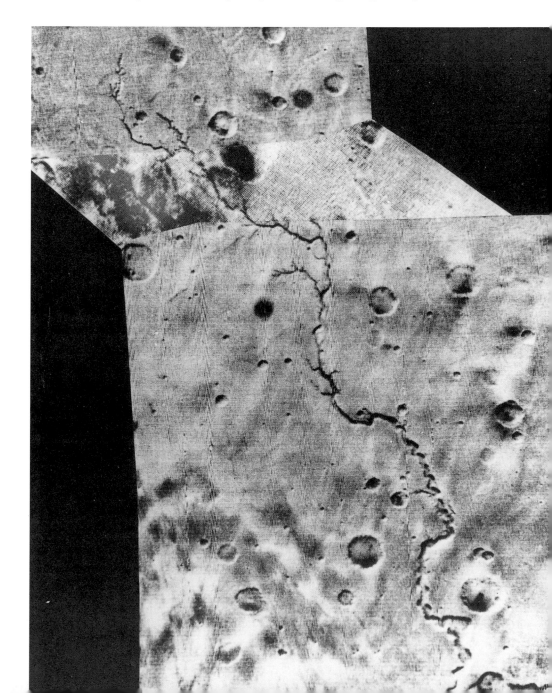

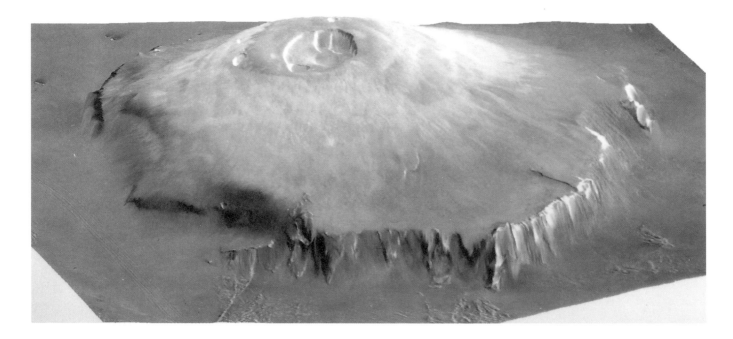

surprise of the astronomers, the first mountain peaks were not crater rims – as on the Moon – but the tops of four vast volcanoes, each larger than any volcano on Earth. As the dust settled to the ground, *Mariner*'s cameras revealed that the northern hemisphere of Mars consists of smooth lava plains with very few craters. To add to the geologists' delight, the clearing dust revealed an immense system of canyons around the planet's equator – later named Valles Marineris to honour the orbiting spacecraft. Most surprising of all on this dry planet, *Mariner 9* discovered narrow, winding valleys that looked for all the world like the beds of dried-up rivers.

These discoveries quickened the pulses of the astronomers and geologists studying Mars. It turned out that the planet has two very different faces. By an unfortunate irony, the three earlier spacecraft had all photographed the planet's southern hemisphere, which is heavily cratered and has changed little since the planet's birth. Volcanic eruptions and flowing water have, however, sculpted most of its northern hemisphere into a totally different landscape – so different that the first close-up pictures of Mars's northern hemisphere from *Mariner 9* seemed to be views of another planet.

Excitement therefore ran high when two successor spacecraft set off for Mars in 1976. Both of the *Viking* space probes had an orbiter craft that would circle Mars and provide even better pictures of the planet as a whole. In addition, each had a spindly-legged lander that would descend to the surface of Mars. Here the two landers would photograph the view, report on the weather conditions and test the soil for signs of life. When the mission had been planned in the late 1960s the prospects for life on Mars seemed bleak. But *Mariner 9*'s images of dried-up rivers suggested that water had once flowed on Mars. Might living cells have formed in Mars's wet past and be hibernating in the red soil even today?

Olympus Mons – Mars's 'Mount Olympus' – is the largest volcano we know in the Solar System. Its lavas have built up a mountain 25,000 metres high and 600 kilometres across at the base. On the left, in this *Viking* orbiter view, lava has flowed over the cliffs that ring the volcano. Olympus Mons bears the scars of very few meteorite impacts, showing that it is comparatively young on the geological scale: its last eruption may have been as recent as 100 million years ago.

From their inclined orbits the two *Viking* orbiters could photograph the whole of Mars's surface in intimate detail. Since two-thirds of the Earth's surface is hidden under water, it is fair to say that we now know the whole surface of Mars better than we do the surface of our own planet. These images of Mars are astounding views in their own right, but they have also provided geologists with clues to the planet's past.

Soon after its birth Mars, like the other rocky planets, resembled the state of the Moon and Mercury today. Its surface was pitted and scarred by the impact of the rocks that crashed down from space to make up the planet. We still see this surface in the southern hemisphere. Among the multitude of craters there are several vast basins blasted out by the largest in-falling asteroids. Hellas, the biggest, is 1,500 kilometres across – as large as the Caribbean Sea – with a flat floor that lies 6,000 metres below the average surface level of Mars. Hellas was probably formed about 4,000 million years ago as the hail of rocks from space was beginning to abate.

At this time the interior of Mars was melting. Molten iron inside the planet probably flowed to the centre to make a dense metallic core, like the central

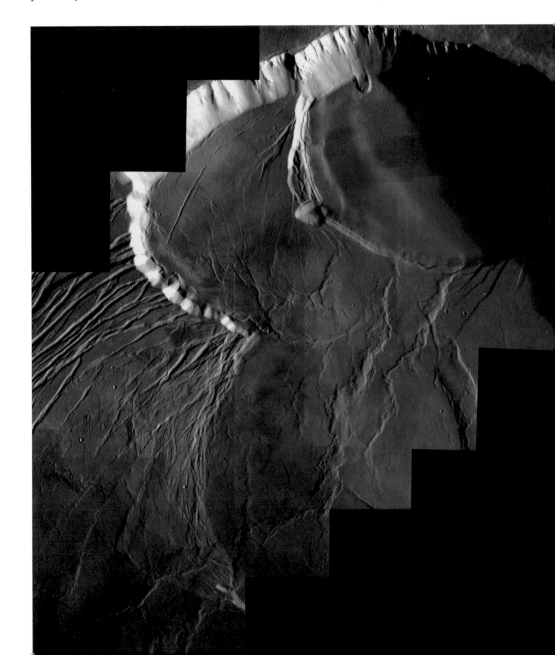

The summit of Olympus Mons is marked by a vast volcanic crater, some eighty kilometres across and over 1,000 metres deep: about one third of it is covered in this *Viking* orbiter photograph. It consists of half a dozen smaller overlapping calderas, the source of lava outflows for many different eruptions. Cracks and ridges run across the solidified lava floors. To give an idea of scale, the deepest caldera seen here (upper right) is large enough to contain the whole of Mount Vesuvius.

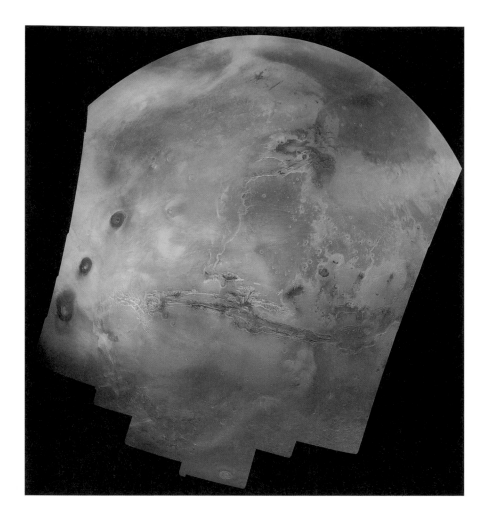

Mars's giant canyon system, Valles Marineris, runs across the centre of this photograph made up from 102 individual images sent back by *Viking Orbiter 1* in 1980. Valles Marineris is 3,000 kilometres long and up to 8,000 metres deep. Water once flowed eastwards along the canyon, and then northwards to disgorge into the dark region Acidalium Planum (top right). This giant crack opened up in the surface of Mars when rising lava forced the surface upwards into a huge bulge, Tharsis: its top is marked by the three volcanoes at the extreme left.

core of the Earth. The molten iron in our planet generates a strong magnetic field, but Mars's core, for reasons scientists still do not understand, does not produce any measurable magnetism.

The hot, soft rocks within the body of Mars began to move in alternating patterns of hot rising rock and cooler regions where the rock sank again. The rising rocks produced hot spots at the surface of Mars. As on the Earth, at each hot spot great volcanoes erupted. But there was one important difference. The Earth has a relatively thin crust, and the moving currents of hot rock break this solid skin into 'plates' that move about over the Earth. As a result, the erupting rocks from a hot spot are spread along the surface of the moving plate above to form a long line of relatively small volcanoes. On Mars the crust is thicker and does not move about, so over billions of years the erupting lavas from the hot spots have built up volcanoes far larger than any on the Earth.

The biggest volcano on Mars is called, fittingly enough, Olympus Mons: Mount Olympus. The name emerged among Earth-based astronomers of the last century, who had no idea of its grandeur. They could occasionally glimpse a white patch on this part of Mars and named it 'Nix Olympica' (the Snows of Olympus). We now know that the 'snow' is a gathering of white clouds over the mountain's towering peak.

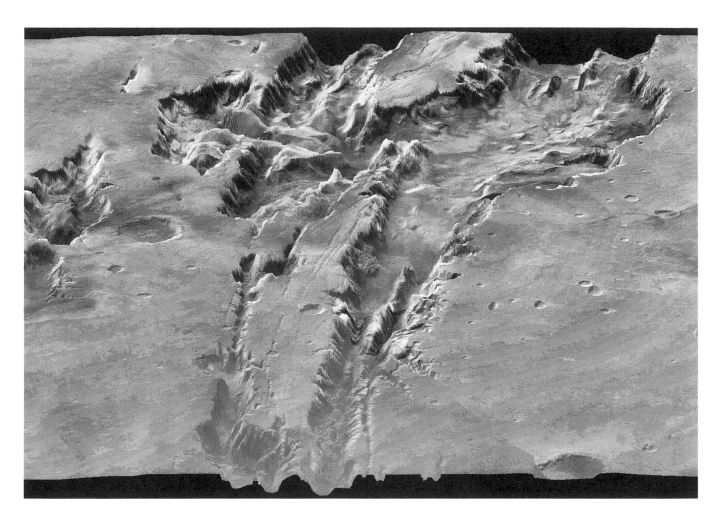

Mars's huge canyon Valles Marineris is far larger than any rift on the Earth. This split in the planet's crust is deep and wide enough to swallow a mountain range the size of the Alps.

The Martian Mount Olympus is far larger than the original on the Earth – in fact, it is bigger than any mountain on our planet, despite the small size of Mars itself. Olympus Mons rises to three times the height of Mount Everest. Its width is even more impressive: with a diameter of 600 kilometres, Olympus Mons is almost wide enough to cover Spain. Around its base is a cliff that towers 5,000 metres above the surrounding plains. The enormous breadth of the volcano means that the slopes above this cliff have a very shallow gradient, about 1 in 15 as they rise to the caldera that marks the summit.

To geologists Olympus Mons is a classic case of a 'shield volcano', a gentle outwelling of rather fluid lava that builds up a broad and shallow-sloped mountain. We find the same kind of volcano above hot spots on the Earth. These are not the violently eruptive and steep cones like Vesuvius but gently sloping piles of basalts, such as the Big Island of Hawaii. Olympus Mons, however, contains enough congealed lava to make the island of Hawaii a hundred times over.

Although it is the showpiece of Mars's volcanoes, Olympus Mons is far from unique. Mars has dozens of volcanoes of various shapes and sizes. The widest, Alba Patera, is about 1,500 kilometres across. Although it shows up on the photographs from Mars orbit, you would probably not notice Alba Patera at

The 'face on Mars' (top) has been cited by some imaginative writers as evidence for intelligent – and artistically inclined! – life on the Red Planet. In fact, the 1·5-kilometre 'face' is one of dozens of unusual hills in the northern plains that have been eroded by the wind: others appear in the lower part of this *Viking* orbiter photograph. (The black dots are places where the television transmission was briefly interrupted.)

all if you were travelling over the surface of Mars: after walking for a quarter of an hour towards its summit you would be only 10 metres higher than when you started.

Near Olympus Mons a vast upwelling of lava from deep inside the planet has raised a huge bulge on the side of Mars. This swelling, Tharsis, is 4,000 kilometres across and rises 10,000 metres above the surrounding plain. Perched on top of Tharsis is a line of three shield volcanoes that look like smaller versions of Olympus Mons itself. In such a comparison the word 'smaller' is deceptive because each of these cones is far larger than any volcano on the Earth.

As deep forces in Mars pushed upwards in the Tharsis region, the surface split open like the skin of an overripe tomato. Thus was formed the great valley system, the Valles Marineris, that spreads eastwards around the equator from Tharsis. Photographs taken from Mars's orbit show Valles Marineris looking like the Grand Canyon of Arizona, but the Martian version is on an incomparably grander scale. Any of its numerous tributaries is more than a match for the Earth's Grand Canyon, while the entire system of fracture stretches for a distance equal to the width of the United States. Valles Marineris is so wide and deep that we could place the whole of the Rocky Mountains inside it and they would disappear from view.

As well as throwing up volcanoes and splitting the planet's surface, the heat engine within the young Mars erupted seas of lava that covered most of the planet's northern hemisphere and hid the original cratered surface. This molten rock has long since solidified into vast smooth plains, sprinkled with just a smattering of later craters.

Once thought to be vegetation, on close inspection the dark areas on Mars turn out to be exposed areas of rock that are swept clear of pale dust by the planet's seasonal winds. Syrtis Major (right of centre) is the most prominent of Mars's dark markings, and is easily visible from the Earth with a small telescope. It is a sloping volcanic plain made of basalt, lying between the old cratered region Arabia (left) and the smooth-floored Isidis Planitia (right), the floor of an old impact basin.

The wind blows freely across these plains, and it has played an important role in moulding the northern Martian landscape. Around the north pole of Mars the wind has heaped up the loose, sandy soil to create a region of sand dunes that is bigger than the Sahara. More widely spread are craters apparently set on pedestals because the wind has worn away the surrounding surface. The wind has also chiselled away at isolated hills, giving them sides that look unnaturally smooth and flat. Among these artificial-looking blocks of rock imaginative thinkers have been able to make out pyramids, ziggurats and at least two huge humanoid faces staring out into space.

When the Martian winds get into full swing they can raise enough dust from the surface to obscure the whole of Mars in a dust storm, as *Mariner 9* found in 1971. Even in less extreme conditions the wind is always blowing the lighter soil particles around, leaving streaks across the Martian surface. With the changing seasons the winds alter direction, blowing dust away from some regions to reveal darker rocks beneath and covering other dark rocky regions with the brighter dust. In the past these changes in the dark patches of Mars misled astronomers. As seen from the Earth, the seasonal 'wave of darkening' seemed to represent the spring-time growth of fresh vegetation.

Winter on Mars can be so cold that the 'air' freezes. The Martian atmosphere is made mainly of carbon dioxide, and at the pole in winter the temperature plummets to −110 °C. The carbon dioxide here freezes to form a large white polar cap of dry ice. The dry ice evaporates again as the temperature rises in the spring and the summer. When it is summer in the southern hemisphere the south polar cap almost disappears altogether. During summer in the northern hemisphere, however, there is always a noticeable polar cap at the north pole that consists of ordinary ice.

As the ice caps grow and recede and the seasonal winds blow dust back and forth, layer upon layer of slightly different soils have piled up in the polar

◀ The white cap at the south pole of Mars consists of solid carbon dioxide, where the atmosphere has frozen solid in a temperature of −110 °C. In the southern summer of September 1977 the polar cap shrank to its minimum size, just 400 kilometres across: in winter, it expands to fill the whole of the area photographed. The polar ice lies on top of sediments that have been etched by wind into a spiral shape.

▼ **Looking down on Mars's north polar cap during the height of summer, *Viking Orbiter 2* photographed a 500-metre-high layered cliff. The white coating on top of the cliff and on the lowlands in the foreground consists of frozen water: the temperature is high enough to evaporate the frozen carbon dioxide that covers the north pole in winter. The fifty-metre-deep layers in the cliff mark periods when the wind deposited sand here: their even thickness suggests that Mars's climate varies regularly, in a way that may be related to the recurrence of Ice Ages on the Earth.**

regions. Deep canyons cut through these regions, revealing these layers to the cameras of the *Viking* orbiters. Some scientists think that these patterns mark past swings in the Martian climate that resemble the Ice Ages on the Earth and so can help us to understand the major changes in climate on our planet.

In the Martian winter as much as one-third of the atmosphere may freeze at the pole, and so the atmospheric pressure on Mars swings up and down wildly with the seasons. A weather forecaster on the Earth regards a change of a couple of percentage points in the pressure as a cause for concern – indicating a major storm, perhaps, or a prolonged drought – but the two *Viking* landers found that the pressure on Mars can change by 30 per cent. Even so, the maximum atmospheric pressure on Mars is only one-hundredth of that on the Earth.

The first daily weather report from the surface of Mars ran as follows: 'Light winds from the east in the late afternoon, changing to light winds from the south-east after midnight. Maximum winds were 25 kilometres per hour. Pressure steady at 7.70 millibars. Temperature ranged from −85 °C just after dawn to a maximum of −30 °C – and this was a balmy spring day!

As well as providing the first weather stations on another planet, the two *Viking* landers analysed the soil beneath them – an iron-rich clay, probably a weathered basalt – and took many pictures of the bleak red desert that

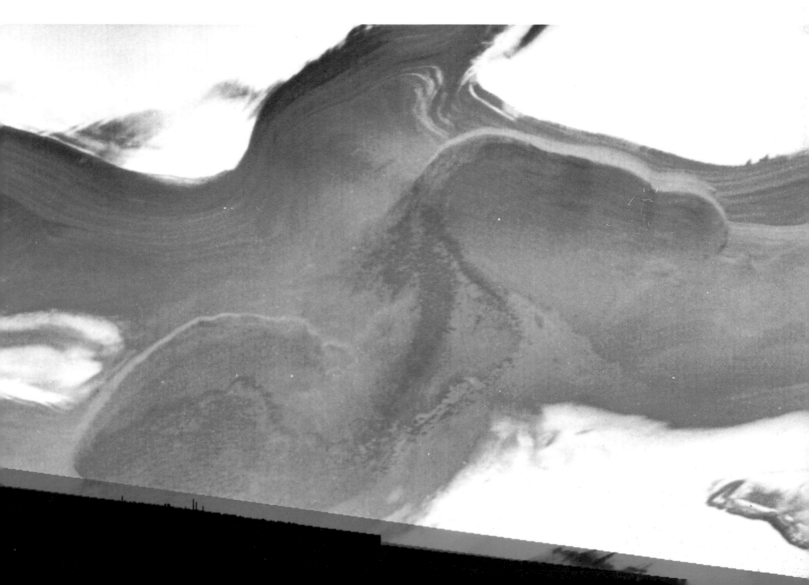

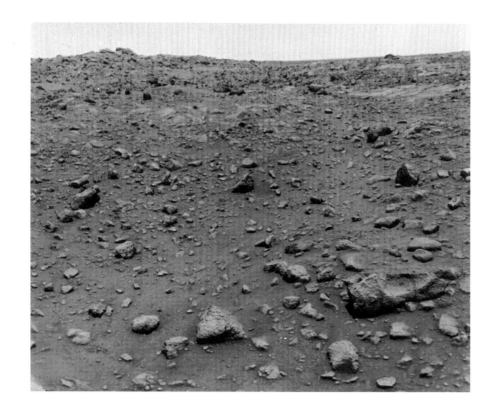

The deserts of Mars have literally rusted away, to form ochre sands that give the 'Red Planet' its nickname. The sky is pale pink with a fine haze of dust, as seen here by the unmanned *Viking 1* spacecraft.

surrounded them. But their most important task was to check for life on Mars.

No one expected to see Martians waving to the cameras on board the *Viking* landers, and it seemed unlikely that there would be anything noticeable growing in the frozen soil of Mars. But there might be single cells in the soil, hibernating from a distant past when Mars was warmer and wetter. Each of the landers carried a scoop in order to pick up a sample of soil and drop it into an on-board laboratory. The soil was tested in several different ways. In all, the soil was warmed and wetted, exposed to bright lights and fed a variety of 'foods'. Instruments in the laboratory could then detect any gases that came off as a result or could measure the soil later to see if components of the foodstuffs had been absorbed. Any dormant cells in the soil should have been awoken by the warmth and water. Taking in the dissolved foods, the cells would grow and multiply until they were numerous enough to produce detectable amounts of waste gas.

A buzz of excitement ran through the experimenters on Earth when the first results were radioed back from the landers. Yes, gas was produced when the soil was wetted. But then disappointment set in. The amount of gas decreased as time went by – the exact opposite of what we would expect from a proliferating colony of cells.

The results from these specially designed biology experiments on the *Viking* landers were perplexing and gave no firm answer to the question of life on the red planet. Ironically, the clinching evidence came from a different experiment altogether, from an instrument designed to measure what the soil was made of. To everyone's surprise, one element was missing entirely from the soil: carbon.

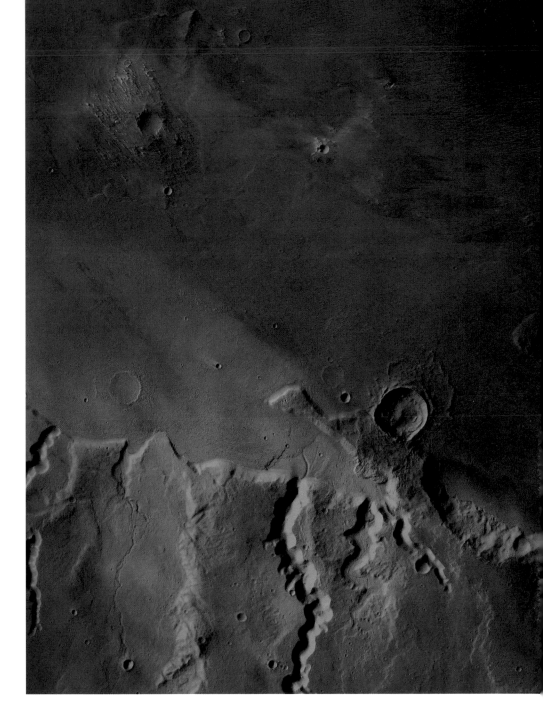

The site of a future Martian base? There are many indications of water in this region, Mangala Valles, near the equator to the south of the great volcano Olympus Mons. Ancient river channels run down into a flat plain that may be the floor of a sea that has long since evaporated. The 'splashed' appearance of the largest crater (right of centre) suggests the in-falling meteorite melted ice that is still frozen into the soil. This water would be invaluable to a manned base – and it also makes this region a prime target for scientists looking for remains of early life on Mars.

Carbon is the building block of life – indeed, scientists use the term 'organic chemistry' as synonymous with the chemistry of carbon compounds. In even the most barren of the Earth's soils, from a desert or from Antarctica, there are always a few dormant cells, and they would contain enough carbon to register easily on the *Viking*'s instruments. The complete lack of carbon meant that the soil could contain no cells, living, dormant or dead.

This experiment was so sensitive that it would even have detected some carbon in the soil of the Moon – not from living cells but from carbon-rich meteorites that had fallen on its surface. Similar meteorites must also be falling on Mars, so the *Viking* scientists were driven to the conclusion that something on Mars was actively destroying carbon compounds.

Mars's larger moon, Phobos, is a dark chunk of rock twenty-eight kilometres long – its colour a striking contrast to the reddish hue of Mars itself in this photograph from the Soviet *Phobos* spacecraft. Both Phobos and Mars's smaller moon, Deimos, are asteroids captured by Mars as they came close to the planet. Resistance from Mars's upper atmosphere is making Phobos spiral in gradually towards the planet: in about 100 million years it will crash into the surface of Mars and blast out a crater some 300 kilometres across.

The answer, it now seems, lies in the fact that Mars has no ozone layer. The Earth has plenty of oxygen in its atmosphere, and sunlight changes some of the oxygen into ozone. The ozone layer forms a natural screen that keeps out damaging ultraviolet radiation from the Sun – except where, as we now know, it is destroyed by artificially produced gases like chlorofluorocarbons. Mars's atmosphere contains virtually no oxygen, so it has no ozone layer. The planet's surface is exposed to the full intensity of the Sun's ultraviolet rays.

The radiation is powerful enough to alter some of the rocks to a chemically reactive form, known as peroxide. This can oxidize any carbon in the soil into carbon dioxide gas, which will escape into the atmosphere. The peroxide may also account for the puzzling results from the biology experiments. It would

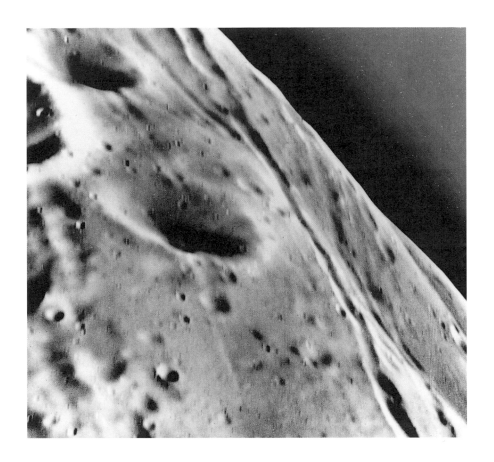

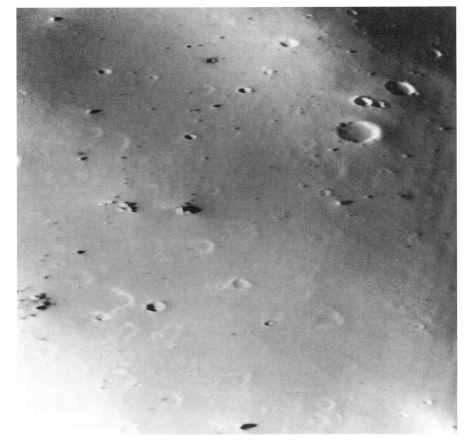

Close-up views from the *Viking* orbiters show that Mars's two moons have different surfaces. ▲ Phobos is peppered with craters of all sizes and is crossed by long grooves that radiate from the moon's largest crater. ▶ Deimos is much smoother, because a layer of dust covers all but the deepest craters: the boulders here are about the size of a house.

instantly oxidize the nutrients fed to the soil to produce a burst of gas. The output of gas would then fall off as the peroxides were used up.

So the disappointing conclusion is that living cells do not exist on Mars, at least at the places where the two *Vikings* landed. But some scientists hope that they may still find signs of life in places safe from the devastating ultraviolet rays. One good place to look would be regions near the poles that are always sheltered from the Sun's radiation. Even better would be deep in sediments that once formed the base of a Martian lake – a more likely location for life to have begun.

So future missions to Mars will carry on the search, targeting regions where water once existed in proliferation – if it ever did. Because the first question to clear up is just how much water Mars did have. Some scientists at present believe that as much as half of Mars was once under oceans. Others say that all the water on Mars was transitory, with the rivers that carved the now-dry valleys evaporating into the atmosphere even as they flowed along.

Soon after Mars was born, volcanoes must have spewed out vast amounts of carbon dioxide and water vapour – enough to make an atmosphere at least ten times thicker than it is today. These two substances are excellent 'greenhouse gases', and probably trapped enough of the Sun's heat to raise Mars's

Sunset over Chryse Planitia, photographed by *Viking Lander 1* in 1976. The light from the Sun – now below the horizon – is being scattered by the gas and dust in the Martian atmosphere: the distinct bands in the sky are caused by the camera's response to the faint light. With nightfall, the temperature can plummet by as much as 50 °C, from a typical daytime temperature of −30° to −80 °C.

The older regions of Mars (upper left) are covered with craters and cut by dry valleys dating from a time when Mars was a much warmer world. The younger parts of the surface (lower right) are covered by flat plains consisting of lava flows, ash from volcanoes or – possibly – rocks deposited at the bottom of ancient seas. This *Viking* orbiter photograph shows the boundary between the old and new terrain in Amazonis Planitia, which lies to the west of Mars's vast volcano Olympus Mons.

temperature above the freezing point of water. Around this time, about 4,000 million years ago, rivers flowed through the cratered landscape of Mars's southern hemisphere, and carved out winding valleys with many tributaries.

But Mars could not hold on to its thick atmosphere. Some astronomers have suggested that Mars lost its original air in the final bombardment of giant meteorites, which occurred about 4,000 million years ago: the exploding gas clouds from each impact of a giant meteorite would have stripped away the atmosphere near by.

Recent results from the Soviet *Phobos* spacecraft, however, show that an energetic wind of particles from the Sun may have been responsible for stripping away most of Mars's atmosphere. The space probe was sent to investigate the larger of Mars's two moons, Phobos. This is a potato-shaped piece of rock only twenty-eight kilometres in length – twice as long as Mars's other moon, Deimos. A computer fault on board meant that ground-controllers lost touch with the *Phobos* craft as it attempted to rendezvous with the eponymous moon, but the space probe had already obtained important new information about Mars itself. In particular, it found that the solar wind is stripping away the atmosphere at a rate of 50,000 tonnes per year – fast enough to have denuded the planet of most of its original atmosphere soon after its birth.

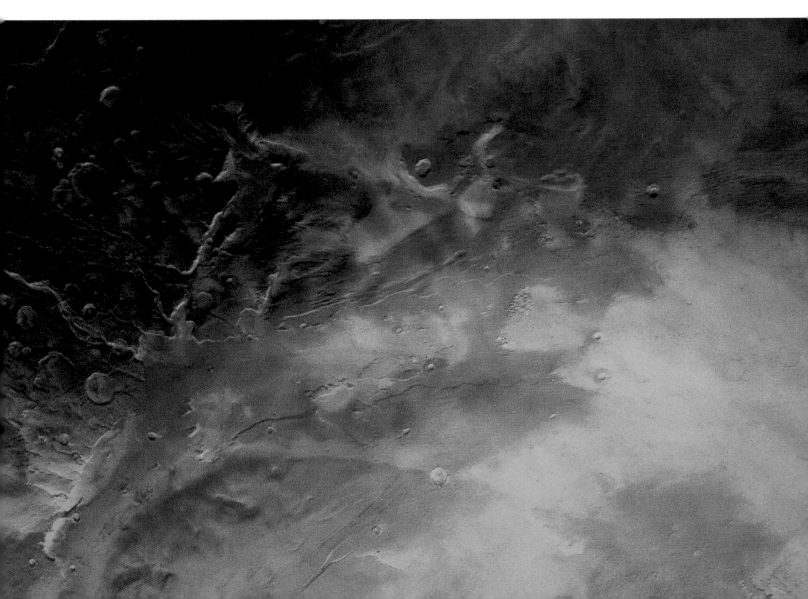

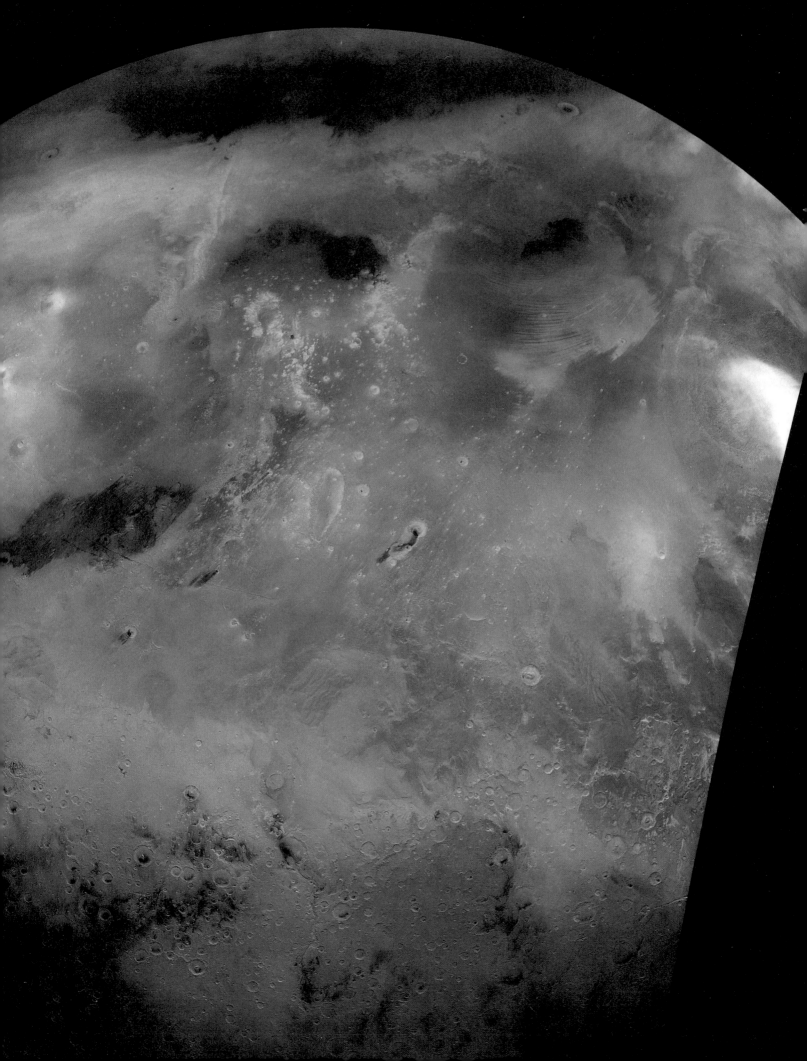

With its atmosphere thinned down, Mars became colder and colder, and its water froze into the soil. Where lava welled up from the planet's interior, however, the heat melted the ice under the surface to form an underground reservoir of liquid water. Eventually, this water would gush out, in a flood that eroded a wide, straight valley. The pictures from *Mariner 9* and the *Viking* orbiters show many of these giant outflow channels – now dry – in the younger volcanic regions of Mars. They look very different from the earlier meandering valleys with tributaries.

But the big question is whether any of this water lay for long periods on the surface in lakes, seas or oceans – long enough for life to begin. So far there is no definitive answer. An infra-red camera on board the *Phobos* probe has shown that some of the rocks on Mars's surface resemble the Earth's sedimentary deposits – that is, rocks laid down under the sea. And some of the signs of erosion in Mars's northern hemisphere look more like the work of the sea than the effects of wind. Some scientists have suggested that the northern plains of Mars are the bed of an ancient ocean that filled and then dried up at least twice in the planet's history: once in the early days of Mars, when the winding rivers flowed, and then again when underground water gushed out in the giant outflow channels around the volcanoes.

But the question of water on Mars will have to wait for a much more detailed investigation of the red planet. A whole bevy of future missions is planned: more sophisticated orbiters will photograph the planet at the revealing infra-red wavelengths; balloons will float around in the planet's winds, landing when they lose their buoyancy at night, floating away again at dawn; and robot 'rovers' will patrol the surface to select interesting rocks, which will automatically be sent back to the Earth for analysis.

Finally, some time in the next century a team of visiting astronauts will arrive on Mars. They will have two main tasks. One is to find out, once and for all, whether living cells have ever existed on the red planet. The other is to check the feasibility of setting up a permanent base for people on Mars. Despite its thin atmosphere and chill temperature, Mars is the only other planet where people could live permanently, drawing drinking water from the icy soil, and extracting breathable oxygen from the water. When an independent Martian colony becomes viable, 'intelligent Martians' will cease to be a myth and become reality.

Spacecraft orbiting Mars have found it is a very different world from predictions based on long-range views from the Earth. A telescope on Earth shows dark markings in the red deserts and occasional brighter patches. This *Viking* orbiter picture shows that the dark patches are merely regions of rock swept clear of the bright desert dust: they have little to do with the important geological features of the planet, such as craters, volcanoes and canyons. The bright patch (upper right), visible to Earth-based telescopes, is a cloud that sometimes forms over the Olympus Mons.

JUPITER

5

Aptly named for the king of the gods, the planet Jupiter is indeed the mighty ruler of a vast kingdom. This giant planet and its extensive family of moons resembles a miniature version of the Solar System.

Bands of white and orange clouds swirl around Jupiter, the giant of the Solar System, photographed here by the space probe *Voyager 1*. Jupiter is made almost entirely of gases, and its weather patterns appear as ovals that are white or orange in colour. The Great Red Spot (lower left) is three times the size of the Earth. The volcanic moon Io hangs in front of the planet.

In size, Jupiter is second only to the Sun in our Solar System. It is so large that you could put all the other planets inside it and still have room to spare. Jupiter is more than three times heavier than the next most massive planet, Saturn, and its strong gravity keeps in tow a set of sixteen moons. As well as being more numerous than the members of the Sun's 'family', Jupiter's entourage contains four worlds that would make decent-sized planets in their own right. The largest of Jupiter's satellites, Ganymede, is considerably bigger than Mercury and Pluto, and almost rivals Mars.

Jupiter is so massive that many astronomers now regard it not as a 'planet' at all, but as a 'brown dwarf' – a body that is intermediate in mass between a star and a planet. Astronomers have only invented the term recently, as they have thought more carefully about the distinction between stars and planets. A star, everyone agrees, is a lump of gas so massive that nuclear fires have ignited at its centre, providing enough energy for it to shine brightly for millions or even billions of years. In order to switch on these reactions and shine as a star, the lump of gas must be at least seventy times heavier than Jupiter.

Until a few years ago the only objects we knew that were less massive than stars (ignoring the tiniest bodies, such as moons and asteroids) were the nine worlds that circle the Sun in the Solar System. These were lumped together under the single traditional term 'planets'. Astronomers are now beginning to suspect, however, that there are objects in our Galaxy that are not massive enough to shine as stars themselves, but nor are they circling a star, so they should not be called planets. Because these objects are smaller than stars normally are, and do not shine with ordinary light, astronomers have, somewhat facetiously, called them 'brown dwarfs'.

A typical brown dwarf is a dozen times heavier than Jupiter. It does not shine because it is not massive enough to ignite a central nuclear fire. But the brown dwarf can radiate heat energy, because it is still shrinking from its birth and – as is familiar to anyone who has energetically pumped a bicycle tyre – a gas becomes warm when it is compressed.

Brown dwarfs are more massive than the average planet in the Solar System, but where do we draw the line between a brown dwarf and a planet? There is no really clear answer. The main distinguishing feature is that a brown dwarf

produces a 'significant' amount of heat from its own interior, while a planet gains its heat mainly from the Sun.

This leaves Jupiter sitting astride the fence. Like a star or a brown dwarf – but unlike the Earth – Jupiter is made almost entirely of gases. And it is generating its own heat. Infra-red telescopes and instruments aboard spacecraft have found that Jupiter produces almost as much energy from its interior as it receives from the Sun. The most likely explanation is that Jupiter is shrinking slightly. (Not that we will ever find out directly, because it needs to contract by only one millimetre per year to supply this amount of internal heat.) If we apply the definition of a brown dwarf rigorously, we should describe the main bodies of the Solar System as one star, one brown dwarf and eight planets.

Out of respect for tradition, however, we will call Jupiter a 'planet' for the rest of this chapter. As Jupiter is the largest of the Sun's family, astronomers can fairly easily make out its main features with telescopes on the Earth, even though Jupiter lies over 600 million kilometres away. For centuries, astronomers have been mesmerized by the ever-changing patterns of clouds: bright 'zones' of cloud running parallel to the planet's equator, with darker 'bands' between, where we can see deeper into Jupiter's atmosphere. The most famous landmark on Jupiter is the Great Red Spot in its southern hemisphere. The name speaks for itself, but to give an idea of what 'Great' means on Jupiter, this oval weather system is three times the size of the planet Earth. Unlike any terrestrial weather pattern, the Great Red Spot has lasted for several centuries,

▶ Viewed from above the planet's north pole, Jupiter's bands of cloud appear as concentric coloured circles: the hues may be caused by compounds of sulphur or complex organic (carbon-based) compounds. In this composite of many *Voyager* photographs, the black square at the north pole (centre) is a region out of reach of the spacecraft's cameras. The small circles are eddies caused by fast winds. The white clouds lie at the highest levels in the atmosphere, while the reddish ovals are gaps where we look deep into the gaseous planet.

at least since the 1660s, when primitive telescopes became powerful enough to show it.

Even the smallest telescope shows that Jupiter is not a sphere: it bulges at the equator, and is flattened at the poles. A more careful study reveals the reason. Despite its huge size, Jupiter is spinning round more rapidly than any other planet, with a 'day' that is less than ten hours long. The rapid rotation

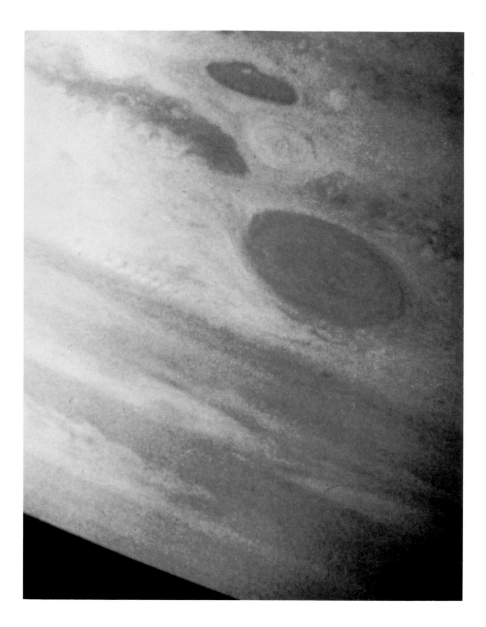

◄ The first close-up views of the Great Red Spot came from the *Pioneer 10* and *11* craft in 1973 and 1974. The spot stands out clearly in this *Pioneer 11* image, taken in December 1974, because it was then surrounded on all sides by high white clouds. The Great Red Spot is three times the size of the Earth: its colour is probably due to phosphorus, dragged up from the planet's interior.

flings matter outwards at the fast-moving equator, producing the flattened shape.

Astronomers on the Earth managed to 'weigh' Jupiter well before space probes got anywhere near the planet, by measuring the strength of its gravitational pull on its moons. This provides the single most important clue to Jupiter's composition. Jupiter is big enough to contain 1,300 Earths, yet it is only 318 times as massive as our planet. It is clear, therefore, that it must be made of something much less dense than the rock and iron that constitute the Earth. When we allow for the fact that matter in the centre of Jupiter must be compressed by the weight of the overlying layers, it turns out that the only materials light enough to fit the bill are the gases hydrogen and helium.

Astronomers have investigated exactly how much Jupiter is flattened as it spins around, and measured its gravitational field more accurately from its powerful tug on passing spacecraft. Combining these data with the way that

► As *Voyager 1* approached Jupiter in February 1979, the spacecraft photographed the Great Red Spot and its environment in unprecedented detail. Turbulent winds around the spot are creating eddies and vortices, and their swirling energy feeds the Great Red Spot's rotation. The neighbouring oval white spot is a smaller, cloud-covered version of the Great Red Spot: it formed sixty years ago.

materials behave under high pressures in the laboratory, we come up with the following picture of what is inside Jupiter.

At the centre, where the temperature soars to 24,000 °C, there is a small core of molten rock. Small is a relative term here: in such a huge planet, even this insignificant core is fifteen times heavier than the Earth.

Surrounding the core is a deep layer of hydrogen, squeezed by a pressure of 10 million Earth-atmospheres. This immense force compresses the hydrogen to a state where it behaves more like a liquid than a gas, and changes its nature so that the hydrogen conducts electricity like a metal. Electric currents in this

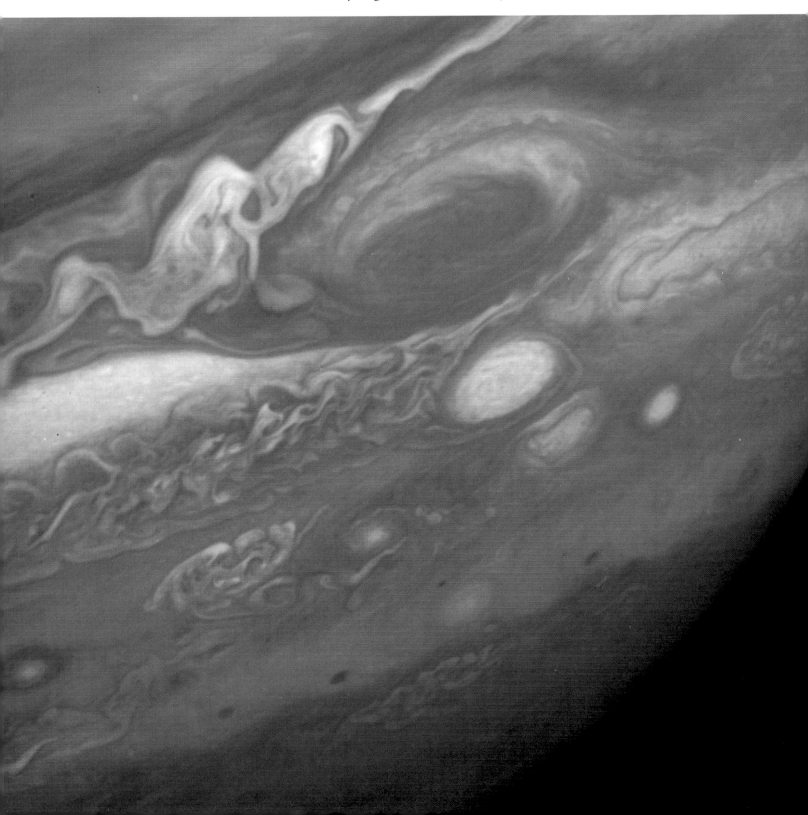

'metallic hydrogen' layer generate a magnetic field, in much the same way that electricity in the Earth's metallic iron core produces our planet's magnetism. The giant planet, not surprisingly, generates an immensely powerful magnetic field – 20,000 times stronger than the Earth's.

Above the metallic hydrogen is a deep 'sea' of ordinary liquid hydrogen, which makes up the bulk of Jupiter. At the top of this sea, there is no distinct surface. The hydrogen just thins out until it becomes an atmosphere of gas. The atmosphere is 1,000 kilometres deep – a mere skin on Jupiter's great bulk – and consists mainly of hydrogen, with some helium and smaller amounts of

▼ **Deep inside the Great Red Spot,** *Voyager 1* **photographed clouds as small as thirty kilometres across. As the spot rotates anti-clockwise, once every six days, it sweeps up the veils of overlying white clouds that stretch across the top of this image.**

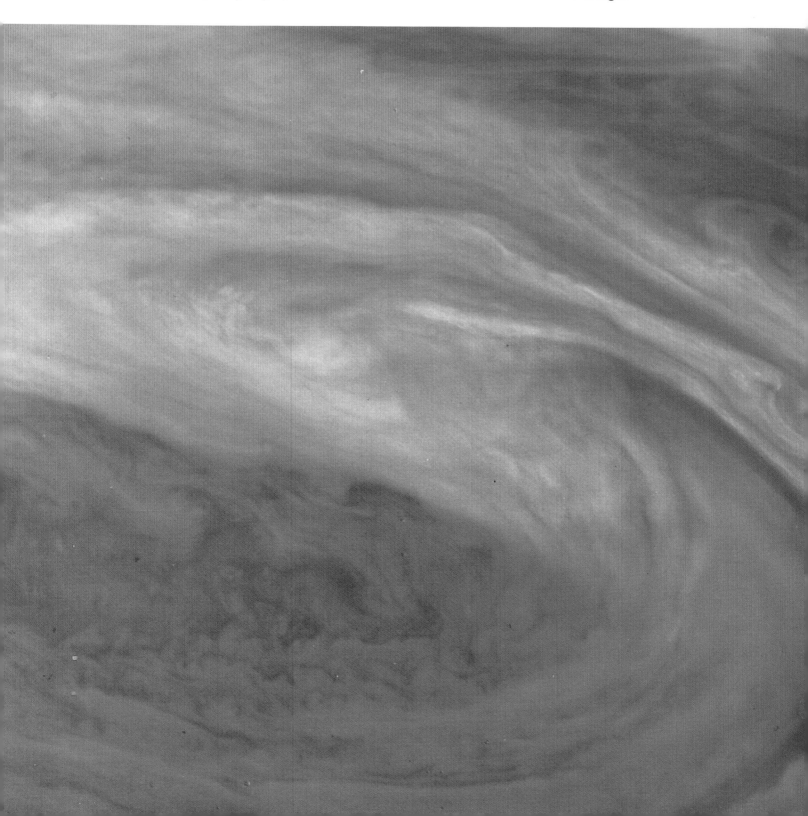

methane, water, ammonia and hydrogen sulphide. These compounds, although only a minor ingredient in the atmospheric brew, are important, because they condense into the clouds that deck most of Jupiter's upper atmosphere. Astronomers think that even smaller traces of exotic substances, like polysulphur compounds and phosphine, are responsible for tingeing the clouds with exotic tints that make Jupiter's atmosphere the most colourful in the Solar System.

But there is not a lot else we can discover with even the most powerful telescopes on Earth. We needed spacecraft to find out more. The first two probes to Jupiter left Earth in the early 1970s. *Pioneers 10* and *11* were, as their name suggests, trailblazers. Before sending a more sophisticated craft, astronomers wanted to know if a space probe could survive a passage first through the rocky wasteland of the asteroid belt between Mars and Jupiter, then through the intense radiation belts that are trapped in Jupiter's magnetic field.

In the event, both *Pioneers* breezed through. They hit no asteroids and survived the harsh environment around Jupiter, even though the radiation turned out to be a thousand times the lethal dose for an astronaut. Simple cameras on board took the first close-up pictures of Jupiter's clouds and its Great Red Spot. But these few snapshots told us little about the way that Jupiter's weather works. That had to await the more sophisticated *Voyager* spacecraft.

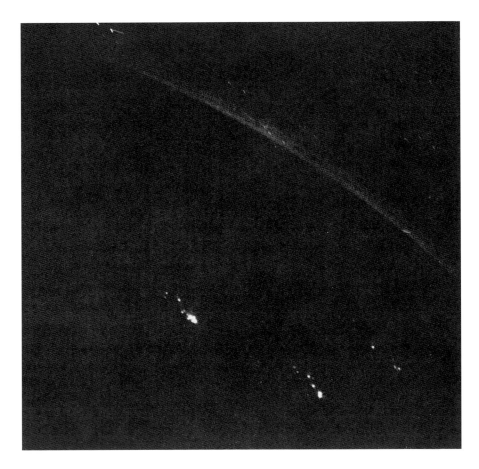

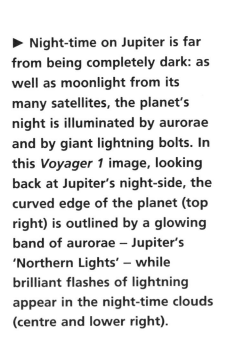

▶ **Night-time on Jupiter is far from being completely dark: as well as moonlight from its many satellites, the planet's night is illuminated by aurorae and by giant lightning bolts. In this *Voyager 1* image, looking back at Jupiter's night-side, the curved edge of the planet (top right) is outlined by a glowing band of aurorae – Jupiter's 'Northern Lights' – while brilliant flashes of lightning appear in the night-time clouds (centre and lower right).**

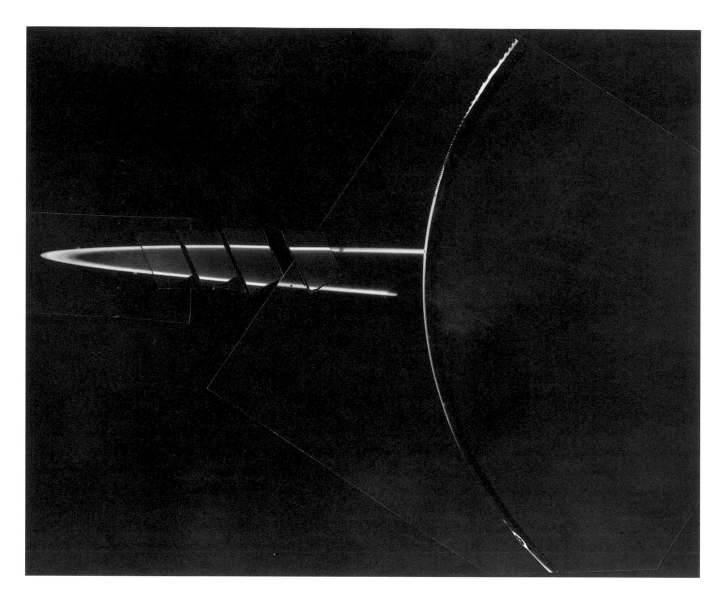

The two *Voyagers* mark the pinnacle of Phase One of the exploration of the Solar System: the first snapshots of new planets from spacecraft flying past. Despite some engineering problems, both craft provided far more information than their designers had dared to hope. Between them they have turned the four remote giant planets – Jupiter, Saturn, Uranus and Neptune – from tantalizing specks in a telescope into familiar friends. Virtually everything we know about these planets (not to mention their rings and their moons) is due to this pair of doughty spacecraft.

The *Voyagers'* first port of call was Jupiter. Their sophisticated cameras not only took much better pictures than the *Pioneers* had done: they took so many frames – over 30,000 – that scientists could string together the pictures of Jupiter and make short movies showing how the planet's winds blew the clouds along.

In the *Voyager* movies we can see the coloured bands and zones at different latitudes travelling around the planet at different rates, at the mercy of winds

Jupiter's faint ring is most easily seen when it is backlit by the Sun. Here, *Voyager 2* has photographed part of the night-side of Jupiter rimmed by sunlight (right), with the ring extending out to the left. Most of the apparent breaks in the ring are caused by gaps between the individual images making up this mosaic: the dark gap adjacent to the planet's bright edge is caused by the shadow of Jupiter falling on to the ring.

that blow alternately east and west as we move from the equator to the pole. The *Voyager* scientists were surprised to see winds that at first sight resemble the pattern of winds at different latitudes on the Earth, such as the Trade Winds and the Roaring Forties. After all, the Earth's wind patterns are produced in a thin layer of gas above a surface that is solid or liquid, while Jupiter's atmosphere has no distinct bottom to it. We would expect the wind currents to carry on downwards into the liquid hydrogen below.

At some latitudes the winds on Jupiter blow steadily at 500 kilometres per hour. What gives these winds their energy? Ultimately, the source must be heat: heat from the Sun, and heat from inside Jupiter. Meteorologists studying the *Voyager* movies found that the heat energy is driving small eddies – miniature swirls of gas in the atmosphere. As these swirls amalgamate into larger eddies, their energy of rotation drives the gas immediately to the north and south in opposite directions, to produce winds that blow east and west in neighbouring bands of latitude, rather as a turning car wheel tries to propel the ground below backwards and therefore moves the car forwards.

A similar process drives the gases in the Earth's atmosphere, with the larger eddies forming the anticyclones and depressions that swirl over the meteorologists' charts and bring us alternate good and bad weather. Jupiter, however, is much more efficient at converting heat energy into winds. Only 1 per cent of the heat absorbed in the Earth's atmosphere is turned into energy of wind, while Jupiter can convert over 10 per cent of the heat in its atmosphere to the energetic winds that race around the fast-spinning planet.

The larger an eddy is, the longer it can survive before giving up its energy to the global pattern of winds. This is the secret of the Great Red Spot. The *Voyager* movies show that the Spot is simply a very large eddy, turning around once every six days: not so much a hurricane as a large anticyclone, a region of high pressure. The Great Red Spot has grown so large that it can survive for hundreds of years. Indeed, a detailed study of the movies suggests that this giant spot has a strategy that will enable it to survive for very much longer: it has turned cannibal. The Great Red Spot sucks in smaller eddies that come near it, feeding on their energy of rotation to keep the big Spot turning for the almost indefinite future.

When the *Voyager* spacecraft viewed the dark side of Jupiter, they found towering thunder-clouds that discharge lightning flashes 10,000 times more powerful than any on the Earth, and brilliant aurorae where charged particles slam into the atmosphere from space. Even more surprising was what *Voyager 1* found above Jupiter's equator: a faint ring.

When the *Voyager* mission was planned, astronomers knew of only one planet with rings: Saturn. No telescope on Earth has ever shown any hints of a ring around Jupiter, but – just in case – the mission planners lined up *Voyager 1* to take one shot of the region above Jupiter's equator. Although the picture was rather shaky and blurred, there was definitely something there – and so *Voyager 2* was programmed to take a better look.

Jupiter's ring turned out to be a pale shadow of Saturn's glorious spectacle. There is just the one main ring, only a few thousand kilometres from its sharp outer edge to the fuzzier inner boundary. From here, there is an even fainter scattering of particles extending down to Jupiter's clouds. The ring is so dim that we would scarcely be able to see it with the human eye alone, even if we went to Jupiter to take a look.

Voyager 2 found that the ring is brighter when it is backlit by the Sun. This means that the particles making up the ring must be very small, about the size of grains of pollen. Under the pressure of sunlight, and as they fight their way through Jupiter's radiation field, these microscopic satellites must be losing energy, and as a result spiralling downwards towards the planet's cloud-tops. These descending particles make up the very faint inner part of the ring.

Over the 5-billion-year life of Jupiter, the planet's ring should have disappeared, as all the microscopic particles spiralled in to the planet itself. So why does Jupiter have a ring today? Astronomers believe the dust particles must be continuously 'quarried', to regenerate the ring. Most likely there are several 'moonlets' orbiting Jupiter in the region of the rings. These moonlets are only a few kilometres across, too small for *Voyager* to see. When meteorites, attracted by Jupiter's powerful gravity, pound into the moonlets, they chip off microscopic fragments that go into orbit in their own right to form the ring around the planet.

In addition to Jupiter's ring, the *Voyager* spacecraft discovered three previously unknown moons orbiting close to Jupiter. This brought the planet's total to sixteen satellites. As if to help us remember them, Jupiter's moons fall into four 'families', each containing four moons. And, to continue the analogy with the Solar System, the four moons nearest to Jupiter are quite small, while the next four are giants; further out, we find four small moons, as if to parallel tiny Pluto, and, finally, another family of four tiny satellites that have probably been 'captured' by Jupiter, just as the comets may have been captured by the Sun.

The two innermost moons patrol just outside Jupiter's ring, and help to keep the edge of the ring sharp: their gravity prevents the dust particles in the ring from drifting outwards. The next moon, Amalthea, is the largest of the inner group. Even so, it is only 270 kilometres across at its widest, and it was a triumph when the keen-sighted American astronomer E. E. Barnard spotted it through an Earth-based telescope in 1892.

The other small moons of Jupiter – the eight that form the two outer groups – were all discovered on long-exposure photographs taken with telescopes on the Earth. None is as big as Amalthea, and the smallest, Leda, is one of the tiniest moons known in the Solar System: only ten kilometres across, it is about the same size as Mars's puny satellite Deimos. The *Voyagers* took no close-up pictures of these eight moons, so we know very little about them. The four moons in the outermost group, however, orbit Jupiter in the opposite direction to all the other moons (and to the planet's spin), so astronomers

Two of Jupiter's largest moons appear in front of the planet in this image from *Voyager 1*. On the left is Io, coloured red by sulphur and its compounds; brilliant white icy Europa lies to the right. This photograph indicates just what a giant Jupiter is among the planets: Io and Europa are each larger than the planet Pluto and approaching the size of Mercury.

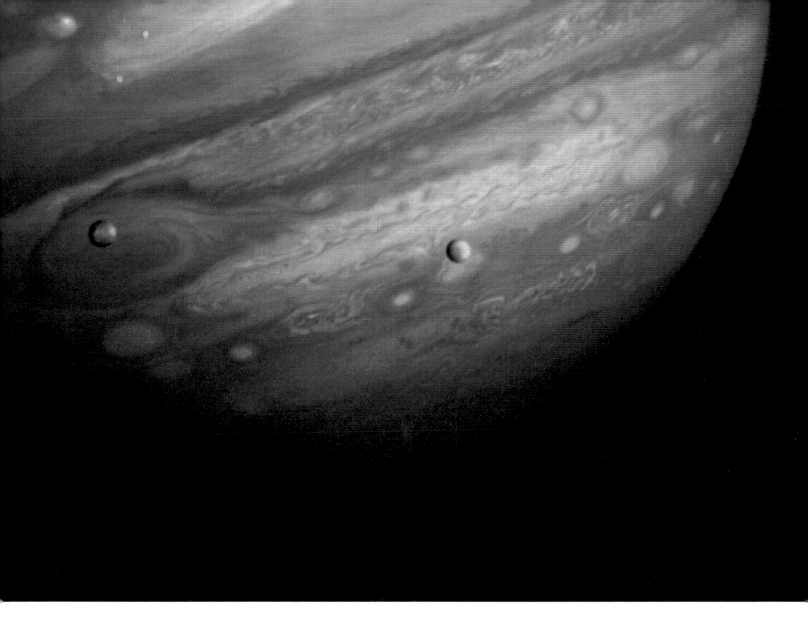

think they were not born with Jupiter but are asteroids that flew past the planet and were captured by its strong gravity.

The four largest moons of Jupiter are in an entirely different league. They are so massive that if they were circling the Sun we would think of them as significant planets in their own right: they are all much bigger than Pluto. Even though they lie hundreds of millions of kilometres from the Earth, these moons would be bright enough to be seen with the naked eye, if it were possible to shield our eyes from the brilliant light of Jupiter right next to them. Certainly they are clearly seen through a pair of binoculars, and they were among the first objects to be discovered when astronomers turned telescopes to the sky in the early seventeenth century. The first person to note them was the German astronomer Simon Marius, but Galileo studied them in detail, and these four large moons are now usually called the Galilean satellites.

The outermost of the four Galilean moons, Callisto, is in size almost an exact twin of Mercury. The two worlds also match in appearance, as they are two of the most heavily cratered objects in the Solar System. While Mercury has some

◄ Callisto is the darkest of Jupiter's large moons, its brown surface broken by bright areas where in-falling meteorites have splashed out fresh ice from its interior.

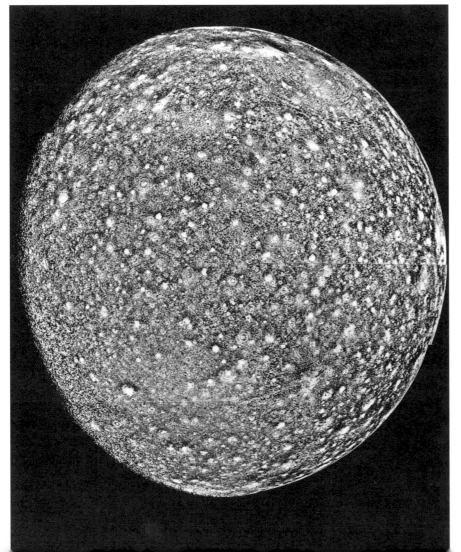

◄ A high-contrast image shows that the surface of Callisto is entirely covered by craters, unaltered by any kind of geological activity since this moon was born. ► On one side is Valhalla, a huge 'bull's-eye' 2,600 kilometres across, where a giant meteorite hit Callisto in its early days.

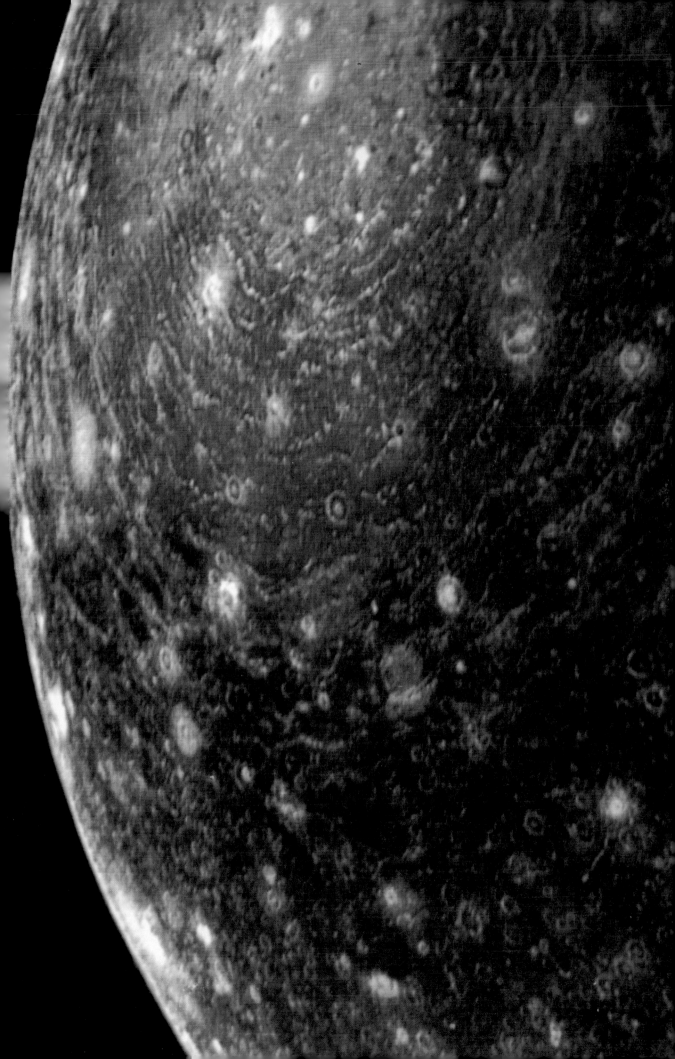

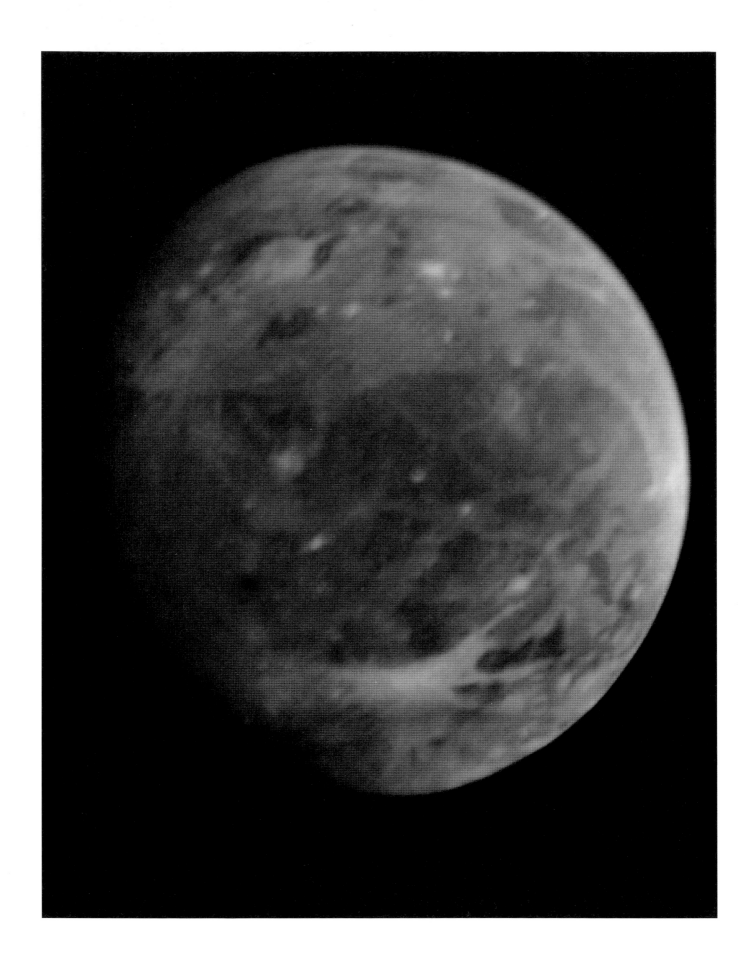

◄ Dark regions on Jupiter's largest moon, Ganymede, are the oldest parts of its terrain — similar to the ancient cratered surface of Callisto. ▶ The dark regions on Ganymede are separated by lighter-coloured regions that appear in close-up to consist of winding ridges and grooves. ▼ The brighter material has been brought up from within the rocky-ice moon as various blocks of Ganymede's old crust have moved sideways, creating a complex pattern of intersecting grooved terrain between the darker regions.

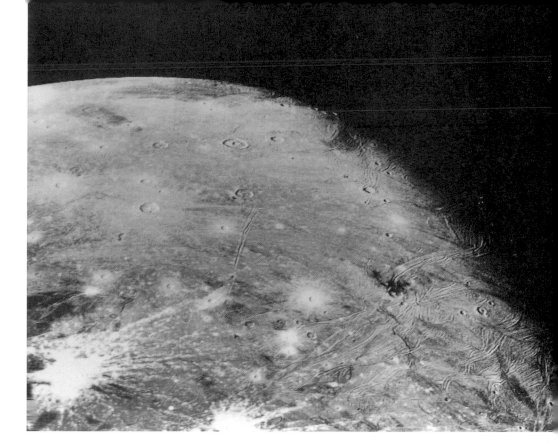

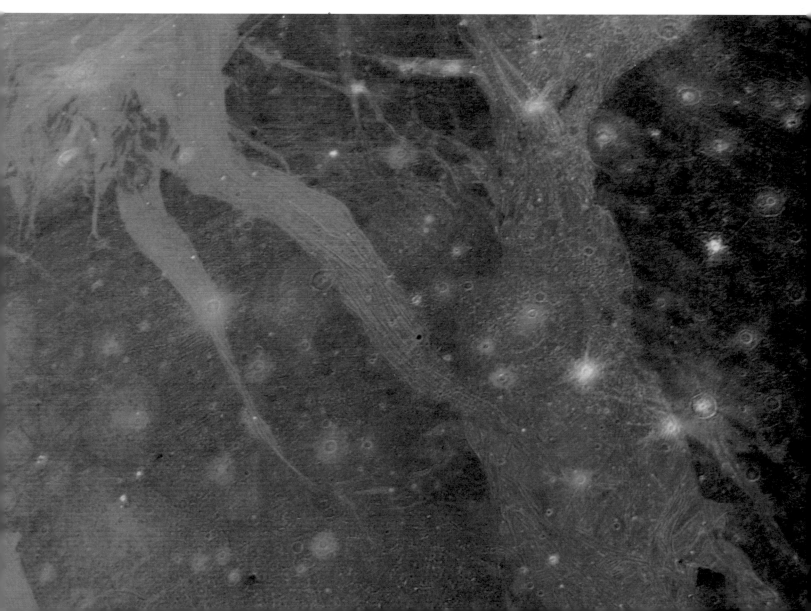

slightly smoother plains between the older craters, every square kilometre of Callisto's battered face shows signs of cosmic bombardment. One immense collision in Callisto's past sent out destructive waves that have created a huge set of circular cracks, known as Valhalla.

Next in, towards Jupiter, we find Ganymede. With a diameter of 5,262 kilometres, Ganymede is the largest moon in the Solar System. It is bigger than the planets Pluto and Mercury, and is almost the size of Mars. From a distance Ganymede's surface looks piebald: close-up photographs show that it has darker regions that are heavily cratered, like portions of Callisto; these are separated by light-coloured regions, where the surface has been stretched. Geologists think that the old dark regions of Ganymede have tried to move apart, like the drifting continents of the Earth, but this attempt at plate tectonics on Jupiter's moon froze up soon after it began.

Europa, still closer to Jupiter, is the smoothest world we know. Its bright white surface is free of craters, mountains, valleys or volcanoes. At first sight Europa resembles nothing so much as a cue ball for billiards, enlarged almost to the size of the Earth's Moon. Computer-processing of the photographs

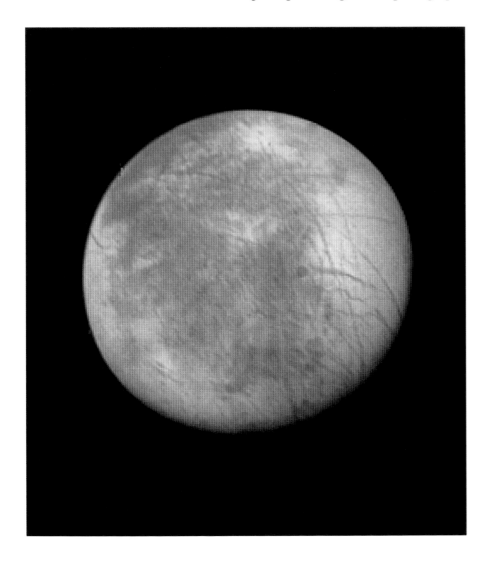

◄ An image with enhanced contrast is required to show any details on blindingly white Europa. This moon is completely covered in smooth fresh ice, broken by cracks that stretch most of the way around Europa. ► In close-up we can see that brown-tinged water – now frozen as well – has welled up to fill the cracks. Looping across the landscape are long low ridges whose origin is still a mystery.

from the *Voyagers* reveals a network of faint shallow cracks and a few long ridges traversing its surface, but these are all in low relief. To scale, they are no higher or lower than the trace of a felt-tip pen run over the surface of the billiard ball.

The white smooth surface of Europa looks like an ice rink, and this similarity is almost certainly more than skin deep. Callisto, Ganymede and Europa are all made of a mixture of rock and ice – kept frozen because Jupiter's system lies so far from the Sun that the temperature is always below the freezing point of water. Many millions of years ago, however, Europa was subject to a gravitational tug-of-war involving the other moons and Jupiter, which released heat energy inside Europa. The heat melted the ice within this moon, and as a result water flowed up to the surface to cover Europa with a rolling ocean. Once the tug-of-war subsided, however, the chill of space began to take over and the ocean started to freeze.

The worldwide ocean on Europa froze from the surface downwards. At first it was covered with a thin skin of ice, occasionally broken up by ocean currents into separate ice floes. Later these floes welded together again, and the boundaries formed a network of cracks, looking just like the surface of the ice sheets on the Arctic Ocean. Just as the Arctic Ocean freezes over on top while remaining liquid underneath, some scientists have wondered if there may still

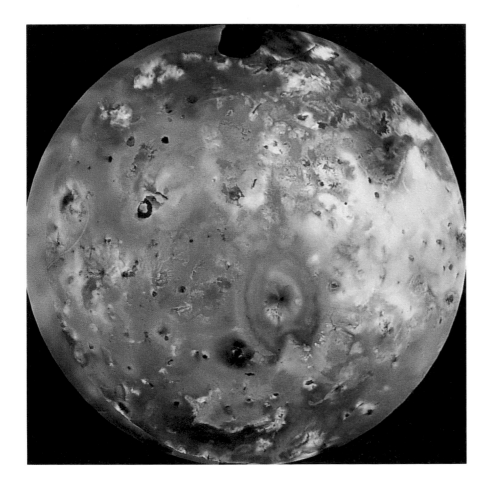

Io is the twin of the Earth's Moon in size, but it could hardly look more different. Orange and yellow compounds of sulphur coat the entire world, covering over the original cratered surface. Circular patches are not impact craters, but material ejected from volcanoes that erupt from its incandescent interior: the large heart-shape consists of ejecta from Pele. (The black region – top – was not viewed by the *Voyager* spacecraft.)

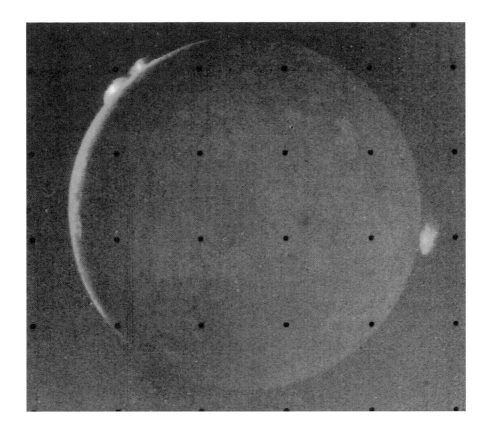

Looking back at Io, *Voyager 2* saw three volcanoes in action at once. The sunlit crescent of Io is on the left here, while the 'night-time' side is illuminated by light reflected from Jupiter (the black dots are calibration marks in the camera). The volcano on the right is erupting gases 185 kilometres into space.

be liquid water under the continuous ice cover on Europa. If so, then there is a remote chance that some kind of life may have formed there, and alien 'fish' may be swimming beneath an icy ceiling that separates them from the rest of the Universe.

Even stranger than Europa is the fourth of the Galilean satellites. Io is currently suffering a vicious tug-of-war from the gravitational pull of Jupiter and the other moons. The conflicting tugs on Io raise its temperature to such a degree that Io produces more heat, for its size, than any other object in the Solar System apart from the Sun. This heat has not only melted the ice that Io probably contained originally, but has boiled it all away into space. As a result Io is a dry and dense ball of rock, similar in both composition and size to our own rocky Moon.

But there the resemblance with the Earth's dead companion ends. Io is the most active body in the Solar System. The heat inside drives immense eruptions, stunningly recorded by the cameras on the *Voyager* spacecraft. They found that Io has at least half a dozen vents where gas spurts hundreds of kilometres into space, in shapes that resemble huge umbrellas. These fumes have condensed on to Io's surface, entirely covering its original craters with a smooth coating of red, orange and yellow sulphur. Here and there, the *Voyagers* found dark lakes of liquid sulphurous lava.

According to geologists, the eruptions on Io are not so much volcanoes as geysers. A volcano on the Earth spews out molten rock that has risen from our planet's hot interior. If this rock does not reach the surface but instead rises

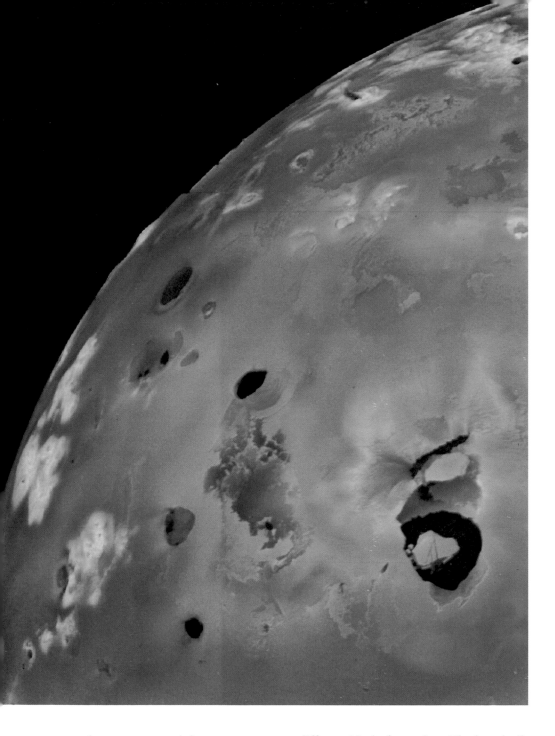

◀ Io displays many kinds of volcanic landform. The volcano Loki (foreground) consists of a dark, horseshoe-shaped lava lake and a straight dark rift which is erupting lighter-coloured gases from its ends. Lava flows reach outwards from many volcanic calderas.
▶ Small white patches consist of frozen sulphur dioxide that has fallen like snow on to the surface after being erupted from small vents.

into strata containing water, we get a different kind of eruption. The heat boils the water, which then bursts through the surface as a geyser. On Io, the molten rock within is not itself erupting, but it is heating up pockets of sulphur or sulphur dioxide that lie just beneath the surface, boiling them until they erupt as sulphurous geysers.

The geysers on Io are throwing out about 10,000 million tonnes of matter every year. The sulphur that falls back on the surface is 'recycled' through the geysers again and again, but a small proportion of the erupted gas escapes this fate. Some of this gas stays with Io, to cloak it with an extremely tenuous atmosphere. More of the escaping gas is lost to space, spreading out along Io's orbit to form a gently glowing 'doughnut' of gas around Jupiter.

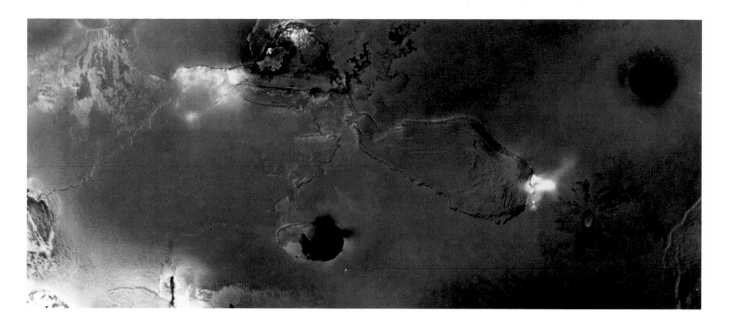

Io as much as Jupiter itself is the target for the next space probe. Launched in 1989, the *Galileo* probe has gained speed by swinging past Venus once and the Earth twice, before it eventually reaches the giant planet in 1995. A small probe, detached from the main spacecraft, will drop into Jupiter's atmosphere to measure its composition and meteorology at first hand. The main part of *Galileo* will go into orbit around the planet, to initiate Phase Two of our investigation of Jupiter. Despite problems with its main antenna, *Galileo* will send back thousands of highly detailed views of the giant planet's swirling atmosphere and of the eruptions on Io.

Unlike the orbiting probes we have already sent to Mars and Venus, *Galileo* will give us long-term surveillance of not just one planet-sized world but five at once, with Jupiter's ring and lots of smaller moons thrown in.

In the years between *Voyager* and *Galileo*, astronomers have come to realize that studying Jupiter has implications far beyond the realm of the Solar System. It now seems legitimate to regard Jupiter as a brown dwarf, albeit a small one. Some astronomers think that most of our Galaxy's mass is made up of huge numbers of brown dwarfs, too dim for our present telescopes to detect. If so, *Galileo*'s views of Jupiter and its family will provide us with a unique chance to study continuously and in close-up an example of the most common kind of astronomical system in our Galaxy.

SATURN

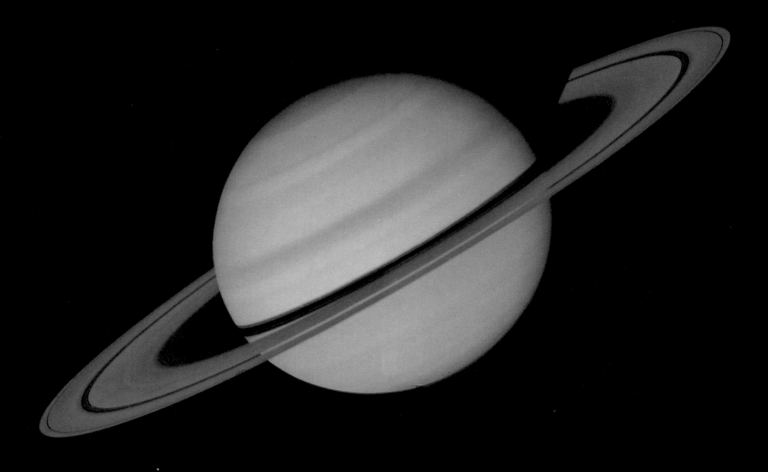

6

Astronomers have aptly nicknamed Saturn the Lord of the Rings. Although we now know that all four of the giant planets possess ring systems of some kind, Saturn easily outclasses the others. The rings of Saturn are the most extensive and the brightest, and they contain far more material than the narrow dark rings around Uranus and Neptune or the tenuous smoky ring around Jupiter.

For a century or more Saturn's rings have held a folkloric status, along with Halley's Comet and the supposed canals of Mars. They are so large and bright that we can see them from the Earth with a small telescope: Saturn's glittering prize is one of the most beautiful sights available to the casual stargazer. So the excitement of the first spacecraft encounters, *Pioneer 11* in 1979 and the two *Voyagers* in succeeding years, undoubtedly centred around their astonishing close-ups of the ring system. But just as important scientifically were the images and other measurements of Saturn itself, and of its huge family of moons – the most extensive in the Solar System.

In addition to its rings, Saturn has several other claims to fame. It is the second largest planet, overshadowed only by mighty Jupiter. (Astronomers who maintain that Jupiter is a 'brown dwarf' would class Saturn as the biggest ordinary planet.) Saturn is a giant by anyone's reckoning, weighing in at ninety-five Earths. But its matter is spread out pretty diffusely, in a globe large enough to contain our planet 750 times over. As a result Saturn has the lowest density of any planet – so low that Saturn would float on water, if we could find an ocean large enough.

Saturn's low density is the first of two clues that it is not a solid world, but consists mainly of gases – principally the lightweight substances hydrogen and helium. The second clue is in the planet's shape. The glorious rings generally distract our eyes from another of Saturn's superlatives: it is the most flattened planet of all. Saturn spins round in 10 hours, 40 minutes, and this rapid rotation makes it bulge out around the equator. While it would take eight and a half Earths to stretch across Saturn from pole to pole, the distance across its distended equator amounts to nine and a half Earths.

From Saturn's density and the way it is flattened, astronomers have been able to work out what is inside the planet. By and large it resembles its larger sibling Jupiter: in the middle is a core made of liquid rock, several times heavier than the Earth. Around the core is a layer of liquid hydrogen under such high pressure that it conducts electricity like a metal. Next comes a thick

Saturn is one of the glories of the Solar System, whether seen from the Earth or – as here – by a passing spacecraft. This *Voyager 1* photograph, taken in 1980, encompasses the full extent of Saturn's magnificent rings – stretching over a quarter of a million kilometres – and three of the planet's many moons.

layer of ordinary liquid hydrogen, mixed up with helium. On top, we find a thin veneer of atmosphere.

Thus far, Saturn sounds no more than a scaled-down version of Jupiter, but the visiting spacecraft have found oddities on and around the planet that indicate its interior has its own share of idiosyncrasies.

First, Saturn is a few degrees warmer than it should be. The planet is not only warmed by the Sun, but is generating some heat deep inside. This may not seem too odd, because astronomers have known for many years that Jupiter generates its own warmth by its continuous gradual shrinking, but this explanation does not work for the rather smaller Saturn. All the calculations show that a planet of Saturn's mass should have stopped shrinking billions of years ago.

The most likely answer is that the mix of gases in Saturn's deep interior is separating out into its constituent parts, like oil and vinegar in salad dressing that is left for a while after shaking. In the case of Saturn, the 'oil' and 'vinegar' are hydrogen and helium. The slightly heavier helium atoms gradually drizzle down through the hydrogen, generating heat as they fall. The *Voyager* spacecraft found some extra evidence to back up this theory: the top layers of Saturn contain only half as much helium as we find in the outer layers of Jupiter. The rest has presumably dripped down to the planet's core.

Saturn, like Jupiter, has a strong magnetic field. This in itself is no surprise, because we would expect moving currents of metallic hydrogen to generate electricity and magnetism, as they do in Jupiter. Before the spacecraft reached Saturn, physicists had developed a neat theory to explain how the moving currents in a planet's electrically conducting core could generate magnetism. The theory seemed to explain why the Earth and Jupiter have magnetic fields while slow-rotating Venus does not. The magnetism, the theorists found, had to come from currents in the conducting core that are not symmetrical: as a

result, a planet's magnetism would not be symmetrical and would not line up with the poles of rotation. The theory fitted the magnetism of the Earth and Jupiter, where the magnetic poles lie a few degrees of latitude away from the actual poles.

But when the *Voyager* spacecraft probed Saturn's magnetism they found that Saturn's magnetic poles lie exactly at its true north and south poles. (Another superlative: Saturn has the least tilted magnetism of any planet in the Solar System.) Thus Saturn has told the theorists that the way a planet generates its magnetism is rather more complex than they had previously thought: scientists

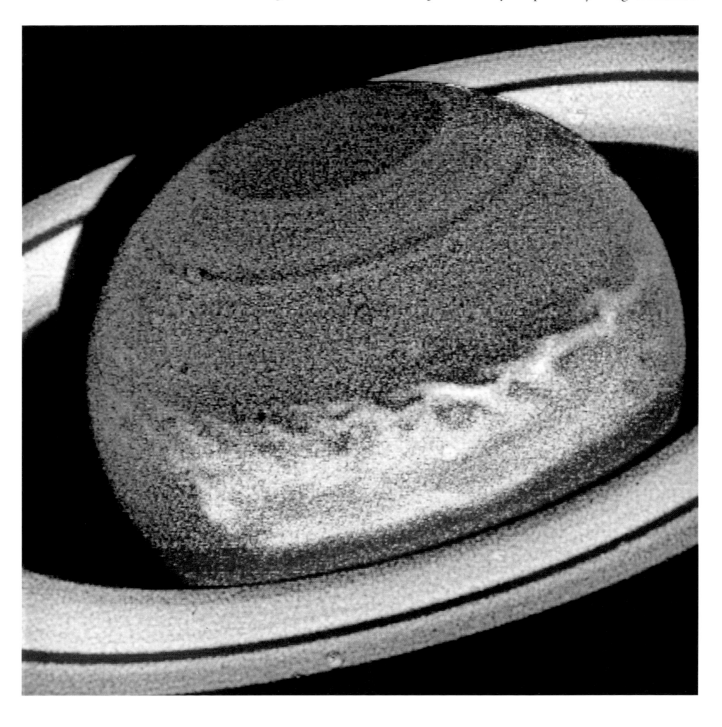

Saturn's clouds are generally much more uniform than Jupiter's, but many small swirls and eddies show up in colour-enhanced images from the *Voyager* spacecraft. ◀ One curl of cloud lies at the edge of a bright band that marks a jet-stream – a narrow region of fast winds – at a latitude of 47° north. ▶ Nearer the planet's north pole, *Voyager 2* found several eddies only 250 kilometres across, half the size of a typical hurricane on the Earth.

are still struggling to explain Saturn's deceptively simple pattern of magnetism.

Its weather systems are also something of an enigma. The planet has bands of cloud like those on Jupiter, but over the top lies a layer of yellowish haze that largely hides them from view. Just occasionally a swirling patch of bright cloud erupts through the haze as a 'white oval' so large it can be seen from the Earth. Amateur astronomers are sometimes the first to spot an outburst on Saturn: in 1933, a large white oval was discovered by Will Hay, a well-known English comedy actor. Other white ovals have burst on to the normally bland face of Saturn in 1960 and in 1990.

Neither of the two *Voyager* craft was lucky enough to pick up a white oval when they passed Saturn in 1979 and 1980. Even their close-up views of the planet showed little detail below the haze. It took some strong computer-enhancement to reveal bands and small spots in Saturn's atmosphere: NASA scientists turned up the contrast between bright and dark regions, and boosted the colour differences to produce weird multi-colour pictures that at first sight bear no resemblance to Saturn's bland face. But the details revealed in these images have allowed the scientists to unravel the planet's weather patterns.

In broad outline, Saturn's weather is similar to Jupiter's. Small swirls of gas feed the rotation of larger eddies and generate bands of high speed winds that blow parallel to the planet's equator. On Saturn the winds blow in the same

direction at almost all latitudes, with the most powerful nearest to the equator. Here the wind speeds top 1,800 kilometres per hour – ten times hurricane force on the Earth. Saturn vies with Neptune for having the most powerful gales in the Solar System.

Although computer-processing showed some details in the atmosphere of Saturn, nothing could help the scientists when they turned to *Voyager*'s pictures of the planet's largest moon, Titan. Even before any spacecraft reached Saturn, astronomers suspected that this moon had some 'air' of its own, and

The extensive atmosphere of Titan, Saturn's largest moon, shows clearly when viewed from its dark side. The Sun is illuminating a narrow crescent (left) of Titan's all-enveloping orange clouds, while the more tenuous upper atmosphere – extending hundreds of kilometres above the clouds – appears as a blue ring surrounding Titan.

speculated that Titan might have liquid pools, or even oceans. At this frigid distance from the Sun water would be frozen solid, but methane or ethane (the main ingredients of 'natural gas') might condense into a liquid at Titan's low surface temperature.

The scientists who had predicted a dense atmosphere were proved correct – and with a vengeance. Titan has not only a thick atmosphere, but thick clouds too, which cover its entire surface in an impenetrable layer. The cameras on *Voyager 1* were programmed to take dozens of close-up views of Titan's surface, but the pictures they sent back just showed cloud, cloud and more cloud. With *Voyager 2*, NASA did not bother with more than a cursory glance at this totally hidden world.

But the scientists' disappointment has been more than offset by mounting excitement about the kind of world that may lie beneath the clouds: *Voyager 1* proved that Titan is one of the most interesting places in the Solar System. Although technically a moon because it orbits Saturn rather than the Sun, Titan is larger than Mercury and Pluto, and it has an atmosphere that is well into planet class. Although two other moons – Jupiter's Io and Neptune's Triton – have wisps of atmosphere, the dense mantle around Titan is unique for a moon. In fact the atmosphere of Titan is not only denser than that of the smaller planets Mercury and Pluto, but also thicker than that surrounding Mars – and even denser than the air we have on planet Earth.

The resemblance to the Earth is more than skin deep, despite the two worlds' immensely different distances from the Sun. The 'air' on Titan is made mainly of nitrogen, like the Earth's atmosphere, but is very different from the carbon dioxide gases of Venus and Mars. Moreover the dense orange clouds

suggest that Titan is a 'deep-frozen' version of the early Earth preserved in the chilly depths of the outer Solar System – and that therefore it holds vital clues to the formation of life on Earth.

Scientists studying the origin of life have suggested that the main chemicals of life – amino acids, for example – were formed from simple gases when the Earth's early atmosphere was bombarded with energetic radiation from space or racked by intense thunderbolts. Experiments in the laboratory have shown that gases pounded by radiation or electrical discharges do indeed react to form amino acids and other compounds needed to build up DNA, which forms the core of living cells.

The orange clouds of Titan are, as far as we can tell, the results of this chemistry experiment taking place on a planet-wide scale – a mirror of the early Earth. On our planet these chemicals were washed by rain to the seas and oceans, where they reacted to build up more complex compounds that ultimately became living cells. On frozen Titan, however, the water has always been locked into the surface, as solid ice, so these orange-coloured chemicals have largely remained hanging in the atmosphere.

What strange landscape lies below the orange clouds? Although no one has

One face of Iapetus (to the left in this *Voyager 2* image) is as black as tar, while the other is as bright as snow. Astronomers believe that the dark material lies on top of a naturally bright surface, but they do not know if it has come from inside Iapetus or has fallen on to this moon from space – possibly splashed out from the neighbouring dark moon, Phoebe.

Moving from Titan in towards Saturn, we come across a series of moons that despite being ice rather than rock bear a family likeness to our own Moon. They are heavily cratered by impacts from space. One exception is Enceladus. Its smooth plains look as though they are continually coated with fresh falls of snow from volcanoes erupting on its icy surface, or drowned by flows of liquid-water 'lava' from these suspected ice volcanoes.

The other moons of Saturn seem to be as dead as our own Moon, apart from the ravages of celestial impacts. Two of them, Mimas and Tethys, bear craters fully one-third as large as the world itself. The impacts that blasted out these craters must have almost broken these moons apart.

In fact, we know that one companion world did come off worse than Mimas or Tethys. Closer to Saturn we find a pair of small moons, Janus and Epimetheus, that follow precisely the same orbit around Saturn. These moons are irregular in shape and jagged around the edges. They are almost certainly the halves of a moon that was smashed in two by a giant icy meteorite.

Although there are faint bands of matter circling Saturn further out than the Janus–Epimetheus twins, it is when we come closer to the planet that we start to encounter the main set of rings. And in this journey in towards Saturn there are still four moons to be met. This is not chance, for there are close links between the small moons and the rings.

Giving Mimas the appearance of a giant eyeball, 390 kilometres across, is a crater that is fully one-third the diameter of Mimas itself. In comparison to its parent world, this crater, Herschel, is the largest known in the Solar System. The impact that caused it must have almost blasted Mimas apart.

Heavily cratered Dione bears the scars of many impacts over billions of years. Although it looks much like our Moon, Dione – like Saturn's other moons – is made mainly of ice, mixed with smaller amounts of rock. Long cracks show that Dione expanded slightly in the distant past and split its crust.

The rings are not a solid sheet of matter, but consist of billions of chunks of ice all orbiting Saturn as miniature moons in their own right. The 'particles' making up the rings are so small that the *Voyagers* could not see them individually, but scientists have been able to make a fair guess at their sizes partly on the way the rings blocked the radio signals from the *Voyagers* when the spacecraft passed behind the rings.

The largest particles in the rings are about ten metres across – snowballs the size of a house – but these are comparatively rare. There are more and more particles of smaller and smaller sizes, down to regular fist-sized snowballs. In some parts of the rings these are the smallest particles that we find, and the space between them is quite clear. In other regions there are many smaller fragments, forming a snowstorm of swirling flakes between the larger snowballs.

Saturn's magnetic field marshals the smallest fragments of all – microscopic crystals of ice – into a set of bands that appear rather darker than the rest of the rings. These bands stretch across the rings outwards from the planet itself, and

move around with the planet's rotation, just like the spokes on a wheel with Saturn as the hub.

The main ring particles all orbit Saturn precisely above its equator, but at a wide range of distances. As a result the ring system of Saturn is extremely thin. From one edge to the other, the main rings stretch 273,000 kilometres – two-thirds the way from the Earth to the Moon – but they are no thicker than the size of the largest particles, around ten metres. If we tried to match the thinness of Saturn's rings with a scale model cut from ordinary paper, then we would end up with paper rings that are two kilometres across!

The photographs from the *Voyagers* show that the main particles in the rings follow each other around the planet like beads on a necklace, forming a vast number of narrow ringlets. From Earth we cannot see the 10,000 or so separate ringlets, and in our ground-based telescopes they are blurred together

Seen in close-up, Saturn's rings turn out to be made of thousands of narrow ringlets. Crossing the brightest regions are long dark streaks that stretch outwards across the rings, and rotate with the planet like the spokes of a wheel. The spokes consist of microscopic particles of ice, under the control of Saturn's magnetic field.

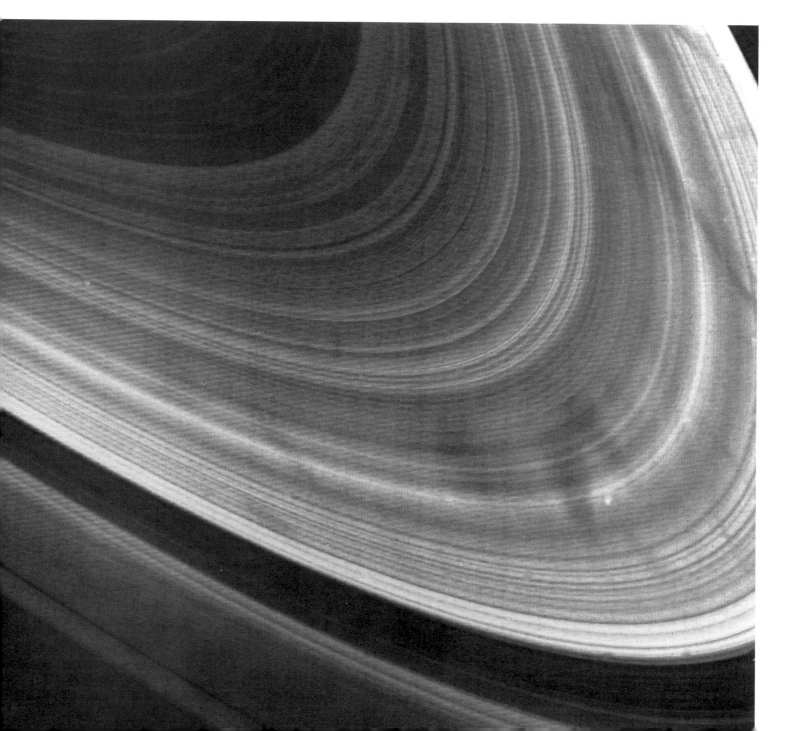

The rings of Saturn are largely transparent: here we can see part of the planet's globe (top right) through the rings. The large gap in the ring system (lower right) is the Cassini division; the Encke division is the narrow dark gap near the outer edge of the rings. In 1990, astronomers analysing old *Voyager* pictures found a tiny moon orbiting Saturn within the Encke division.

to make up just three broad rings: the faint C-ring, nearest to the planet, the bright B-ring and then – beyond a narrow dark gap – the A-ring.

Despite years of analysing the images from the *Voyagers*, astronomers are still perplexed by the vast number of ringlets around Saturn. Some are perfectly circular, while others are oval-shaped and a few form a tight spiral around the planet, like the groove on a gramophone record. In some places the flat plane of the rings is slightly corrugated, and we see ringlets at the crests and dips of the corrugations. Even the overall distribution into three main rings is still a puzzle: why are the ring particles segregated into the three very different regions of the C-, B- and A-rings, and why do these have such sharp edges?

The moons closest to Saturn certainly bear some of the responsibility. Although these small moons have only a weak gravitational pull on the particles in the ring, the pull is repeated over and over again with each orbit.

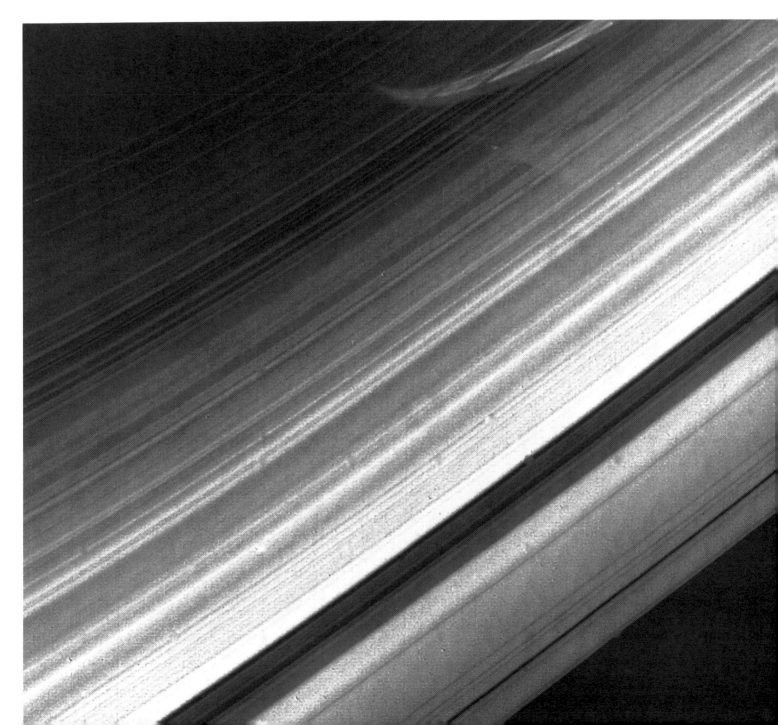

Just as we can make a child on a swing go higher and higher with only a gentle push if we time the push correctly, so the regularly repeating gravitational pull of a small moon can have an unexpectedly large effect on the ring particles.

Gravity is a force that pulls two objects together, but when we have three bodies involved, things can get more complicated. Even if we think of just one moon orbiting Saturn, and one ring particle, we actually have a system of three bodies, because massive Saturn itself is always the major player in the game. In the interplay of gravitational pulls, as the moon and the particle both orbit Saturn, we often find that the moon's gravity affects the particle's orbit in such a way that the particle moves away from the moon. In other words, with Saturn dominating the gravitational system it seems as though the moon is actually repelling the ring particle.

The outermost of the main regions, the A-ring, is nearest to the moons, and so it feels their effects the most. The pulls of the twin moons Janus and Epimetheus, together with the smaller but nearer Prometheus and Pandora, raise at least sixty spiral patterns in the A-ring. And the tiny moon Atlas, just outside the A-ring, is responsible for holding the outer edge of the giant ring system firmly in place. Here is a classic case where a moon is apparently repelling the ring particles, and preventing any particles in the A-ring from moving out beyond Atlas's orbit.

▶ The strange F-ring surrounds Saturn beyond the edge of the broad rings (at lower left). This view astounded scientists when *Voyager 1* sent it back to Earth in November 1980. It shows that the F-ring consists of three separate strands, with the two brighter strands braided together, in a way that apparently defies the normal laws of particles in orbit. Now astronomers believe that the gravitational pull of the shepherd satellites, Prometheus and Pandora, near the F-ring can produce these twists and kinks. (The apparent break in the ring is a calibration mark in the camera.)

◄ The most detailed picture of the F-ring, taken by *Voyager 2* in August 1981, shows it comprises at least four narrow strands. This stretch of the F-ring is not braided, probably because the shepherd moons are far away on the other side of the planet.

Another small moon is orbiting Saturn within the A-ring. Its 'repulsion' is clearing a narrow gap in the ring that stretches right around Saturn. Astronomers on Earth had glimpsed this gap, the Encke division, and the *Voyagers* showed it clearly. At the time (1979–80) no one could see a moon within the gap, but the close-up pictures showed its edges were slightly wavy in places, as if disturbed by the gravitational wake of a passing moonlet within the Encke division. From these clues astronomers were able to track down exactly where the moonlet should have been throughout the two *Voyager* encounters and locate the pictures in which it should appear. By computer-enhancement, the researchers managed to pick out the image of the new moon – in 1990, when the *Voyager* pictures were ten years old.

Many astronomers now think that a bunch of small moons is responsible for the main gap in Saturn's rings, the Cassini division between the A-ring and the B-ring. For decades astronomers had believed that this gap was swept clear by the gravitational pull of Mimas, because a particle in the gap would orbit

Saturn exactly twice for each orbit of Mimas. But the effect of distant Mimas cannot explain the very sharp edges to the Cassini division. A set of small moons within the division, on the other hand, would sweep out a tidy gap with neat edges.

The most spectacular example of a moon's gravitational tricks is on display just outside the orbit of Atlas, beyond the main ring system. Here, the trailblazing *Pioneer 11* craft found a single very narrow ring, the F-ring. This was before astronomers had pictures of the ringlets in Saturn's main rings, or the narrow rings around Uranus and Neptune, so the F-ring came as a surprise. The researchers wondered why the particles should stay in such a narrow ring rather than spreading inwards and outwards to create a broader and more diffuse ring.

The *Voyager* craft supplied the answer. It found one small moon orbiting Saturn just inside the F-ring and another orbiting just outside. These two moons, Prometheus and Pandora, act as gravitational 'shepherds' that keep the particles of the F-ring from straying beyond the ring's narrow confines.

But if the *Voyagers* solved one puzzle, they created another. The pictures showed that the F-ring is not a single narrow ringlet but consists of two or three strands, which in places are braided together like a girl's pigtail. At the time the discovery flummoxed scientists, and press reporters latched on to some off-the-cuff comments, for headlines such as: 'The F-ring defies the laws of Nature!' But now astronomers are confident they can explain the braided F-ring solely by referring to the law of gravity. If the F-ring consists of particles with a wide range of sizes, then the gravity of the shepherd moons has different effects on the larger particles and on the smaller particles. As a shepherd moon passes along the inside or the outside of the ring, its gravity sorts the ring particles according to their sizes, into two or three different strands.

Even the *Voyager* close-ups have left unanswered the two most basic questions about Saturn's rings – the questions that have been in astronomers' minds ever since the Dutch astronomer Christian Huygens first saw the planet's glorious display through a telescope in the 1650s. How did the rings of Saturn arise, and why is Saturn the only planet with such brilliant rings?

These two questions are in fact linked, and our best guess at the answer comes from comparing Saturn with its neighbours, Uranus and Neptune. These planets have rings that are very sparse, and made of very dark material. They bear all the hallmarks of being old – depleted of matter as particles have collided and been ground into dust that has fallen down into the central planet, and blackened by radiation from space. Bearing this out is the total amount of material in the rings. If it were all put together, the rings of Saturn would make a body almost 400 kilometres across, but the material that is left in the decaying rings of Uranus and Neptune currently amounts to a body only a few kilometres in diameter.

Astronomers now think that the rings of Saturn are comparatively young, formed perhaps 50 million years ago, when the Solar System had reached

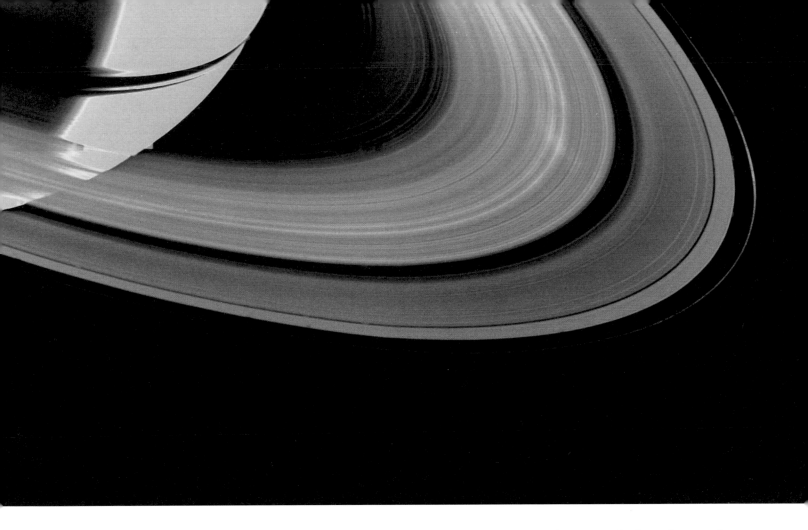

Above and overleaf: **Farewell to Saturn – contrasting views from the two departing** *Voyager* **craft.**

▲ **Looking back on the sunlit surface of Saturn's rings,** *Voyager 1* **had a grandstand view of the ringlets, the dark gaps and the narrow F-ring. Part of the planet appears at the top left, with the shadow of the rings round its equator.**

99 per cent of its present age. So the reason why Saturn is the only ringed planet is more a matter of timing than a fundamental difference. If we had lived in the age of the dinosaurs, we might have seen Saturn without a ring, and Uranus or Neptune looking as resplendent as Saturn is now.

If Saturn's rings did form so recently, they cannot simply be matter left over from the planet's birth, as astronomers at one time believed. Almost certainly the rings consist of debris from a moon of Saturn that was shattered into billions of icy shards by a giant cosmic collision.

We know that Saturn's moons have had a violent past – as witnessed by the huge craters on Mimas and Tethys, and the two halves of a shattered moon that now share the same orbit as Janus and Epimetheus. The rings of Saturn are the remains of a moon as large as Mimas that has been smashed apart by the collision of a giant meteorite or comet.

The older ring systems of Uranus and Neptune also point to Saturn's future. Over time the bright rings will become more and more tarnished, and they will thin out as the smaller particles fall inwards and are absorbed into Saturn itself. Only for the past one-hundredth of the Solar System's history has Saturn possessed its beautiful and unique rings: perhaps an equal amount of time into the future the rings will be so diffuse and blackened as to be almost invisible. We are lucky indeed to be living at a time when Saturn is at its most magnificent.

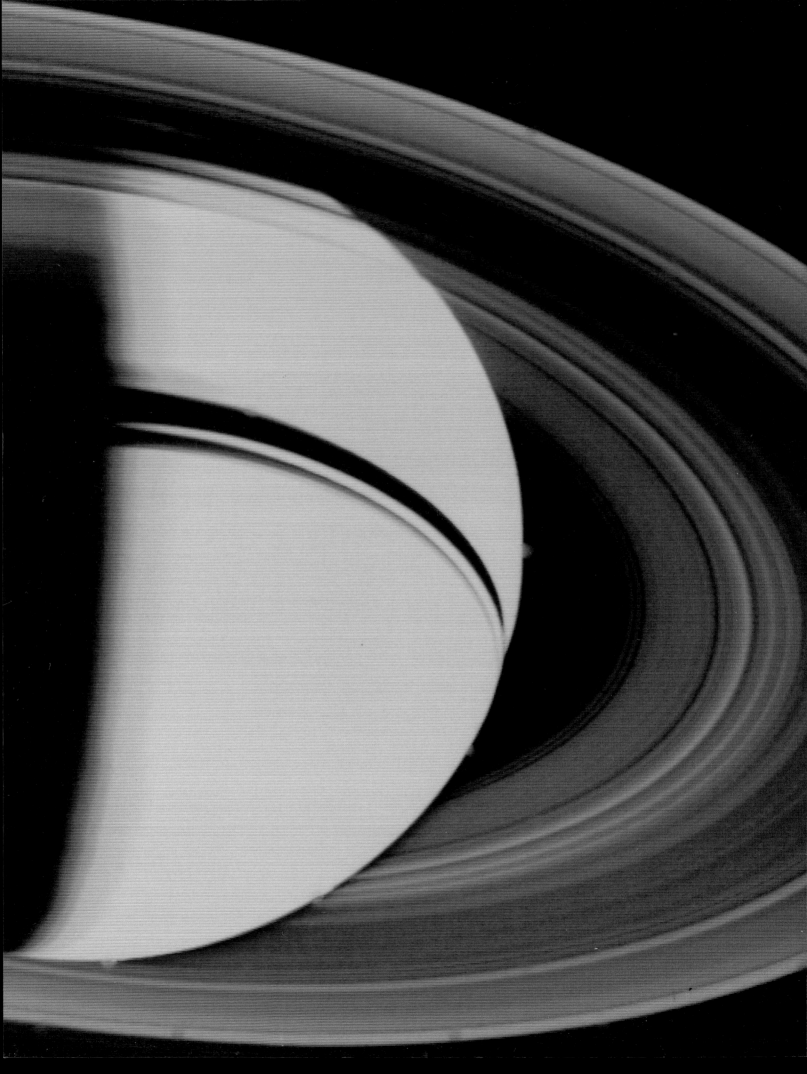

Voyager 2 saw the underside of the rings – the side not lit by the Sun. The result is almost like a photographic negative. The middle broad ring – the B-ring – appears the brightest in direct sunlight, because it is most densely packed with icy particles. These particles block sunlight so effectively that the B-ring is the darkest when seen from the underside. Conversely, the thinly populated Cassini division looks exceptionally bright in the view from *Voyager 2*. Colour differences are accentuated when we view the dark side of the rings: the reddish tinge to the B-ring and the bluish-green of the inner C-ring and the Cassini division show that the icy particles in different rings contain different impurities.

URANUS

7 In any atlas of the Solar System, the least interesting page must be that devoted to the seventh planet. Uranus appears only as a bland and featureless bluish-green globe, even to the cameras of *Voyager 2*, which passed close by the planet in 1986. The photographs show a planet that is plainer than the shrouded worlds Venus and Titan (the largest moon of Saturn). While the all-enveloping clouds on these two worlds show at least some fluffy wisps or tinted bands, with Uranus we look into a deep empty atmosphere of gas, as if we are gazing into a lifeless and bottomless ocean.

The results from *Voyager* confirm what astronomers have suspected for the two centuries that we have known of Uranus: it is the most mysterious of the planets. Although it is a giant world, four times the diameter of the Earth, Uranus lies so far away that it is barely visible to the naked eye. With hindsight, historians have found that astronomers of the distant past did occasionally record Uranus as a faint star, but none of them noted its position well enough to realize that it was moving gradually from night to night.

In 1781 a leading amateur astronomer happened to turn his powerful home-made telescope on to this 'star', and found it was in fact a planet almost twice as far away as Saturn. William Herschel was a Prussian musician working in England, and this discovery launched him into a full-time career as King's Astronomer. Among his many later achievements, Herschel went on to find the two largest of the new planet's moons, Oberon and Titania.

Later astronomers increased the number of moons orbiting Uranus to five, before *Voyager* visited the planet. The orbits of these moons told astronomers a strange thing: Uranus is tipped up on its side as it orbits the Sun. As the planet moves around the Sun every eighty-four years, its extreme tilt produces the most unusual seasons of any planet. At some times – as, for example, when *Voyager* reached Uranus in 1986 – one of the poles is facing the Sun. We then see the moons moving in circles around Uranus as if they were the concentric rings in a darts target where the planet itself is the bull's-eye. Twenty-one years later Uranus is side-on to the Sun, and we observe the moons travelling up and down as they move around an equator that is vertical in our view. Another Uranian season later, after a further twenty-one years, the other pole is facing the Sun and we see the moons circling the bull's-eye in the other direction.

Even at close range, Uranus appears totally featureless. As *Voyager 2* approached this distant world in January 1986, its camera revealed a planet with a deep atmosphere tinged blue-green by methane gas and virtually free of clouds. Because Uranus is tipped over on its side as it circles the Sun, we are here looking directly at one of its poles.

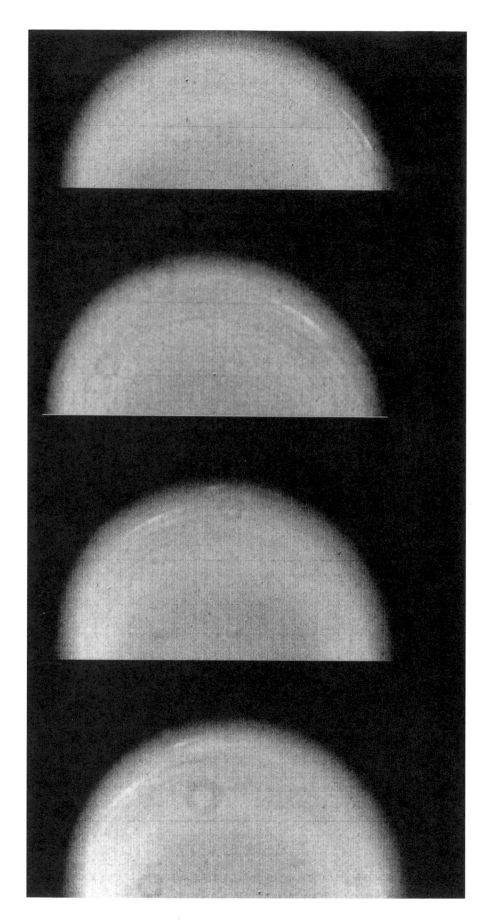

By enhancing the contrast in *Voyager* images to the limit, scientists could just pick out a couple of long pale clouds near the equator of Uranus. The clouds appear near the top of the planet's disc in this sequence of pole-on views, covering a period of four and a half hours. The clouds seem to move anti-clockwise as Uranus rotates.

The rings of Uranus are very thin and dark, and long exposures were needed for the *Voyager* cameras to capture them at all. The most prominent is the outermost, or epsilon ring: its particles are kept in a narrow path by two shepherd moons, Cordelia and Ophelia – marked here with their original provisional names 1986U7 and 1986U8.

In 1977, Uranus surprised astronomers again. As a team of researchers watched a star disappear behind the planet, they found that the star blinked on and off several times before and after the planet covered it over. They guessed that Uranus must have a set of narrow rings that blocked out the star's light but could not be seen directly from the Earth. This was the first indication that any planet other than Saturn had rings, and – as it was to be another two years before *Pioneer 11* discovered the narrow F-ring of Saturn – it was the first detection of very narrow rings around a planet.

Two centuries of observing the planet itself had left astronomers with little hint of bands, clouds or spots, such as they had seen on Jupiter and Saturn. And *Voyager* showed that such hopes were futile. Even in close-up Uranus presents a bland face to the Universe. Only with the most severe computer-

Backlit by the Sun, broad sheets of dust appear between the narrow rings of Uranus. The microscopic dust particles shine brightly when the Sun lies behind them, like cigarette smoke caught in a shaft of sunlight. This tenuous scattering of dust has been chipped off the larger particles in the narrow rings, and is spiralling down towards the planet. Streaks in this photograph are trails of stars, smeared out as *Voyager* targeted Uranus in this ninety-six-second exposure.

enhancement could the scientists make out any details on the planet. The polar region, it seems, is slightly darker than the rest of Uranus, and near the equator *Voyager* found a couple of faint straggly clouds, deep in the planet's bluish-green atmosphere.

Although Uranus's inscrutable face seems to give little away, astronomers have been able to discover a fair amount about conditions inside the planet. From the planet's mass and its size, we can calculate that Uranus has a density intermediate between that of a dense rocky planet like the Earth and the low-density gas giants Jupiter and Saturn. The bulk of the planet must be made of something less dense than rock, but more substantial than gas. The answer is, almost certainly, water: most of Uranus is a deep warm ocean.

The interior of Uranus differs in a subtle way from that of the other planets (except for its twin, Neptune). Most planets have interiors like an onion, where we find distinct layers of different substances – for example, Jupiter's rocky core is surmounted by successive layers of metallic hydrogen, liquid hydrogen and atmosphere. Uranus consists, broadly, of rock at the centre, water above and an atmosphere on the top. But there are no sharp boundaries. If we travelled outward from the centre we would find the hot rocks becoming gradually mixed with superheated water, and we would then pass imperceptibly into a dirty ocean. This ocean consists mainly of ordinary water, but dissolved in it we would find ammonia and methane. There is no distinct surface to this ocean. Towards the top, the water just thins out into an

Miranda has the most bizarre geology of any world in the Solar System: various regions look so different that astronomers have called it 'a world put together by a committee'. Although only 480 kilometres across, this moon has been highly active, with a surface marked by several huge oval patterns. The youngest, Inverness Corona (lower right of centre), has sharp corners and bands of light-and-dark material that make a characteristic chevron.

atmosphere composed largely of hydrogen and helium. Traces of methane gas in Uranus's 'air' give the planet its bluish-green tinge.

Voyager 2 discovered that Uranus – like the Earth, Jupiter and Saturn – has a strong magnetic field. But there the resemblance ends. In the case of the other three planets, the magnetism is generated near the core and lines up, more or less, with the planet's axis of rotation. The magnetic field of Uranus is generated halfway out from the planet's centre towards its surface, and is tipped up at an angle of 60° to the poles of rotation: it is as if the Earth's magnetic poles were as near to the equator as Cairo and Brisbane.

A planet's magnetism is generated by swirling currents in a fluid that can conduct electricity. The Earth has a conducting core of liquid iron, while the central regions of Jupiter and Saturn contain metallic liquid hydrogen. As a result, these very different kinds of planet have a similar kind of magnetism. The centre of Uranus on the other hand consists of rock that does not conduct electricity, so the planet's core cannot generate much in the way of a magnetic field.

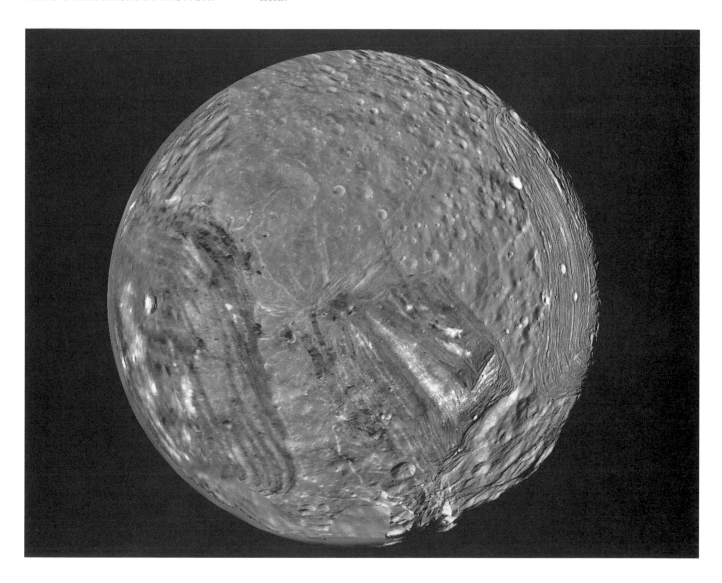

The lower reaches of the dirty ocean, however, are good conductors of electricity. Here the high pressure breaks up the individual molecules of water into electrically conducting oxygen and hydrogen atoms. Swirling ocean currents stir up this mixture and generate the planet's magnetism. Just as the patterns in a planet's atmosphere are not entirely symmetrical – witness the Great Red Spot on Jupiter – so the unevenness of the ocean currents means that the magnetic poles can lie at a crazy angle, as we find on Uranus and on its twin planet Neptune.

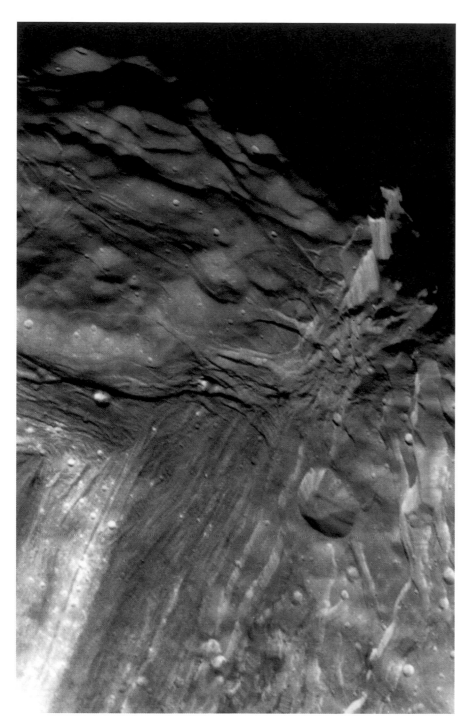

A giant cliff is highlighted at the edge of Miranda in this *Voyager 2* photograph. The top of this cliff, Verona Rupes, towers as high over its base as the summit of Mount Everest rises above the lowest point on the Earth's ocean floor – and this on a world that is less than one-twentieth the diameter of the Earth.

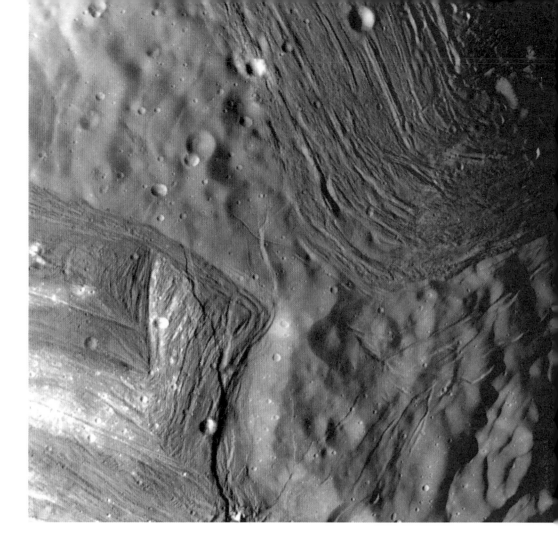

Details of the 'chevron' in Inverness Corona (lower left) appear in this overhead view of Miranda. To the upper right is part of the 'racetrack', more properly known as Elsinore Corona. Both regions were probably formed by large – but shortlived – upwellings of material from within this icy moon.

As Uranus spins, it whirls the magnetic field around with it. By measuring the changing magnetism as *Voyager 2* flew by, the NASA scientists could work out the rate at which the planet turns on its axis. The length of the 'day' on Uranus came out as seventeen and a quarter hours. Just as Uranus is intermediate in size between the giants Jupiter and Saturn on the one hand, and the rocky planets Mars and the Earth on the other, so too its rotation period lies between the roughly ten hour 'day' of Jupiter and Saturn and the 24-hour rotation period of the Earth and Mars.

Once they knew how quickly the interior of the planet was turning, the NASA astronomers could work out how fast the two faint clouds spotted by *Voyager* were moving. They are blown by winds at the hurricane pace of 700 kilometres per hour – but this is comparatively slow when compared to the powerful winds of Saturn or Neptune.

Meteorologists are still puzzling over the weather patterns on Uranus. Because the Sun's heat is currently falling on one pole, rather than on the equator, the meteorologists expected the circulation of the planet's atmosphere to be very different from those of the other giant planets. In particular, the winds might blow mainly south and north, towards and away from the heated pole. But the winds in fact blow parallel to the equator, apparently controlled more by the planet's rapid spin than by direct heating from the Sun.

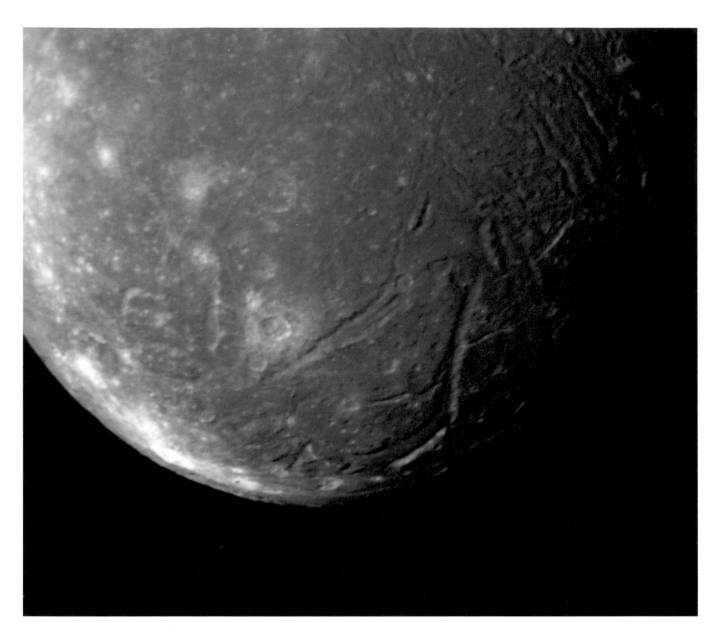

Although winds do not blow directly from one hemisphere to the other, Uranus must have some way of transporting heat from the sunlit pole to the darkened side. *Voyager 2* found that the pole facing away from the Sun – a region that has been in complete darkness for over twenty Earth years – is every bit as warm as the pole now facing the Sun.

When the *Voyager* scientists worked out the total heat budget for Uranus, they found that the planet is radiating almost exactly as much heat as it receives from the Sun. This might not be a surprise in itself, but it makes Uranus unique among the giant planets. Jupiter, Saturn and Neptune all produce heat in their centres, so they radiate away about twice as much energy as they receive from the Sun.

Since Uranus is also unique in being tipped up at right angles to its orbit, some scientists have sought to combine the two facts. In its early days, Uranus

▲ The surface of Ariel is partially cratered and partly broken by large fractures. ▶ A computer reconstruction of *Voyager* images, including lines of latitude and longitude, shows that the fractures run more or less around the equator. Like the planet itself, all of Uranus's moons are tipped up so much that the Sun was shining directly on one pole when *Voyager 2* flew past.

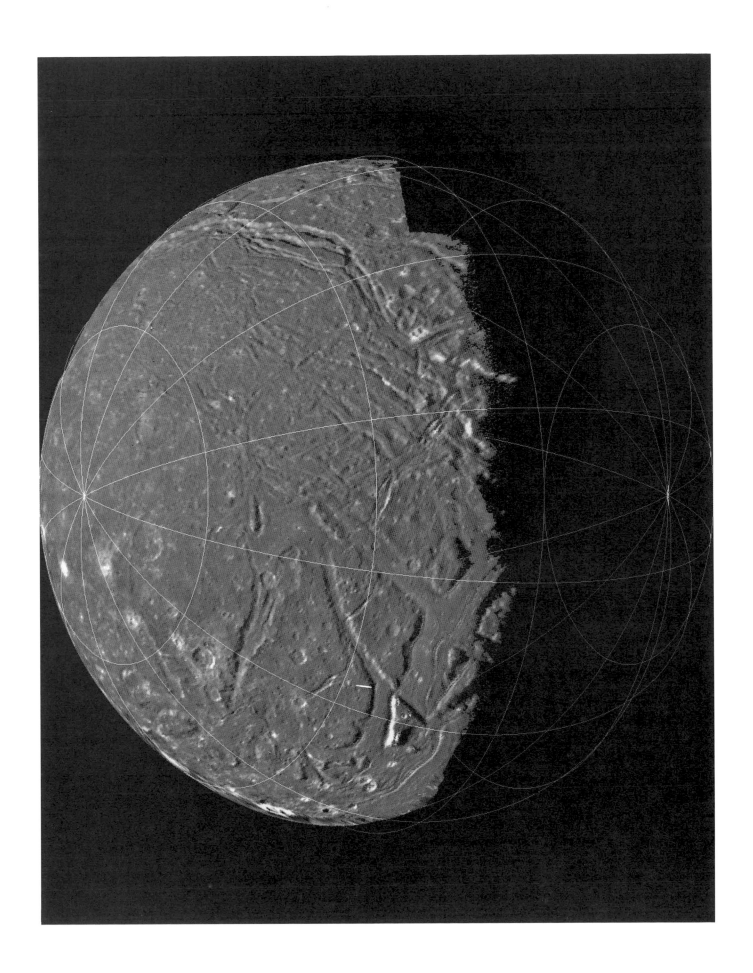

was formed from a vast number of small icy planetesimals. It probably started out rotating upright, like the other planets. Suppose that one of the last planetesimals to hit the almost-formed planet was exceptionally large – as massive as the Earth – and struck Uranus near one of its poles. The momentum of the impact could have knocked the planet sideways, to produce its strange tilt. Such an impact might have stirred up the centre of the planet as well, cooling it down rapidly so that today there is little heat left to be released.

Other scientists take almost the opposite view. The planet is currently very hot inside, they argue, just like its twin Neptune. But the layers of ocean and atmosphere provide very good insulation, so that the heat is trapped in the centre of the planet. We can compare Uranus and Neptune to a Thermos of hot water and a hot-water bottle respectively: although the Thermos is equally

hot inside, we cannot detect this heat from the outside because it is so well-insulated.

While it took some hard work on the *Voyager* results to add anything to our knowledge of Uranus itself, the spacecraft's cameras scored an immediate success with the planet's rings. Astronomers on Earth had suspected that the planet has narrow rings, but *Voyager 2* photographed them for the first time. Its close-up shots revealed the silk-fine strands of the rings in intimate detail.

Uranus has ten narrow rings and one that is slightly broader. They are made of material that is pitch black – among the darkest matter in the Solar System. Although they all look rather similar at first sight, the rings of Uranus sport some subtle differences. Some are slightly tilted relative to the planet's equator, some are definitely not circular but form an oval shape. The outermost and brightest of the set, the epsilon ring, is not only oval but is much wider at its furthest point from the planet.

The dark chunks of matter that make up the rings are typically as big as a car or a small truck – several metres across. In the rings of Saturn pieces this size are accompanied by a much larger number of smaller chunks, but Uranus's rings have practically no particles less than a metre in size.

The other difference from Saturn is in the brightness of the ring particles – the difference between blindingly white fresh snow and the black of coal. Astronomers have two ideas to explain the difference, and the true answer may involve both. The rings of Saturn consist of pure ice, like its bright moons. But the moons of Uranus are dark and rocky, so the planet's rings probably also consist of matter that is naturally dull. Additionally, the ring particles of Uranus may have been darkened by a prolonged exposure to radiation in space: astronomers now think that the rings of Uranus have been around for much longer than those surrounding Saturn today.

Voyager found ten new moons orbiting Uranus more closely than the five larger moons visible from the Earth. These small dark moons are the quarry from which the matter in the rings is being extracted. Solid bodies from space, like the nuclei of comets, fall into the region around Uranus so frequently that these moons are suffering a continuous bombardment that smashes pieces of rock out of their surfaces. This debris falls towards Uranus to form the dark rings.

The celestial bombardment continues to chip away at the rocky fragments in the rings, breaking off smaller and smaller fragments – down to the size of microscopic particles of 'dust'. The dust particles cannot stay in the ring, however. They feel friction from the outermost parts of Uranus's extensive atmosphere, and, like satellites brought down to Earth by the drag of our air, the dust particles spiral down towards the planet.

Voyager 2 caught a unique view of this dust around Uranus. After it had flown past the planet, the spacecraft took a long backwards look – and saw not eleven fairly narrow, dark rings but a swathe of around a hundred broad bright bands around the planet, looking for all the world like part of the ring system

Umbriel is a dark moon, about the same size as Ariel – 1,160 kilometres in diameter. It has very little colour in its grey surface, and unusually few dark or bright patches – except for the bright crater Wunda (top right), 110 kilometres across, where light-coloured material seems to have seeped up from within Umbriel.

of Saturn. The bright bands are made of microscopic dust particles. Unlike larger particles, the dust is brightest when you gaze through it towards the Sun – just as road-dust on a car windscreen looks brightest when you drive towards the Sun. This view from *Voyager* showed that ten of the main rings are practically devoid of dust – confirming calculations that the atmosphere will very quickly sweep a dust particle out of the ring where it was born. After only a century the mote of dust will descend right through the region of the bright bands and burn up as a meteor in Uranus's denser atmospheric layers.

The two innermost of the newly discovered moons, Cordelia and Ophelia, orbit on either side of the outermost narrow ring, the epsilon ring. They act as 'shepherds' to prevent the ring-particles from straying. Each of the other narrow rings probably has a pair of shepherds, but these must be so tiny that *Voyager* could not detect them.

The other eight small moons lie further out than the ring system. Given the heavy bombardment from space, some of these moons may be shards from a larger moon that was broken into pieces. Some scientists believe that such cosmic violence is the only way to explain the weirdness of Uranus's strangest moon, Miranda.

Miranda is the smallest of the Uranian moons that we can see from the Earth. With a diameter of less than 500 kilometres, Miranda would fit into our Moon four hundred times over. Small moons are, on the whole, dead moons, and scientists expected that Miranda would show little more than a vast number of craters. But *Voyager 2* found that Miranda has some of the most exciting and perplexing landscapes in the Solar System, including a cliff about twenty kilometres high. If Miranda were scaled up to the size of the Earth, this cliff would reach up to the orbit of the Space Shuttle.

Unique to Miranda are three large rectangular or oval shapes, 200 to 300 kilometres across. Geologists have come to call them ovoids or coronae. These features were probably all formed in a similar way, but they have been changed to different extents. The youngest – or the least altered by later geological activity – is a chevron-shaped marking with high ridges, strong contrasts in brightness and sharp corners. The others are more subdued and, over time, gravity has flattened out their ridges and contours.

Some scientists argue that a freak catastrophe must be responsible for these unique markings on Miranda. All of the moons of Uranus are made of a mixture of rock and ice. According to this theory, the interior of Miranda originally settled to give it a core made mainly of rock, with most of the ice nearer to the surface. But an immense impact then broke the moon apart. The various fragments of the shattered Miranda gradually reassembled to make up one moon again. Now, however, the ice and rock regions were scattered at random. As the regions of rock tried to sink and the ice to rise, they produced these characteristic ovoid shapes.

More likely in the eyes of most researchers is the idea that Miranda has always been a single body. The gravitational pulls of the other moons at some

The large moon Oberon is splattered with bright ejecta from impacts. The dark patch near the centre is the floor of a large impact crater, while the mountain seen at the edge of Oberon (lower left) is the central peak of an even larger crater.

stage warmed its interior, so regions of ice within began to rise – like the rising hot spots of molten rock within the Earth. The ovoids mark the top of these hot spots, which froze solid before they could stretch and squeeze the entire crust of Miranda.

The four outer moons of Uranus are larger than Miranda, but none is even half as big as the Earth's Moon. They also provide an object lesson in the different ways that small moons can evolve. Next from the planet we come across Ariel and Umbriel. Virtually twins in size, some 1,200 kilometres across, these two worlds could not differ more in appearance.

Ariel is covered with dark and bright patches, and its surface is broken by a complex set of fractures and grooves. In the floor of the valleys there are frozen flows of lava. At this distance from the Sun, it is so cold that we would not expect to find liquid rocks: the temperature is well below the freezing point of water. The outflowing lava before it eventually froze was probably a mixture of

water and liquid ammonia, which would have a lower freezing point than either liquid separately.

In contrast to the geological activity on Ariel its twin, Umbriel, is a sober and sombre world. It is dark, reflecting only half as much sunlight as Ariel, and the surface of Umbriel bears virtually no interesting markings, merely an assortment of craters that date from its birth. As if to compound the mystery, however, *Voyager* photographed a single bright crater on Umbriel, possibly one that has penetrated the moon's dark outer crust to reveal brighter ices within.

Titania, the biggest moon of Uranus, resembles in some ways a larger version of Ariel, with large cracks running across its surface. Its twin, Oberon, is a heavily cratered moon with little of interest – except for a huge mountain near one edge. Although Oberon is only one-eighth the diameter of the Earth, this mountain rears to twice the height of Mount Everest. It is probably the central peak of an enormous crater.

Although scientists have now made some brave stabs at understanding this planet's interior, its magnetic field, its meteorology, its rings and the geology of its varied moons, Uranus has given away little, even to the probing *Voyager* spacecraft. We are still unsure about the answer to the most fundamental of the planet's mysteries, why it spins on its side. Until a spacecraft can explore Uranus in detail, the seventh planet will remain an enigma.

A parting view of Uranus, as *Voyager 2* completed its successful encounter with the planet. The inside of the thin crescent appears green as sunlight passes through a thick layer of methane gas; the outer edge is whiter, because a layer of haze reflects the Sun's light without changing its colour.

NEPTUNE

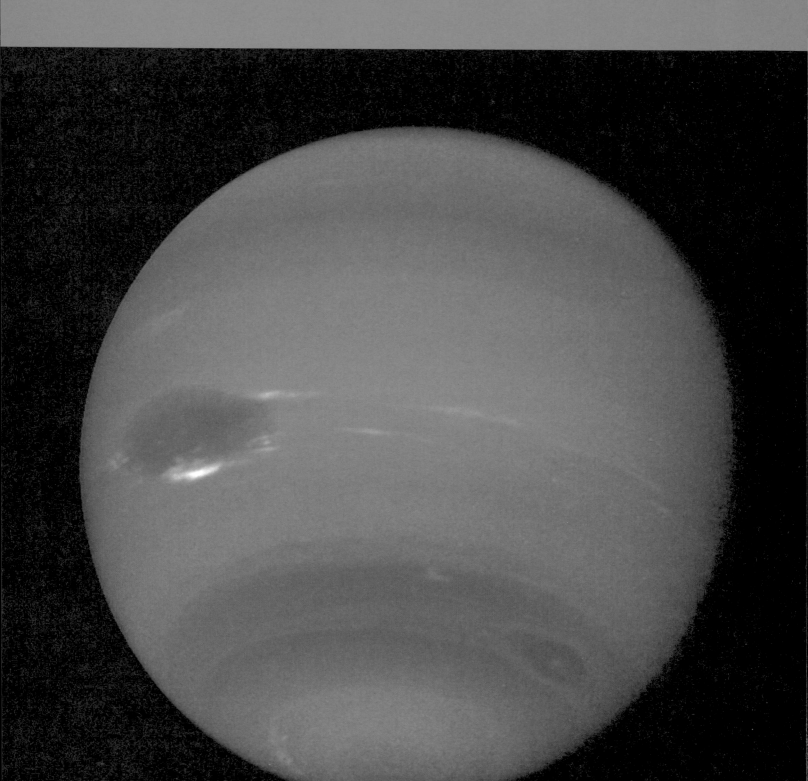

8

When the spacecraft *Voyager 2* swept past its final planet in 1989, astronomers viewing the pictures on Earth were in for a nostalgic surprise. *Voyager*'s cameras showed Neptune to be a blue planet with wispy white clouds, accompanied by a large, rocky-looking moon. No one had expected to find, in the outer fringes of the Solar System, a world so reminiscent of our own 'Blue Planet'.

Up till then, we knew virtually nothing about Neptune. The planet is so far away that we need a telescope to see it at all. Astronomers did not know of its existence until the middle of the last century, when they noticed that some unexpected force was pulling Uranus as it moved round its orbit. The best explanation was the gravitational tug of an unknown planet, further from the Sun. Mathematicians in England and France calculated where this planet should lie, and in 1846 astronomers at Berlin Observatory picked it out as a faint moving 'star'.

Even the most powerful telescopes on Earth show Neptune as little more than a small, dim blur, with a few hints of bright clouds. Astronomers knew roughly how big Neptune is, and that it holds at least two moons in orbit. There were also tantalizing hints that the planet has broken rings – 'arcs' – that stretch only part way round Neptune.

As a result practically everything we know about Neptune has come from the encounter between the hardy spacecraft *Voyager 2* and the second Blue Planet. Despite its superficial resemblance to the Earth, deep down Neptune is a very different world. It is a giant planet, about four times the size of the Earth, and it has no solid surface. Like its slightly larger 'twin', Uranus, Neptune may have a small core of molten rock at its very centre, but the bulk of the planet, as befits its name, consists of water. The lower regions of this vast warm ocean are mixed with rocky material at the core to form a dense mud, while the top of the ocean gradually peters out into an atmosphere made largely of hydrogen and helium gases. A small amount of methane in Neptune's 'air' gives the planet its homely colour, for this gas absorbs red light and reflects mainly the blue wavelengths back into space.

The centre of Neptune is extremely hot: its temperature of $7,000\,°C$ is higher than that at the surface of the Sun. Some of this heat leaks outwards, warming up the outer parts of the planet before it escapes into space as infra-red radiation. As a result, the atmosphere of Neptune is as warm as that of Uranus, even though the planet is much further from the Sun – although 'warm' is a relative matter, as the outer parts of both these distant planets are at a temperature of $-214\,°C$.

The second 'Blue Planet' – after the Earth – Neptune is made almost entirely of water. It is also the windiest planet in the Solar System. Gales up to 2,000 kilometres per hour sweep around Neptune, carrying dark spots and other weather patterns with them.

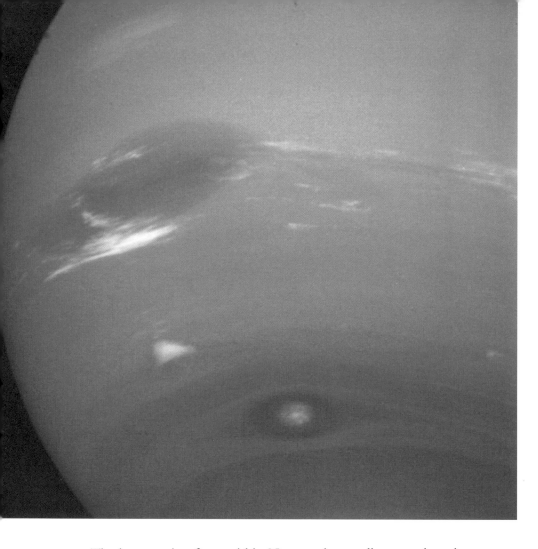

Neptune displayed three prominent weather patterns when *Voyager 2* passed the planet in 1989. The Great Dark Spot (middle left) has white clouds around the edge, while the Small Dark Spot (bottom) has a small pale cloud over its centre. Between them is the Scooter, a triangular white cloud that lies deeper in the atmosphere. The weather patterns travel round Neptune at different speeds, and this is a rare shot of the three close together.

The heat coming from within Neptune is actually more than the amount that it receives from the Sun. Scientists are still puzzled as to the source of this interior heat. According to one theory, Neptune became extremely hot when it was born, in a maelstrom of planetesimals that crashed together, and this original heat is still seeping out. On the other hand, the planet may be generating heat at the moment. If this is the case, the heat probably comes from various materials separating out within Neptune, like a bottle of salad dressing that is shaken and then left to separate into layers of oil and vinegar. We observe this phenomenon in the case of Saturn. Heat is generated as the heavier materials sink to the centre.

Some scientists have suggested that this heavier material consists of a well-known but rather exotic substance. Towards the bottom of the planet's warm ocean the pressure is high enough to break up molecules into their constituent atoms. One of the substances dissolved in the water is methane, which consists of carbon and hydrogen atoms. The high pressure may winkle the carbon atoms out of the methane molecules, and squeeze them together as crystals of pure carbon – in other words, giant diamonds.

The pressure also destroys water molecules deep in the oceans of Neptune, to form a mixture of oxygen and hydrogen atoms that can conduct electricity well. Swirling currents in this conducting liquid generate a magnetic field. The

The Great Dark Spot is a storm-system as large as the Earth, spinning round once every sixteen days. Festoons of cirrus cloud – made of frozen methane – condense around its edges as winds sweep up and over the Spot.

strongest currents are a long way out from the planet's core, over halfway from the centre to the cloud tops. This region is situated south of the equator, so that we find a magnetic 'pole' at a latitude of 47° south. Here the magnetic field is about as strong as the Earth's. As we go around the planet, we move further away from the source of the magnetism, so the 'north' magnetic pole of Neptune is actually the place where the planet's magnetism is weakest.

As Neptune rotates, it sweeps the magnetic field around. *Voyager 2* felt the ebb and flow of the magnetism as the planet spins round, and so the scientists could measure the planet's rotation period – its 'day'. The most precise measurement came from regular pulses of radio waves, emitted by the magnetic field each time the planet turned. These showed that the 'day' on Neptune is sixteen hours, seven minutes in length: like the other giant planets, Neptune spins more rapidly than the Earth, despite its much greater size. Its day, like its size, is not very different from that of Uranus.

In its appearance, however, Neptune is a complete contrast to its bland and featureless twin. At a latitude of 20° south, Neptune has a Great Dark Spot – an oval-shaped dark cloud as large as the Earth. The edges of the dark spot are festooned with banners of bright white clouds. Near the south pole is another, smaller dark oval. This one also has patches of white cloud in attendance, but this time they lie in the centre of the spot. In between the two dark spots is a

white patch that lies deeper in the atmosphere. When they first saw it, the *Voyager* scientists dubbed this bright cloud 'The Scooter', as it scoots around the planet much faster than the dark spots.

Later, when the radio and magnetic observations revealed the true rotation period of Neptune beneath the clouds, the Scooter turned out to be a tortoise. It actually stays more or less in the same place relative to the deepest regions of Neptune. Instead, the two dark spots are 'scooting' in the opposite direction to the way in which the planet is rotating, at 1,000 kilometres per hour. The winds associated with these clouds are blowing at twice this speed – ten times faster than hurricane force winds on the Earth. The winds are so rapid that they almost break the sound barrier on Neptune, making it the windiest planet in the Solar System.

The fast winds on Neptune and the planet's complex weather patterns have posed a great puzzle to meteorologists. Even if we add together the heat coming from the distant Sun and the heat generated in the planet's core, the total is so small that it should not be able to drive large masses of gas around Neptune at almost supersonic speeds. The processes driving Neptune's weather must be far more efficient than the forces that operate on the Earth – showing that we still have a long way to go in understanding how a planet's atmosphere works.

▶ Streamers of high cirrus cloud – made of frozen methane – appear in bold relief as the Sun throws their shadows on to the atmosphere some fifty kilometres below. *Voyager 2* took this picture just two hours before the craft skimmed over the planet's north pole, only 5,000 kilometres above the cloud tops.

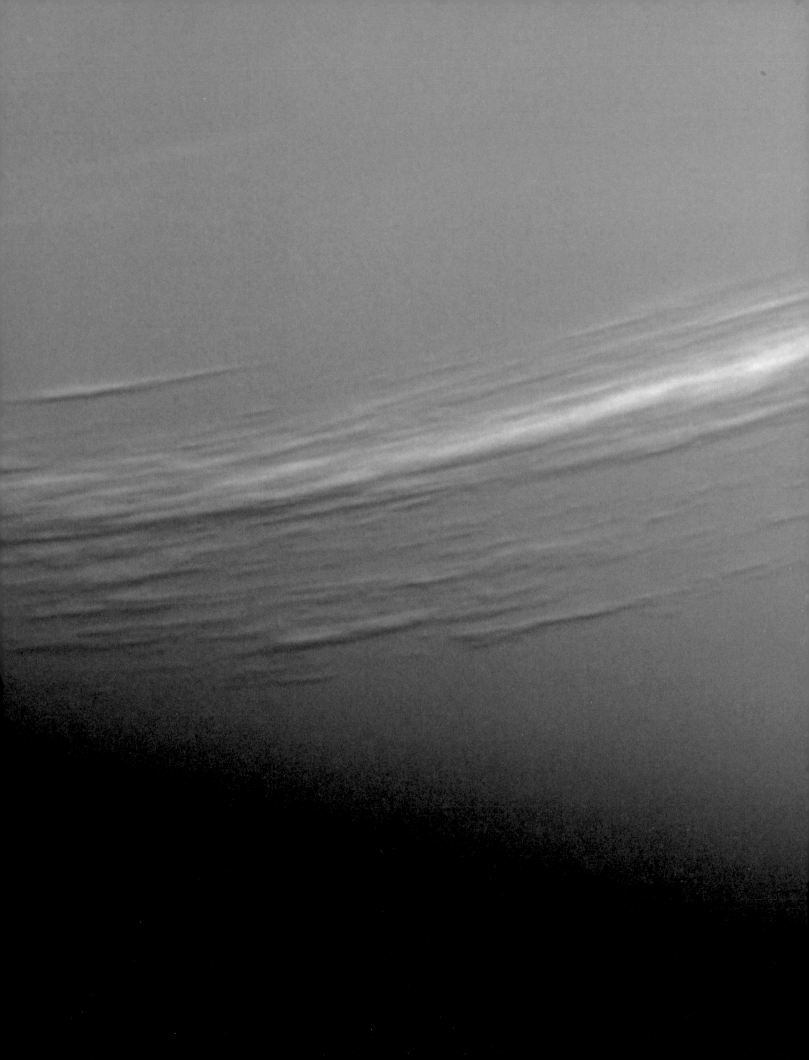

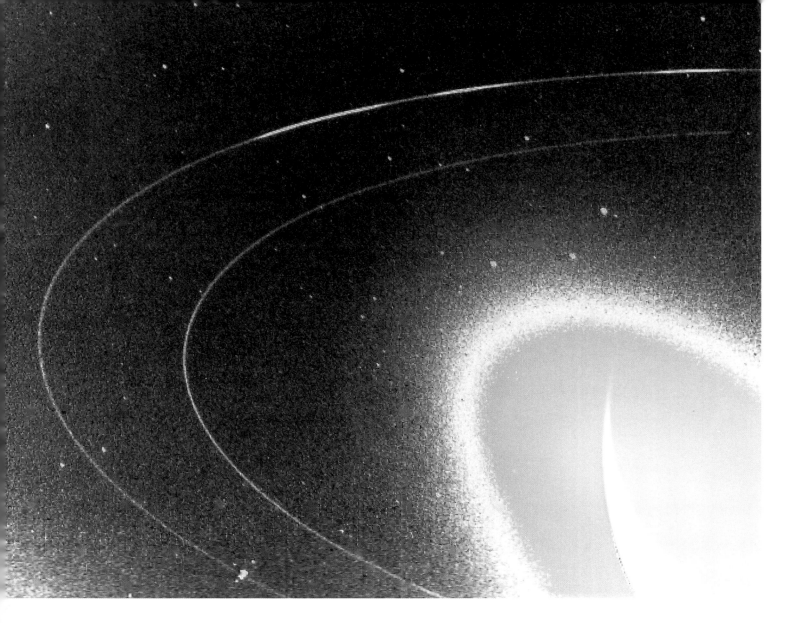

Neptune's Great Dark Spot is another puzzle: so far, no one is sure why it is 'great', 'dark' or a 'spot'. Movie sequences made from *Voyager*'s images show that the spot is rotating in an anti-clockwise direction, turning once every sixteen days. Jupiter's Great Red Spot also rotates anti-clockwise, and the two spots bear a distinct family resemblance. They are at about the same latitude, and are roughly the same size relative to the planet. The difference in colour is of little importance: Jupiter's spot is probably tinted by very small amounts of phosphorus that are irrelevant to the meteorological conditions that produce the spot.

The white clouds are somewhat easier to explain. High-level winds on Neptune become cooler as they blow up and over the Great Dark Spot, so that methane gas freezes out as tiny crystals of white 'ice'. Water in the Earth's atmosphere freezes in a similar way into ice crystals that form cirrus clouds. When the Sun shines at the right angle, the banners of methane cirrus on Neptune cast shadows on the bluish atmosphere far below.

Like the other giant planets Neptune has a set of rings, but those of Neptune

Neptune's faint rings appear most clearly in a view that *Voyager 2* obtained looking back at the planet (the tip of the crescent Neptune appears within the overexposed area at lower right). The outer of the two narrow rings contains three regions that are brighter and more densely packed with matter than the rest: astronomers on Earth had already suspected the existence of these 'arcs' because they can block the light from a distant star.

are the sparsest and the most difficult to see. Using very long exposures, the cameras on *Voyager 2* revealed two dark, narrow rings, and a couple of rings that are broader and dimmer. The rings are made of rocks as black as coal and probably the size of a car or a small truck, similar to the dark rocks that form the rings around Uranus.

As well as rocks, the rings of Neptune contain a vast amount of microscopic dust, produced by the grinding down of the larger rocks. This dust looks brightest when it is backlit by the Sun, and in *Voyager* pictures of the dark side of Neptune the rings look brilliant as the sunlight catches the dust particles in them. From this perspective, the rings of Neptune look very similar to the view from the front – unlike the backlit view of Uranus, where we see broad sheets of dust dragged downwards from the rings by the planet's extended atmosphere. Neptune's rings, on the other hand, lie above the limits of its 'air', and so the dust remains where it was produced, travelling in the same orbit as the larger pieces of rock. Over billions of years the colliding rocks in the rings have been ground so exceedingly fine that half the matter is now in the form of dust.

The rings of Neptune are very sparse, containing only one-thousandth as much matter as the rings around Uranus. Put together, all the rocks and dust in Neptune's rings would make a body only a few kilometres across – and this matter is spread out over 125,000 kilometres. As a result, the rings are so faint that an astronaut who flew past Neptune in the track of *Voyager* would not be able to see them with the unaided eye. All that would be visible, with a good bit of squinting, would be three brighter regions in the outer narrow ring – the three 'arcs' of Neptune.

A huge cap of frozen ices covers much of Triton, Neptune's largest moon, its extent showing particularly well in this picture taken as *Voyager 2* approached Triton from under its pole. The ices, of frozen methane and nitrogen, lie on the coldest surface in the Solar System. Regions not covered by ice (top) are reddish-brown in colour.

These arcs had perplexed astronomers for years. We cannot see them from the Earth, but they had given themselves away on the rare occasions when Neptune happened to pass in front of a star. Sometimes astronomers had seen the star disappear briefly when it was still some way from Neptune itself, suggesting that the planet has a narrow ring that blocks the star's light for a short period. But more often than not nothing would happen to the star's light until it disappeared behind Neptune itself. The only way of reconciling these results was to suppose that the planet has short segments of rings, or 'arcs'. With hindsight, and the *Voyager* pictures, we know that Neptune's rings do go all the way round the planet, but the material is generally spread so thinly that it does not noticeably dim a star's light. The suspected arcs do exist, as denser and brighter portions of the outer ring where the material is dense enough to hide a star. The extra matter here consists of rocks chipped

Geysers on Triton – sometimes called 'volcanoes' – first gave away their existence by the long dark trails of soot that they had left across the pinkish polar ices. ◄ The largest streak here is almost 100 kilometres long; many smaller dark streaks run parallel, blown by the prevailing wind in Triton's tenuous atmosphere. ▼ An oblique view shows that the dark material rises vertically for 8,000 metres, and is then blown sideways. The lower of these two identical photographs is marked with arrows showing the top and bottom of the vertical plume, the length of the horizontal cloud and the far end of the shadow of the dark cloud on the ground.

off a number of 'moonlets' in the arcs, each about ten kilometres in diameter.

The discovery of the arcs raises as many questions as it answers. Each time the moonlets, or the smaller fragments, bump together they must change their speed a little – either slowing down or speeding up slightly. The faster and slower particles should gradually spread around the ring, away from bright arc regions, until the whole ring appears about the same brightness. But this is not happening. In fact, astronomers have looked again at the records of the rings hiding starlight from telescopes on the Earth, and have concluded that the arcs must have been very similar several years before *Voyager* reached Neptune. Some force, as yet unknown, must be keeping most of the outer ring's material in the three arcs.

The ring material is probably shepherded by small moons orbiting nearby. *Voyager* found six new moons around Neptune. Three of these lie so close to the planet that they orbit Neptune between its innermost broad ring and the first of the narrow rings. Another moon lies between the two narrow rings.

We had already had a hint of the next moon out, Larissa. In 1981, astronomers in Arizona saw a star disappear when it was near to Neptune, and suggested that a small moon had blocked out the star's light. But there was only a remote chance that a tiny moon would come exactly between the star and the telescopes in Arizona, and most scientists did not take this suggestion seriously. When astronomers blamed later star disappearances on arcs around Neptune, it was natural to say that the arcs had hidden the star in 1981 as well. We now know that the arcs were in the wrong place to have hidden the star in 1981, but Larissa was in exactly the right position.

The outermost of the newly discovered moons, Proteus, is the second largest in Neptune's family. We cannot see it from Earth because it lies too close to the planet's bright glare, although powerful telescopes on the Earth can show us the slightly smaller Nereid, which lies a long way out from Neptune. *Voyager* did not see Nereid in close-up, so we still know little about it, except that it goes around Neptune in a large oval orbit much further out than the rest of the family of moons.

Neptune's largest moon, Triton, is one of the strangest worlds in the Solar System. About two-thirds the size of the Earth's Moon, Triton is made of solid ice and rock. It is one of only three moons in the Solar System with an atmosphere, a tenuous mixture of nitrogen and methane that is much thinner than the dense cloak around Titan, but denser than the ephemeral sulphur gases of Io. The atmospheric pressure is little more than $\frac{1}{100,000}$ of 'sea-level pressure' on the Earth.

The surface of Triton is the coldest place we know in the Solar System (only Pluto might be colder, but we do not know its temperature accurately). A thermometer on Triton would register $-235\,°C$, just 38 degrees above the absolute zero of temperature. It is so cold that some of Triton's air freezes out at its poles, coating them with a large ice-cap of solid nitrogen and methane. Organic molecules have tinged the ice pink.

On a world that is literally frozen solid, astronomers were totally amazed to find active geysers. Triton is far too cold for its geysers to spout steam and water, like geysers on the Earth, and instead it sends up plumes of nitrogen gas that break through cracks in the solid nitrogen of its polar cap. The gas plumes rise 8,000 metres into the atmosphere, and are then blown sideways by

The topography of a frozen lake, some 200 kilometres across, is brought out in a *Voyager 2* image of Triton that has been processed to exaggerate the relief. The mountains are in fact only 1,000 metres high. Triton is made largely of ice, and the lake has appeared where water gushed out because of internal heating: to geologists, water behaves on Triton like lava on the Earth, and this 'lake' is better described as a volcanic caldera.

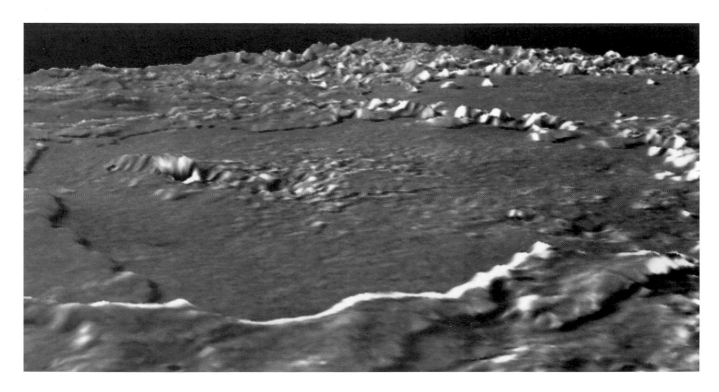

through the dim
split into two or r
kilometres of sma
of a molten mixtu
of small dark plai

No one has ye
into being, but t
conclusion: at so
must have forme
bodies in the Sola
Its unique landsca

This idea ties ii
large moons of th
the way in which
the north pole, th
Triton's orbit car
been born in orb
the planet's rota
though Triton v
gravity as it passe

Two worlds th
another. Their m
trajectories altere
as it went by. Po
friction slowed i
head-on: in this
the smaller worl
could never escap

Immediately a
orbit, as Nereid
large moon, to st
return the gravi
practically a perf

Today, Neptu
giant and a froz
planets in genera
processes that g
Triton can tell u
world. Studying
planets for the p

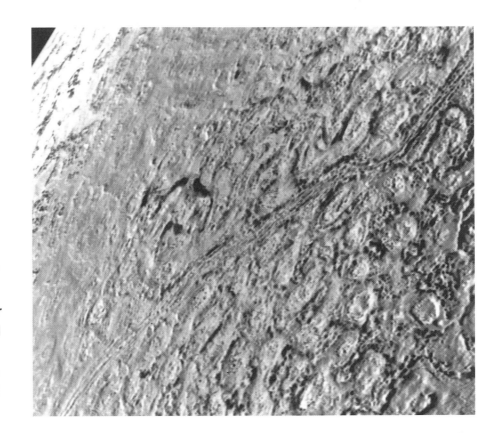

▶ Much of Triton is covered by strange dimples with low raised rims. They are too similar in size and too regularly spaced to be impact craters, and geologists think they may have formed after Triton melted and then solidified again.

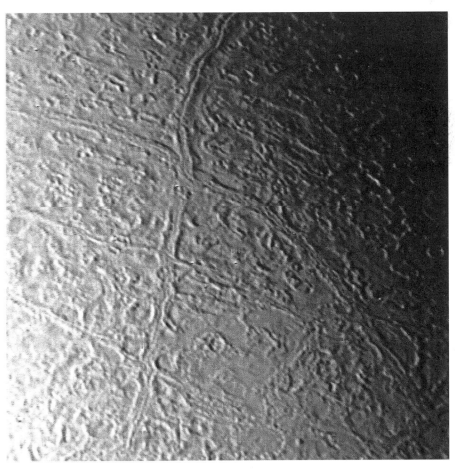

▶ Running across the surface are several long double ridges, sometimes crossing over one another. They are probably cracks in the crust that have filled with ice.

PLUTO

high-altitude winds. Specks of black soot from b
blasted upwards in the geysers, and the winds sp
streaks that can stretch over a hundred kilometres fr

No one is sure what makes these nitrogen geysers
heat at the bottom of the frozen ice-cap, and this
energy that rises from within Triton. A more likely s
the distant Sun. Although sunlight is weak on Trito
may be able to act like the panes of glass in a greenh
bottom of the ice-cap, the accumulated warmth evap
nitrogen, to form a pocket of gas. When the pressure
bursts through the icy surface as a geyser.

The geysers are not the only part of Triton to ma
books on frozen moons. Where we see regions that a
cap, scientists expect to find a surface covered by c
similarly sized moons going around Saturn. But *Ve*
has virtually no craters. In fact only a few regions of
resembles conventional geology, such as a couple o
must be frozen lakes.

Much of the surface is covered with strange 'dimp
five kilometres across and only a few hundred metre

9

The most distant planet is also the most mysterious. This is partly because Pluto is the only major world so far unvisited by a spacecraft. But even the little that we know of Pluto sets it apart from the other eight planets – to such an extent that some astronomers think Pluto should not be called a planet at all.

For a start Pluto is by far the smallest and least substantial planet. It would take twenty-five Plutos to make up the mass of the next smallest, Mercury. In many ways Pluto is more like the asteroids or 'minor planets' that circle the Sun between the orbits of Mars and Jupiter. It is only ten times heavier than the biggest asteroid, Ceres.

The orbit of Pluto also sets it apart from the other planets. The planets from Mercury to Neptune follow paths that have a neat family relationship: nearly circular and almost in the same plane. Pluto is the eccentric of the family: its orbit is tilted up at 17° to the rest of the Solar System and its path is so oval that at times – such as the two decades centred on 1989 – it comes closer to the Sun than Neptune.

None the less astronomers have thought of Pluto as the 'ninth planet' since its discovery in 1930, when it was tracked down by astronomers on the hunt for a planet whose gravity was perturbing the paths of Uranus and Neptune. Pluto is certainly as interesting as any of the eight larger planets. Its most unusual feature is that Pluto is a double planet: it has a moon, Charon, that is fully half the size of Pluto itself, and the two bodies are so closely matched that they swing around a balance point that lies between them. It is the only case in the Solar System where a moon is massive enough to swing its parent planet around a point outside the planet's body.

Pluto and Charon are so close that a telescope on the Earth can scarcely show them as two separate bodies. Not until 1978 did a sharp-eyed astronomer notice that the image of Pluto on a photograph was oddly shaped, and inferred the existence of Charon. The Hubble Space Telescope, orbiting above the Earth's distorting atmosphere, has been able to show Pluto and Charon as separate bodies, but even this telescope does not have the power to show any details on the surface of either body.

Like most of the moons in the Solar System, including our own Moon, Charon keeps the same face turned towards its parent planet. The Pluto system is unique, however, in that the planet keeps the same face turned towards its moon. If chilly Pluto had any inhabitants, those living on one side would always see Charon hanging in the sky, six times larger than our Moon appears

Heat from the Pluto–Charon duo makes them show up as the fuzzy white spot in this heat-image from the Infra-red Astronomical Satellite – a remarkable achievement, because these frozen worlds have a temperature around −220 °C. The coloured background consists of 'noise' in the satellite's sensitive electronics and the heat from distant stars of different temperatures.

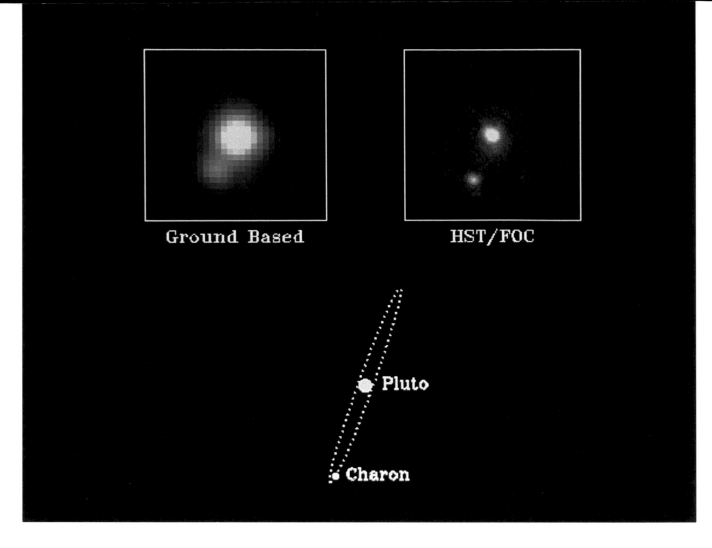

Ground Based **HST/FOC**

Pluto

Charon

fall of fresh snow on the Earth, reflecting practically all of the sunlight falling on them. They are three or four times as bright as the reddish regions around the equator, whose colour is probably due to carbon compounds formed when methane molecules have broken up.

These – admittedly limited – results paint a picture of Pluto that is almost identical to that of Neptune's largest moon, Triton. Not only do the two worlds have similar surfaces, with large, icy polar caps and a darker reddish equator, but they are almost exactly the same size and have the same density, indicating that they are made of a similar mix of rock and ices. The only major difference is their status: Triton is a moon, circling a much larger planet, while Pluto orbits the Sun as a planet in its own right.

Like Triton, Pluto has a tenuous atmosphere, at a few millionths of 'sea-level pressure' on the Earth. Astronomers have probed the planet's air, by watching its effect on stars as Pluto moves in front of them. These measurements tell us that this atmosphere contains methane, but its main component is probably nitrogen (which is difficult to detect from the Earth). The lowest part of the atmosphere contains some hazy layers. The outer regions extend a long way into space, probably as far as Charon, so that the two worlds are wrapped in a shared atmosphere – another unique attribute of this double planet.

The Earth's atmosphere blurs our view of the heavens, and even the best ground-based images (top left) can scarcely show Pluto and Charon as separate bodies. From its perch above the atmosphere, the orbiting Hubble Space Telescope has a sharper perspective. Despite problems with the mirror that focuses its light, the space telescope can easily separate Pluto and Charon (top right) – in just the positions expected from an analysis of their orbits (bottom). But even the Hubble Space Telescope cannot show any details on these distant and tiny worlds.

Pluto is currently at its closest point to the Sun, so it is experiencing the warmest period of the planet's 'year' of 248 Earth years. The atmosphere has grown thicker as the Sun's heat has warmed and evaporated the frozen ices in the polar caps. As Pluto moves away from the Sun again the atmosphere will begin to freeze and fall as snow on to the polar caps. Pluto is currently thirty times further from the Sun than the Earth is, but when it reaches its far point, in 2113, the planet will lie at fifty times the Earth's distance from the Sun. It will then be so cold that the atmosphere will all freeze out and Pluto will be an airless world.

Pluto's elongated orbit has perplexed astronomers since the discovery of the

In the late 1980s, Charon and Pluto happened to pass behind and in front of each other, as seen from the Earth – a lucky chance for astronomers, as such a line-up happens only once every 124 years. As each world hid the other in turn, and threw its shadow on the other, the total brightness of the pair altered. A careful analysis of these measurements has let astronomers map where the bright and dark regions lie on both Pluto and Charon. The sequence on the left-hand side of the picture re-creates how the pair would have looked on 6 February 1989 as Charon passed in front of Pluto. The right hand sequence shows the appearance three days later as Charon moved behind Pluto. Actually to see this view from the vicinity of the Earth we would need a telescope ten times more powerful than the Hubble Space Telescope.

planet. If Pluto can cross Neptune's orbit, then the gravity of the larger planet should either sweep up Pluto or else swing it into a path that throws it out of the Solar System. In fact, two factors combine to save Pluto from this fate. Its tilted orbit is one saving grace, because Pluto always lies well above the orbit of Neptune when it crosses the path of the larger planet.

More important to Pluto's safety is the fact that the planet's 'year' is exactly one and a half Neptune years. Every time that Pluto completes two orbits and comes back to its closest point to the Sun, Neptune has made precisely three orbits and is in the same position as before, off to one side, and well away from where Pluto lies. On the intervening close approaches of Pluto to the Sun, Neptune is exactly halfway round its orbit, and off at a safe distance to the other side. As a result whenever Pluto is closest to the Sun, Neptune is never near to Pluto.

In the light of the new discoveries about Pluto and Triton many astronomers now believe that they started life as siblings. In the region beyond Saturn there were originally billions of small worlds. Most of them came together in two clumps, to form the planets Uranus and Neptune. After it formed, Neptune's gravity rather effectively cleared out the remaining small worlds in the outer parts of the Solar System. Most of them were flung away into deep space, although one was captured by Neptune to become its moon Triton. Our present Pluto was the only one of the original small worlds to survive in its original orbit, because its fortuitous 'year' has always kept it away from the direct influence of the giant planet.

From a computer analysis of the transits and eclipses of Pluto and Charon (shown in the last illustration), astronomers have produced this accurate view of the double planet as seen from the side. Here, the Sun is off to the left, and the shadow of Charon is falling on Pluto. Any (hypothetical) inhabitants of Pluto would see a total eclipse of the Sun.

The latest discoveries about this world are whetting astronomers' appetites to find out more, and NASA has now drawn up plans for a small lightweight spacecraft that could speed out to Pluto in just a few years. The Pluto–Charon pair gives us the only chance to study a well-matched double planet. Even more important, Pluto itself is probably the lone survivor of the bodies that built up the larger worlds Uranus and Neptune. Although Triton has survived since then, it was completely re-faced when Nepture captured it and melted Triton right through. Pluto is, we think, still in its pristine state. It can provide unique clues to processes that gave birth to the furthest planets in the Sun's family.

Origins

10

The nine planets are not the only objects that orbit the Sun. Between and beyond their orbits we find a myriad of smaller bodies. Even if we piled them all together, they would make up a world not much larger than the Earth. Tiny they may be, but these bodies are in their own way as important as the planets themselves.

Crystals within a rocky meteorite show up in distinctive colours under the microscope when a thin section is illuminated with polarized light. They are a history book of the early days of the Solar System. These crystals and round inclusions (chondrules) formed when minuscule particles of dust in a disc surrounding the young Sun coagulated to make small worlds called planetesimals. By studying these crystals in detail, astronomers can work out when the parent planetesimal began to come together (the moment of the birth of the Solar System), how fast and how large the planetesimal grew, and when it was shattered by a collision that sent this fragment on a course to hit the Earth as a meteorite.

The small bodies – asteroids and comets – are relics from the birth of the Solar System. Astronomers now believe that the planets were built up from a cloud of dust, ice crystals and gas that surrounded the young Sun. As it rotated the cloud flattened in shape until it became a disc of matter (with roughly the proportions of an audio compact disc), over 10,000 million kilometres across. Near the centre of the disc the heat from the infant Sun melted and boiled the ice crystals, leaving only particles of rocky dust, like tiny grains of sand individually orbiting the Sun.

These microscopic solid particles stuck together to build up into planetesimals that were several hundred kilometres across – roughly the diameter of the medium-sized moons of the outer planets. Close in to the Sun the grains of dust built up into planetesimals made of rock. Further out from the Sun's heat, where the frozen crystals had survived, the planetesimals were made mainly of ice.

Virtually all the planetesimals eventually came together in nine clumps, to make the planets that we know today. The planetesimals in the centre of the Solar System formed the four rocky planets. The two outermost planets, Uranus and Neptune, were built up from icy planetesimals, which have melted within the planets to form huge oceans. The most massive planets, Jupiter and Saturn, are a special case. They probably began with a collection of icy planetesimals, but became big enough to attract vast amounts of the surrounding hydrogen and helium gases.

The process of planet-birth was so violent that the nine planets and their moons now show little sign of their distant past. As the planetesimals fell together the heat of the collision melted the early planets right through. The four giants are totally fluid to this day, and so bear no overt signs of how they formed. In the case of the inner planets the liquid mixture separated out into a metal core, a thick layer of heavy molten rocks and a thin solid crust of lighter rocks. This melting and differentiation into layers has destroyed any clues to the planets' formation. To add insult to this injury, any secrets held by the early solid crust were obliterated by a final hail of fragments from space. This is the state of our Moon and Mercury today; in the case of the Earth, geological processes – like plate tectonics, volcanoes and erosion – have wiped the slate

clean again. If we had only the Earth to study, we would know very little about the origin of any of the other planets.

This is where the junior members of the Solar System come in. The asteroids and comets are rubble left over from the birth of the planets. The largest of these bodies are almost certainly planetesimals that for one reason or another never came together to make up a planet. The smaller bodies are mere fragments, broken off when planetesimals have smashed together. They are perhaps even more interesting. While we can never get deep inside a planet to find out directly what lies within, the smaller pieces of rubble are actually pieces from inside a planetesimal.

Even better for scientists, we do not have to mount expensive space expeditions to investigate fragments of the building blocks of the planets. The smallest pieces of debris are strewn so freely through space that planet Earth runs into thousands of them every year. The larger fragments survive their fiery passage through the Earth's atmosphere to hit the ground as meteorites.

Most meteorites are made of stone, but one in twenty is totally different from anything we find naturally on the Earth's surface – a metallic mixture of iron and nickel. These 'iron meteorites' were once part of the molten metallic core of a planetesimal that was later smashed into pieces. Many of the stony meteorites on the other hand contain so little iron that astronomers think they have come from the outer regions of a planetesimal where virtually all the iron had sunk to the centre. In either case we are looking at material that may be less altered than the planets themselves, but is still not the original material of the Solar System.

Just a very few meteorites have a different look. Although they are stony, they are dark in colour and contain tiny drops of lighter-coloured rock. Since the dark colour is caused by carbon, and the drops of rock are called chondrules, these meteorites go by the unwieldy name of 'carbonaceous chondrites'.

Strange fibres show up on the surface of the Murchison meteorite, when it is magnified 5,000 times by a scanning electron microscope. This stone, which fell in Australia in 1969, is a carbonaceous chondrite – a meteorite containing a small amount of carbon and carbon compounds mixed up with the rock. The Murchison meteorite was the first place that scientists found amino acids – a building block of living cells – from beyond the Earth. These compounds, however, almost certainly formed as a result of chemical reactions rather than being a product of life.

The first images of an asteroid surprised astonomers by showing that the small world is peanut-shaped and tumbling end over end as it moves through space. When the asteroid, Castalia, passed close to the Earth in 1989 astronomers obtained this sequence of images by the technique of radar astronomy, using the large Arecibo radio telescope. False-colour coding shows that the asteroid seems to consist of two spherical bodies that are touching. They were probably once separate asteroids that have gradually spiralled together. Castalia is less than two kilometres long.

The first close-up picture of an asteroid – Gaspra – was taken in 1991 by the *Galileo* spacecraft, as it crossed the asteroid belt on its way to Jupiter. Gaspra is an irregular lump of rock about 20 kilometres long and 13 kilometres across – about the size of Mars's smaller moon, Deimos. It is almost certainly a fragment of a larger body that was broken up about 500 million years ago.

Most important to astronomers, these rocks show no signs that they have ever melted. The carbonaceous chondrites are either pieces of tiny planetesimals that never melted or pristine chips from the surface of larger ones. They are aggregations of the original matter from which the inner planets formed.

By investigating the naturally radioactive elements in the carbonaceous chondrites, astronomers have been able to work out when they formed. This is the best indication we have to the actual age of the Solar System. It comes out as 4,560 million years.

With a few exceptions – which seem to be pieces of the Moon or Mars, blasted off by giant explosions – meteorites come from a region of rocky rubble strewn between the orbits of Mars and Jupiter. Astronomers found the first bodies here in 1801, and called them asteroids ('star-like') because the tiny worlds appear only as star-like points of light, moving against the background stars from night to night. More appropriate, but less often used, is the term 'minor planets'.

Astronomers have now charted the courses of over 5,000 objects in the asteroid belt, and estimate that the total must run to more than a million. The largest, Ceres, is about 900 kilometres in diameter and contains almost as much mass as all the other asteroids put together. Ceres is probably one of the few rocky planetesimals that has survived intact from the early days of the Solar System. Most of the other minor planets are fragments from collisions between bodies that were originally about the size of Ceres.

The asteroids are almost certainly the building blocks of a planet that should have assembled between Mars and Jupiter, but never actually formed. The gravity of giant Jupiter was powerful enough to keep stirring up the planetesimals in this region, probably flinging most of them out of the Solar System altogether. The matter left in the asteroid belt today would not make a world even as big as our Moon.

Not all the asteroids lie between Mars and Jupiter, and the exceptions are among the most interesting of the minor planets. Some asteroids follow paths that bring them in towards the Sun, crossing over the path of Mars and in some cases the orbit of the Earth. Small fragments that cross the Earth's orbit provide us with our rich bounty of meteorites, but a few larger asteroids take similar paths. If one of these hits the Earth, it can blast out a large crater, like the famous Meteor Crater in Arizona, or cause even worse damage – possibly including the catastrophe that wiped out the dinosaurs 66 million years ago.

Some minor planets stray outwards from the asteroid belt, braving the gravity of mighty Jupiter. The king of the planets has captured at least eight asteroids to form the outer members of its family of moons. Jupiter's gravity has also forced two bunches of asteroids – the 'Trojans' – to follow its own orbit around the Sun, 60° ahead of and 60° behind the planet itself.

The minor planet Hidalgo lives a more dangerous life. It travels right across the orbit of Jupiter, from the inner edge of the asteroid belt to a far point near Saturn's orbit. Further out still is Chiron. The closest it ever comes to the Sun

Meteor Crater in Arizona is a hole in the Earth 1.2 kilometres wide, blasted out by a large iron meteorite some 50,000 years ago. Most of the meteorite was vaporized by the impact, and small solidified drops of iron litter the surrounding desert. The high speed of meteorites means that they cause damage out of proportion to their size: the body that hit the Earth here was only one-twentieth the diameter of the resulting crater.

is just within the orbit of Saturn, while the far point of its orbit is near to Uranus. When it was discovered in 1977, Chiron appeared as a point of light and was naturally classified as an asteroid, albeit unusually far out in the Solar System. But as it gradually came closer to the Sun astronomers found that Chiron was beginning to look fuzzy. It must contain a lot of ices that were evaporating in the Sun's heat to form a large glowing ball that looks just like the head of a comet. Just as the legendary Chiron was a centaur, a cross between a man and a horse, so the celestial Chiron is a cross between an asteroid and a comet.

In most people's minds, a comet is a spectacular sky sight – a glowing sword stretching halfway across the sky. Some comets do look like this, but the great majority are just faint and fuzzy balls of light, visible only with a telescope. Even this show is put on only when a comet is at its closest to the Sun. A comet spends most of its life far from the Sun, where it is merely a small dark lump of ice and rock, invisible against the blackness of space.

Since the discovery of the 'minor planets' orbiting between Mars and Jupiter, astronomers have drawn a clear distinction between rocky asteroids and the gassy comets. But that dividing line has now become blurred. In the early 1990s, astronomers found several more small worlds in the outer Solar System. These smaller kin of Chiron are often called 'centaurs': one has been named Pholus, after another man–horse hybrid from Greek myths (although the discoverers of one cosmic centaur rather incongruously gave it the nick-name Smiley after a character in a John le Carré novel!). Other astronomers call them 'ice dwarfs', to distinguish them from the rocky dwarfs and gas giants of

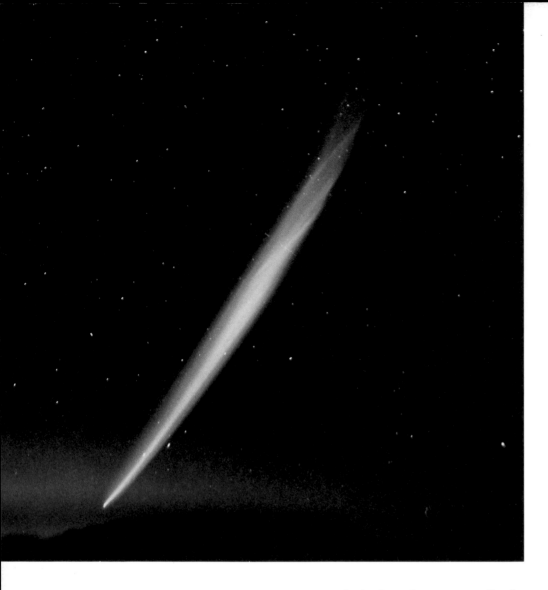

the Solar System. If it happens to stray towards the Sun, the contents of an ice dwarf begin to evaporate, and it starts to grow a huge gaseous head, like a fledgling comet.

In this scheme, the runt planet Pluto is actually the king of the ice dwarfs, the leader of the cosmic centaurs. Now that Pluto is at its closest to the Sun, this normally airless world has grown a layer of atmospheric gases. Some astronomers, only partly tongue in cheek, say we should regard Pluto not as the smallest of the planets, but as a comet to end all comets.

The centaurs are icy planetesimals that have survived the formation of the four giant planets. Many thousands may traipse around the Sun in huge orbits lying in the same plane as the planets, but well beyond the orbits of Neptune and Pluto. This region, the Kuiper Belt, was proposed almost 30 years before the discovery of Chiron, by the Dutch–American astronomer Gerard Kuiper. Smaller icy bodies from the Kuiper Belt may fall towards the Sun as short-period comets – those that return to the Sun within a couple of centuries.

The homeland of the long-period comets lies much further beyond the orbit of Pluto, in a region that stretches halfway to the nearest stars. When the Solar System was born a vast store of comets accumulated in this distant deep-freeze,

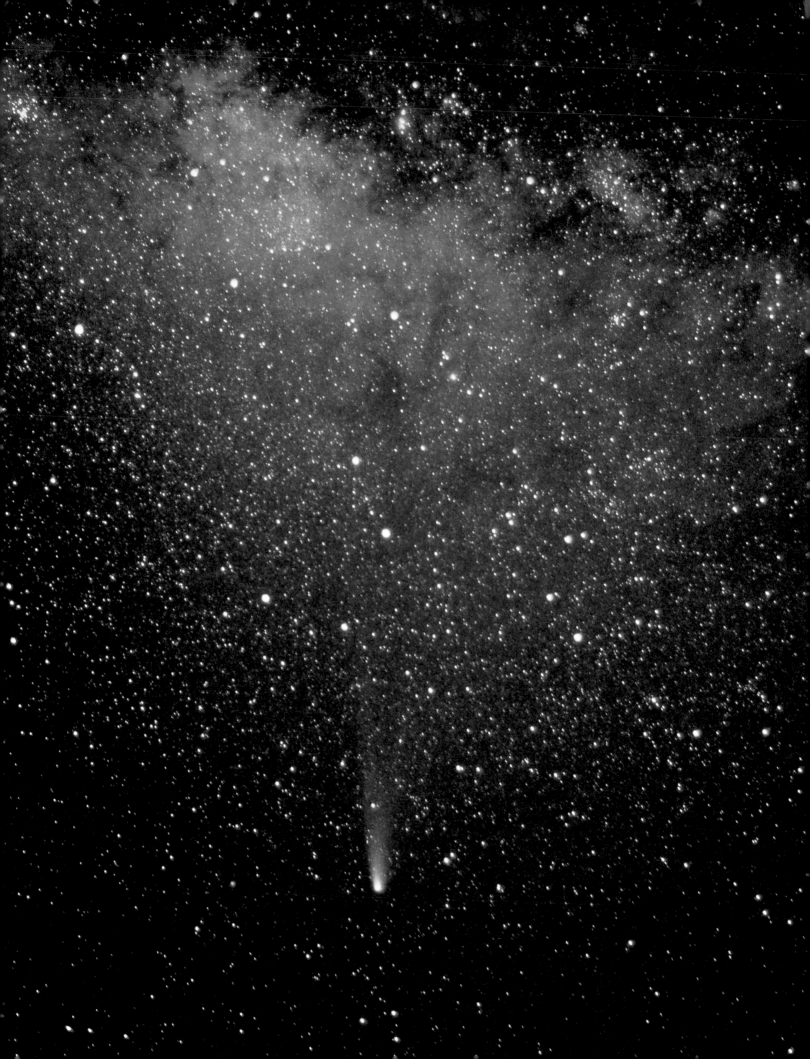

named the Oort Cloud after the Dutch astronomer Jan Oort, who first proposed its existence. Some astronomers think that microscopic ice crystals in the original gas cloud assembled into comets here, just as they formed into rocky or icy planetesimals nearer to the Sun. Other astronomers say that matter was spread too thinly out there: the comets must have formed in the realm of the outer planets, and were then flung further out by Uranus and Neptune.

Whatever the origin of the Oort Cloud, it has provided a safe haven for millions of comets since the birth of the Solar System. But they are so far out that the Sun's gravity is weak, and gravitational pulls from beyond can dislodge a comet from its perch. This outside pull could come from a passing star, from a dense cloud of gas in space or from the assembled distant stars of the Milky Way.

The comet then falls towards the Sun, on a long thin orbit that brings it past Pluto, Neptune, Uranus, Saturn and Jupiter. Somewhere around Jupiter's orbit the Sun's warmth becomes sufficient to boil away some of the ices. The resulting gases and steam form a large fuzzy head that can grow almost as large as the Sun, although it contains very little material.

At this stage it becomes somewhat ambiguous to refer to 'the comet' – do we mean the original small icy body or the huge gaseous head that it has spawned? To keep things clear, astronomers call the icy planetesimal the comet's 'nucleus', while the gases form the 'coma'.

Coming still closer in, as it passes the oribits of Mars and the Earth a comet may begin to grow a tail, or two. At this range the Sun's light exerts a force to be reckoned with. It pushes the tiny dust grains in the coma of the comet outwards to form a long curved tail pointing away from the Sun. The Sun's surface also emits a continuous 'wind' of electrically charged particles, which sweeps past the comet's head and drags out atoms of gas. These form a second tail, which is thinner and straighter. While the dust tail is the yellow colour of reflected sunlight, the gas tail is a fluorescent blue.

A comet's tails always point roughly away from the Sun, so once it has passed its closest point to the Sun, the comet travels tail-first out through the Solar System. As it retreats from the Sun's heat the nucleus cools down and its output of steam and ice begins to subside, until the tail and the coma fade away. The momentum of the bare nucleus carries it out again to the fringes of the Oort Cloud, before its oval path brings it back to the Sun in another 100,000 years or so.

But on one of its rare returns to the region of the planets, this insubstantial visitor will eventually feel an extra gravitational tug from one of the giant planets. This is the beginning of the end. The pull of Jupiter or Saturn bends the comet's path around, trapping it in a smaller orbit. It now passes close to the Sun much more frequently, perhaps several times in a century, and its ices are boiled away rapidly. Within a million years the comet will be dead – either boiled away entirely or left as a clinker of rock denuded of the ice that originally formed most of its bulk.

◀ **Within the head of Halley's Comet jets of gas and dust spiral outwards from a tiny central nucleus. (The nucleus itself is too small to show in these photographs taken from the Earth.) The sequence covers thirty-two hours in the middle of March 1986, when the European spacecraft *Giotto* raced through the comet. As the nucleus emits the jets, they point roughly towards the Sun – which is off the bottom in this sequence – but the Sun's pressure bends the jets around so they eventually constitute a tail that points upwards (away from the Sun), as seen in the wide-angle view on p. 187.**

▶ **The heart of Halley's Comet – as revealed by the *Giotto* spacecraft – is a potato-shaped nucleus of rock and ice sixteen kilometres long. The surface is covered with very dark material, probably containing carbon and carbon compounds. As the ice inside the nucleus is boiled away by the Sun's heat, the resulting steam bursts through the dark crust to form the beginning of the jets seen in the Earth-based photographs (opposite). These jets carried specks of dust that hit the speeding spacecraft at a speed of 280,000 kilometres per hour and eventually disabled many of *Giotto*'s experiments.**

Some of the asteroids that cross the Earth's orbit may in fact be dead comets that have long ago lost their ices and gases. We can catch a fleeting glimpse of these bodies as they shoot past our planet. To investigate a young and active comet is much more difficult. The brightest comets are fresh from the Oort Cloud, or have made only a few visits to the inner regions of the Solar System at intervals of around 100,000 years. We cannot predict when they will turn up; indeed many are discovered by amateur enthusiasts patiently scanning the sky with binoculars to look for an unexpected newcomer.

Only one bright comet has an orbit so small that we can predict its return. Halley's Comet orbits the Sun every seventy-six years, and if it passes near to the Earth – as in 1910 – the comet is a brilliant sight. On its next return to the Sun, in 1986, Halley's Comet was relatively far from our planet, and it put on a dismal show. But the poor view from the Earth was more than compensated by the first ever close-up shots of the centre of a comet.

Because Halley's Comet runs to such a regular timetable, astronomers had years to plan, build and launch an international flotilla of spacecraft that would fly through the comet and investigate its anatomy from the inside. Two small Japanese spacecraft found a huge cloud of hydrogen surrounding the comet's head. A pair of Russian *Vega* probes that had earlier dropped balloons in the atmosphere of Venus flew into the comet's coma and photographed – for the first time – the small icy nucleus at the centre.

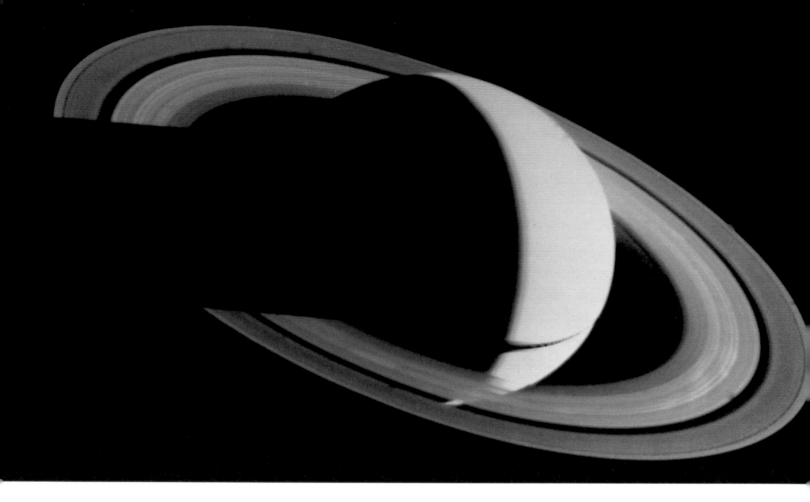

But it was left to the last of the fleet to obtain detailed pictures. The European craft *Giotto* flew closest to the comet's centre, only 600 kilometres from the nucleus. Even though *Giotto* was equipped with a shield to protect it from the dense clouds of dust in the middle of the coma, the impact of a large dust particle set the spacecraft wobbling just a few seconds before the closest encounter. Contact with Earth was lost for a while, but *Giotto* had already succeeded: it had sent back astounding close-ups of the erupting nucleus.

The nucleus of Halley's Comet is shaped like an elongated potato, about sixteen kilometres from end to end and eight kilometres across – very similar in size and shape to Mars's larger moon, Phobos. It turns out that all the awesome magnificence of Halley's Comet, which even at a distance of millions of kilometres has terrified people down the ages, comes from a body little larger than Manhattan Island.

But the real surprise was the colour of the nucleus. *Giotto* found that it was black – darker than coal or even black velvet. Reflecting only 3 per cent of the light that falls on it, the nucleus of Halley's Comet is the darkest object we have ever seen in the Universe (except possibly for the rings of Uranus and Neptune). Like the chocolate coating of a choc-ice, this dark, carbon-rich rock forms a thin layer over the ice that makes up most of the nucleus.

When *Giotto* snapped the nucleus of Halley's Comet, the Sun had heated the black crust to the boiling point of water. The ice beneath the crust was not only melting, but boiling, and jets of steam were erupting through cracks in the

The rings of Saturn – seen here in a farewell shot from *Voyager 1* – are the remains of an icy moon smashed into a myriad pieces by a stray comet. The frozen moons of the outer planets and the nuclei of comets are very similar bodies: both are icy worlds that accumulated in the outer region of the Solar System from flakes of 'dirty snow' when the planets began to grow, and both preserve vital clues to the birth of the Sun and the Solar System.

A particle of dust from a comet streaks to destruction in the Earth's atmosphere, appearing as a brilliant meteor or 'shooting star' as it burns up. The meteor, travelling from upper right to lower left in this time-exposure, produces intense flashes of light as it disintegrates. The reddish background is the aurorae – a glow from the atmosphere as its atoms are excited by electrons from the Sun.

rocky crust. The eruptions swept steam, gas and dust particles out into space to form the comet's coma.

The success of *Giotto* has inspired a more adventurous mission. The *Rosetta* mission is an unmanned craft that will actually scoop up a piece of the cosmic choc-ice and return it to Earth, for scientists to examine in minute detail.

The driving force behind this complex mission is the quest to understand our origins: the beginning of the Solar System and of our own planet. Even the most pristine of the meteorites, the carbonaceous chondrites, are formed from material that was warmed by the young Sun. This light baking was enough to boil away the ices – the main constituent of the original disc – and probably changed some of the ingredients of the rocks.

In the outer regions of the Solar System we find bodies uncorrupted by the Sun's heat. But the largest of these frozen worlds – the moons of Saturn, the asteroid-comet 'centaurs' and the enigmatic planet Pluto – have been altered inside by their own sources of heat, and externally by impacts from bodies drawn in by their gravity.

The comets from the Oort Cloud on the other hand are much smaller planetesimals, unchanged by internal heat or by high-speed impacts. They have been preserved from the Sun's heat in the deep-freeze that exists beyond the realm of the planets. When a comet begins its series of journeys to the inner parts of the Solar System, the outside of the nucleus is heated regularly, but it provides an insulating container that protects the frozen interior. The interior of a comet's nucleus is a natural time-capsule, containing a virgin sample of the material from which the planets were born.

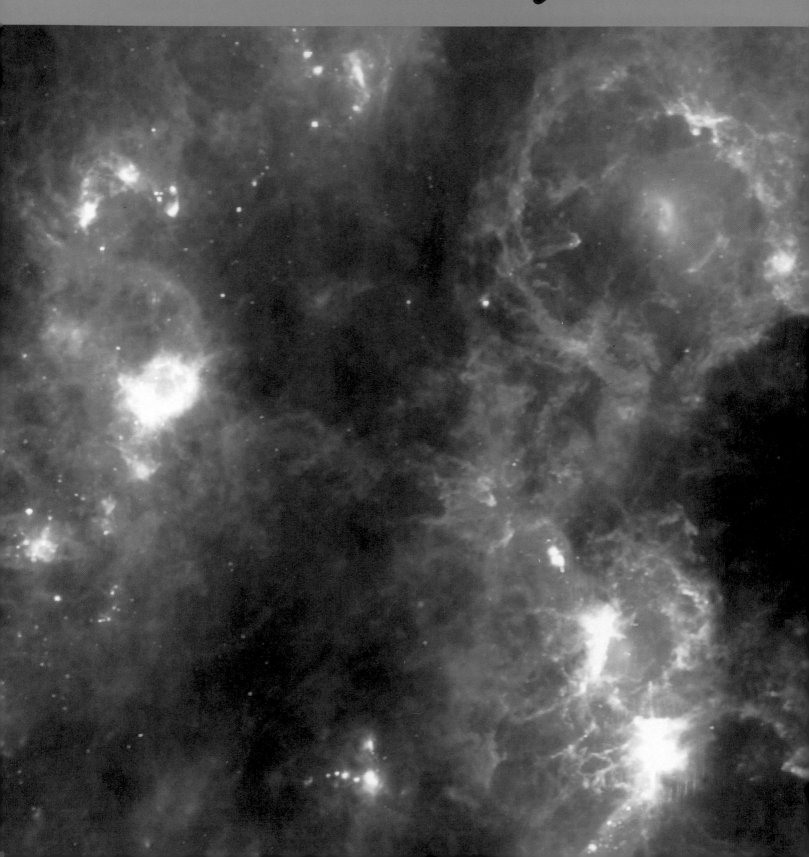

Worlds Beyond

11

Our first forays into interplanetary space with robot spacecraft – Phase One of our exploration of the Solar System – have provided a wealth of information about the other planets that would have been undreamt-of even thirty years ago. These expeditions have, quite literally, widened our horizons. No one can fail to be moved by the images of erupting volcanoes on Io or the great canyons on Mars, nor by the philosophical impact of Titan as a 'primitive Earth in deep-freeze'. But these discoveries, apparently far off in space, also hold some important lessons for us, on our own planet Earth.

Giant loops and streamers of gas and dust – hundreds of light years across – are poised to form into new stars with accompanying families of planets. In this region of sky, our eyes would see the constellations of Orion and Monoceros, but ordinary stars do not show up in this long-wavelength view from the Infra-red Astronomical Satellite. Instead the satellite reveals the normally invisible matter between the stars: the raw material of new worlds.

Venus, for example, holds the secret to the greenhouse effect. Environmentalists – and now governments – are concerned that the build-up of carbon dioxide in the Earth's atmosphere will make our planet hotter by a few degrees, with catastrophic effects on our weather and climate, not to mention the flooding of low-lying countries as the sea-level rises. Venus has taken the greenhouse effect to extremes. It may once have been a close twin of the Earth in every way, with oceans – and just possibly living organisms. But a gradual build-up of carbon dioxide led to a 'runaway greenhouse effect', with the temperature eventually soaring to 465 °C. If we know exactly what went wrong on Venus, we can hope to prevent the Earth's greenhouse from running amok.

At the other extreme Mars has gone from a watery past to a frozen present. According to one theory vast dust storms have helped to cool its surface by reflecting away the Sun's heat, and Mars's climate then became trapped in a cold state. This is a natural version of the 'nuclear winter' theory, in which a nuclear war on the Earth could raise so much dust that our planet would very quickly cool down, and chill into an artificially induced ice age.

Even the giant planets, seemingly so different from the rocky Earth, have something of everyday importance to tell us. What could be more relevant to us than a better knowledge of the weather? The giant planets have enormous atmospheres, with powerful winds and swirling bands of cloud. No one expected Neptune, which receives very little heat from the distant Sun, to have winds that blow almost as fast as the speed of sound. The giant storms – Jupiter's Great Red Spot, Saturn's occasional brilliant white spots and Neptune's Great Dark Spot – show that small eddies of whirling gas can build

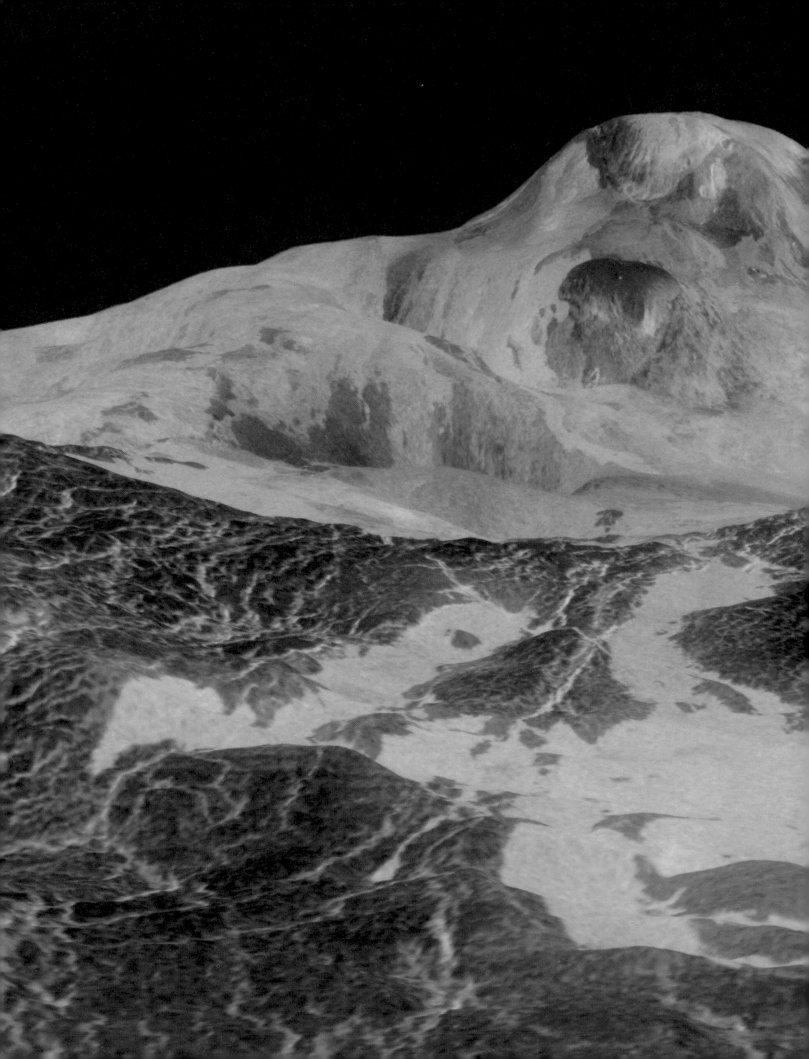

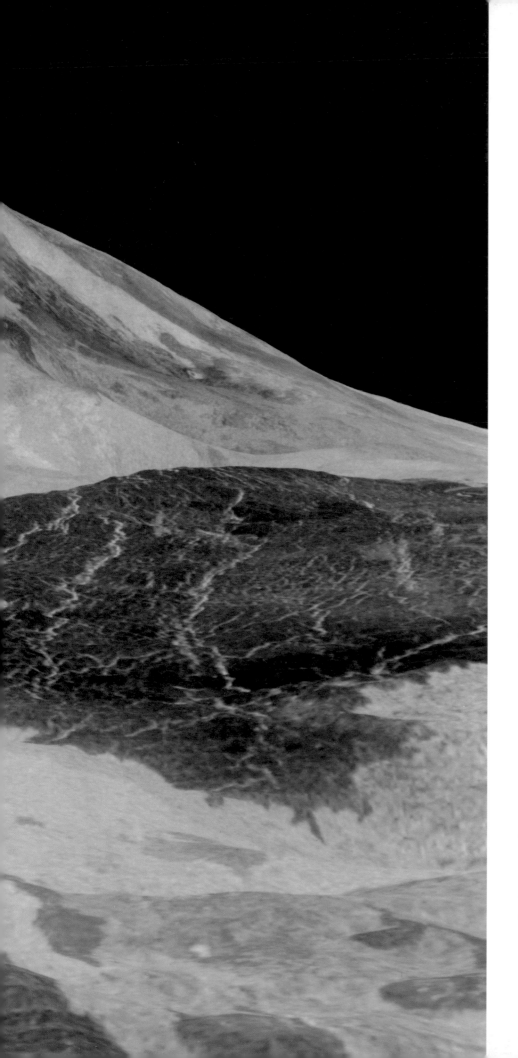

The tallest volcano on Venus, Maat Mons – imaged by the *Magellan* spacecraft with the vertical scale exaggerated – is a natural source of the 'greenhouse gases' that have raised the temperature of our neighbouring world by hundreds of degrees. By studying the creation of Venus's atmosphere and its reactions with the surface rocks, scientists hope to find ways of preventing the Earth from suffering a severe bout of greenhouse heating.

up to a size that we had never suspected. The insights from these planets help meteorologists to understand the way that the Earth's weather works.

At the most prosaic level we can use this kind of information to justify the cost of our planetary expeditions. The *Voyager* missions, for example, have cost $865 million since the project's inception in 1972. Vast as this sum may seem, it is equal to only a single day's expenditure by the US Department of Defense. To put it another way, the US taxpayer has received the stunning *Voyager* images, with their eye-opening vistas and the scientific and – ultimately – practical returns, for about 30¢ a year. That is equivalent to buying just one candy-bar each year since 1972.

The vision of these other worlds transcends mere economics. Planetary scientists point out that the true return from space missions will not be known for many decades to come. After all, Columbus's missions across the Atlantic Ocean did not immediately cover their costs in purely accounting terms!

And a parallel with Columbus is particularly apt, because our spacecraft are

Clues to the Earth's Ice Ages lie buried in the frozen polar caps of Mars. The gaps and scarps reveal layers of sediment deposited as the planet's climate fluctuated. By linking the ancient climates of Mars to the planet's tilt, the shape of its orbit in ancient times or to its planet-wide dust storms, researchers can test various theories that seek to explain why the Earth's climate has sometimes experienced a big chill.

Goodbye Neptune – hallo
Planet Ten? *Voyager 2* took this
parting shot of Neptune and its
large moon Triton from
5 million kilometres away, as it
headed out beyond the known
planets (Pluto is currently
within Neptune's orbit). But
scientists on Earth are carefully
monitoring the spacecraft's
path. If – as many astronomers
suspect – there is a tenth
planet, then its gravity may
pull *Voyager 2* off-course.

exploring new worlds. Even though we have now explored far shores, there is a chance that our knowledge of the bare outlines of the Solar System is incomplete. We know of nine planets, out to Neptune and Pluto, but there are tantalizing hints of a planet beyond.

Astronomers were put on the track of Neptune because of its gravitational pull on Uranus. After the discovery of Neptune they found that both Uranus and Neptune were feeling the pull of a planet even further out. The search for this Planet X led astronomers to Pluto in 1930. Although Pluto was in exactly the right position to be the culprit, it appeared rather faint and small for its gravity to affect its giant neighbours.

In 1978 astronomers discovered Pluto's moon, Charon. The orbit of Charon proved that Pluto was even less massive than anyone had suspected, only one-thousandth the mass calculated for Planet X. But if Pluto was not responsible for perturbing the paths of Uranus and Neptune, then what was? The search was on for Planet Ten.

The first clue, naturally enough, has come from studying the motions of Uranus and Neptune. Since the early years of this century they have shown little sign of being tugged out of place. We can make even more accurate measurements of the paths followed by the four space probes to the outer Solar System: *Pioneers 10* and *11*, and *Voyagers 1* and *2*. These messengers should also be susceptible to the pull of a massive planet, but in all the years of careful tracking they too have shown no sign of a gravitational force from beyond the known Solar System.

Many astronomers, however, believe that the perturbations of Uranus and Neptune measured in the last century are real. They have been led to the idea that Planet Ten follows an orbit that is very elongated and tipped up at a large angle to the orbits of the other planets. In the last century it was comparatively close to Uranus and Neptune and was able to pull them out of place. Now Planet Ten is out of the plane of the Solar System, so it has little effect on the planets or the spacecraft.

According to one prediction Planet Ten is five times heavier than the Earth and orbits the Sun once in a thousand years in an orbit that is at right angles to the orbits of the other planets. Currently it is three times as far out as Neptune and Pluto, and lies in the constellation Centaurus, near to the Southern Cross. This is a difficult area to search for a distant planet, however. The predicted Planet Ten would appear just like a faint star, and Centaurus is packed full of distant stars of the Milky Way.

This false-colour image of the star Beta Pictoris provided astronomers with the first sight of another planetary system in formation. The light from the star itself is hidden behind the black patch in the centre. The yellow and red 'wings' stretching out from the hidden star are the two sides of a tilted disc of dust that surrounds Beta Pictoris, and is several times larger than the Solar System. Its existence suggests that much denser dust exists closer to the star – so dense, in fact, that it has almost certainly condensed into planets.

The best way to search may not be to use an ordinary telescope at all, but to turn to infra-red astronomy. If we could look at the sky with eyes that saw long-wavelength infra-red radiation rather than light, the stars would be extremely dim while the planets would be exceptionally brilliant – even some asteroids would shine brighter than the stars. This is because infra-red is emitted best by bodies that are lukewarm, like the planets and asteroids, rather than the searingly hot stars.

In 1983 the Infra-red Astronomical Satellite, IRAS, made a pioneering survey of the sky as seen at infra-red wavelengths. It detected over half a million sources of infra-red – mainly distant cool stars and unusual galaxies – but if the predicted Planet Ten exists it must have been picked up in this survey. With mounds of data still to analyse, the IRAS scientists are keeping an eye open for an infra-red 'star' that appears to be moving.

IRAS has already provided us with strong hints that the Sun is not the only star to have a family of planets. It found that some stars, like brilliant Vega, produce an expectedly large amount of infra-red radiation. This cannot be coming from the star itself but must emanate from a large amount of lukewarm dust that lies near to Vega. In the case of another of these stars, Beta Pictoris, astronomers have been able to take a picture of the dust around the star. It forms a flattened disc, stretching out to twenty times the size of our Solar System. This dust is probably debris from comets colliding in their home region – corresponding to the inner part of the Oort Cloud that surrounds the Sun.

The Infra-red Astronomical Satellite produced an intimate view of one of the nearest 'star-nurseries', just 450 light years away in the constellation Ophiuchus. While the majestic whorls of dust in Orion (p. 192) give rise to massive stars that shine thousands of times more brightly than the Sun, this small cloud in Ophiuchus is quietly producing stars much more like our own – quite average – star. This is a prime site for finding a close twin of our Solar System.

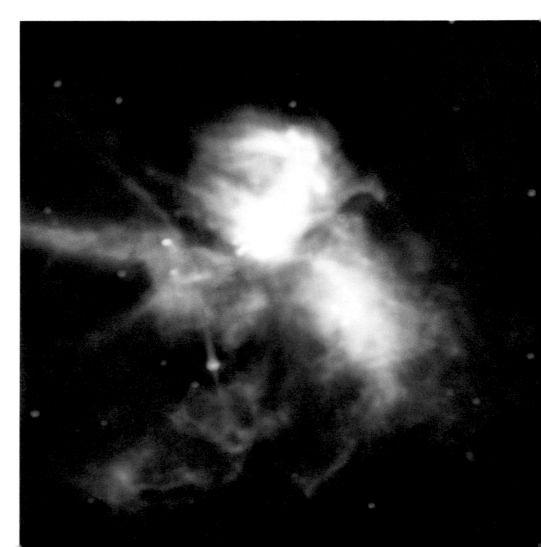

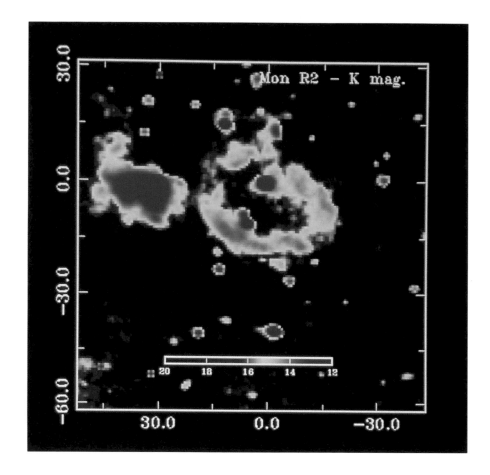

A really detailed peek inside a star nursery – this one in the constellation Monoceros – reveals infra-red radiation coming from warm patches of dust close to a batch of stars that have just been born. This image is one of the first from a new generation of infra-red cameras that can probe deep inside interstellar clouds: they hold out the best hope of catching another Solar System in gestation.

The IRAS results show that many stars are surrounded by solid dusty material, and in all likelihood the matter near to the stars has condensed into planets. But such planets would be too close to the parent star for IRAS to see directly. In fact no telescope yet built could show us a planet like the Earth circling a Sun-like star at the distance of even the nearest star.

But astronomers have become adept at picking up indirect clues. In particular, a planet can give itself away by its gravitational effects. Although we generally say that 'a planet orbits its star', in fact both the star and planet are swinging around a centre of gravity that lies between them. Because the star is by far the more massive of the two, it makes a much smaller orbit around the centre of gravity. But even so we can hope to measure the swinging motion of the star, and so deduce the existence of a planet – or more than one.

The first attempts at this 'astrometric technique' were very encouraging, but the 'wobbles' in the stars' motions turned out to be due to wobbles in the telescope itself. Astronomers' hopes now rest with the Hubble Space Telescope, which observes the Universe from above the Earth's turbulent atmosphere and so provides much sharper views. Although the main mirror in Hubble was inadvertently made to slightly the wrong shape, this flaw does not affect all the telescope's systems. In particular, Hubble has a fine-guidance sensor which lines the main telescope very accurately on to any chosen star. This instrument can measure the slightest wobble in the position of a star, and

should give away the existence of any heavy planets orbiting around a nearby star.

As a star orbits around the centre of gravity of its planetary system, it will also move alternately towards and away from us. This motion affects the wavelength of the radiation that it emits, in a process called the Doppler Effect. With ground-based telescopes it is easier to measure this changing Doppler Effect than it is to detect the wobble of a star back and forth across the sky, and the first results from this fairly new method have made astronomers optimistic about the existence of other planetary systems.

Some two dozen stars have been studied in detail, and half of them seem to be moving regularly towards and away from us. The 'years' of the planets in orbit lie between three months and ten years, roughly the range covered by the Sun's planets from Mercury to Jupiter. These planets are, however, much heavier than any of the worlds in our Solar System. The heaviest ones are around ten times the mass of our local giant, Jupiter, and astronomers prefer to call them brown dwarfs: a brown dwarf is a cross between a planet and a star that is shining very weakly as it contracts in size.

But the smallest ones are almost certainly close relatives of our gas giant planets. The star Gamma Cephei, for example, is orbited every three years by a planet that is only slightly heavier than Jupiter. At the moment we could not measure the effect of a planet less massive than Jupiter, but astronomers are confident that improvements in the equipment will soon reveal the effects of 'Saturns' and 'Uranuses' in orbit around other stars.

Such indirect methods are making astronomers confident of the success of the next generation of planet-seeking instruments. These huge infra-red telescopes orbiting the Earth will carry equipment that can actually see the planets of other stars. They should be able to pick out not just the giant planets, but planets as small as the Earth and Venus. A spectrograph attached to the telescope will analyse the radiation reflected from the planets, to show what gases make up their atmospheres. If the Solar System is any guide, we would expect to find a handful of gases – carbon dioxide, hydrogen and methane – as the usual planetary complement. The presence of oxygen would indicate that a planet must have some kind of active organism that can use sunlight to turn more stable molecules into oxygen – in other words, life.

Once we have located which stars have an interesting planetary system, the next stage is to send robot spacecraft there. This is not as wild an idea as it seems. Even with twentieth-century technology, we can send a spacecraft to the stars: *Pioneers 10* and *11* and the two *Voyagers* are breaking free of the Sun's gravitational shackles and will eventually wander freely among the stars. These craft are travelling quite slowly in comparison to the vast spaces between the stars, but a faster propulsion system and electronics that can endure decades in deep space are all within our grasp. By the centenary of the first close-up views of another planet – the *Mariner 4* photographs of Mars in 1965 – we should be studying in detail a whole new system of planets.

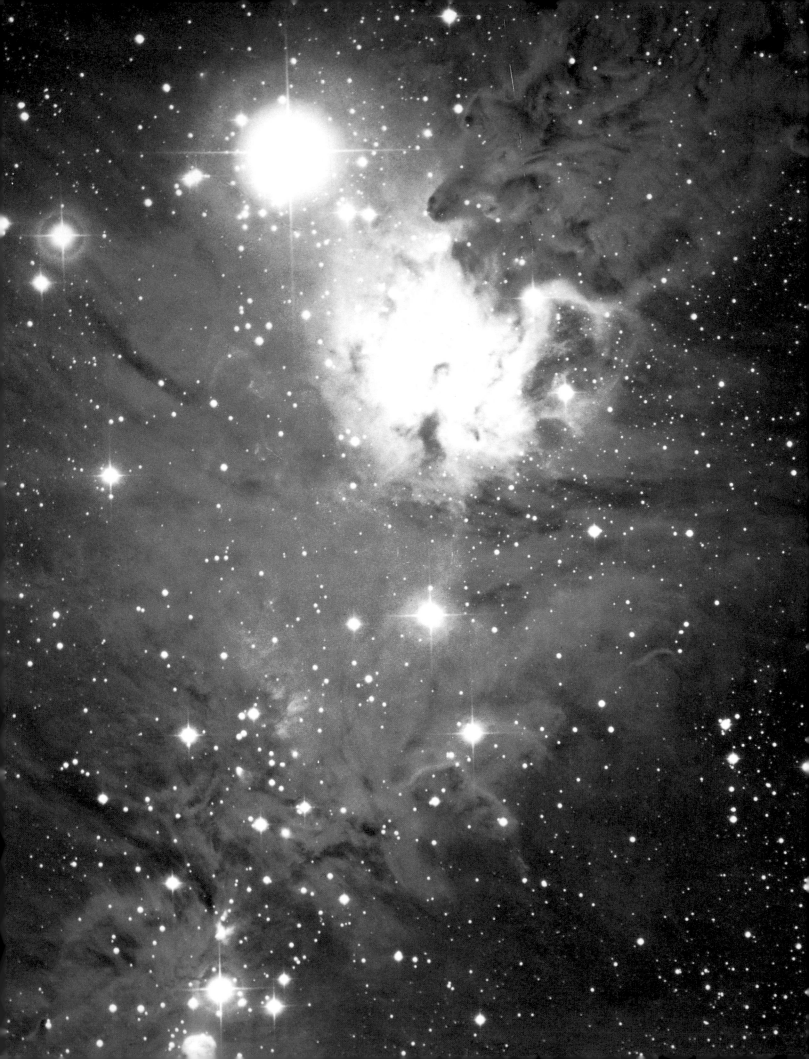

Judging by the variety we find even within our Solar System and the surprises that each new planetary encounter has brought, the planets of another star are likely to be quite different from ours. Unless we come across life in another planetary system, however, these surprises are unlikely to match the excitement we have felt at the close of the twentieth century.

While the progeny of another star are no more than distant relatives of ours, the past three decades have seen the unveiling of our siblings in space. The planets – out to Saturn, at least – are part of our cultural heritage, forming a thread that runs through human mythology, art and literature, as well as science. Even telescopes, however, could tell us little about the other worlds of the Solar System.

The closing decades of the twentieth century have been a unique period in the history of mankind, the era when we stopped merely looking up at the planets, and left our cosy world to venture into the planetary realm. Most people will recall readily the first step of a human being on another world, when Neil Armstrong set foot on the Moon in 1969. But the greater revelation has come from unmanned spacecraft. Humans have experienced only two worlds – the Earth and the Moon – in close-up. The robot craft have introduced us to eight planets and over sixty moons, as well as planetary rings and comets.

The hardy unmanned craft – the *Mariners,* the *Veneras,* the *Vikings,* the *Voyagers, Giotto* and the rest – have unveiled the faces of the closest kin to our planet Earth. At this point in our exploration of the Universe, we can see our planet for the first time in its true context: our newly acquired portrait-gallery of the planets puts the Earth into its correct perspective among our local family of worlds.

Other Suns – other Earths. In the nebula NGC 2264, young stars are emerging from their galactic womb and are blowing away much of the gas and dust left over from their birth. The dust that lay closer to the individual stars has undoubtedly condensed into planets, too faint to be seen here. In a billion years from now – a mere moment in astronomical terms – life may well be emerging on some of these worlds, and beginning to wonder about the Universe around.

Statistics

PLANET	Diameter at equator km and relative to Earth	Mass relative to Earth	Density relative to water	Average temperature °C	Tilt of axis	Average distance from Sun millions of km and A.U.[1]	Range in distance A.U.[1]	Period of revolution ('year')	Period of rotation[2]	No. of known moons
Mercury	4878 0.38	0.055	5.5	350 (day) -170 (night)	0°	57.9 0.387	0.31–0.47	88d	59d (176d)	0
Venus	12,103 0.95	0.81	5.2	465	3°	108.2 0.723	0.72–0.73	225d	243d (E to W) (117d)	0
Earth	12,756 1.00	1.00	5.5	15	23°	149.6 1.000	0.98–1.01	365d	23hr 56m (24hr)	1
Mars	6786 0.53	0.11	3.9	-23	25°	227.9 1.523	1.38–1.66	687d	24hr 37m	2
Jupiter	142,980 11.0	318	1.3	-150	3°	778.3 5.202	4.95–5.45	11.9yr	9hr 55m	16
Saturn	120,540 9.41	95	0.7	-180	27°	1427 9.539	9.00–10.01	29.5yr	10hr 39m	18
Uranus	51,120 4.11	15	1.3	-210	83°	2871 19.19	18.28–20.08	84yr	17hr 14m (E to W)	15
Neptune	49,530 3.96	17	1.6	-220	28°	4497 30.06	29.79–30.33	165yr	16hr 7m	8
Pluto	2280 0.18	0.002	2.1	-220	65°	5914 39.53	29.6–49.3	248yr	6d 9hr (E to W)	1

[1] A.U. = Astronomical Unit, the distance of the Earth from the Sun.

[2] Relative to the stars. If the length of the 'day' (sunrise to sunrise) is very different, it is given in brackets.

Index

Overleaf: The surface of Venus consists largely of smooth lava plains, as seen in this *Magellan* view of western Eistla Regio. On the horizon is the volcanic cone of Gula Mons, some 3,000 metres high. The crater Cunitz, in the right foreground, is 48 kilometres across and was blasted out by the impact of a large meteorite relatively recently in the history of Venus. Within a few hundred million years – a very short time, geologically speaking – fresh lava flows will destroy the crater.

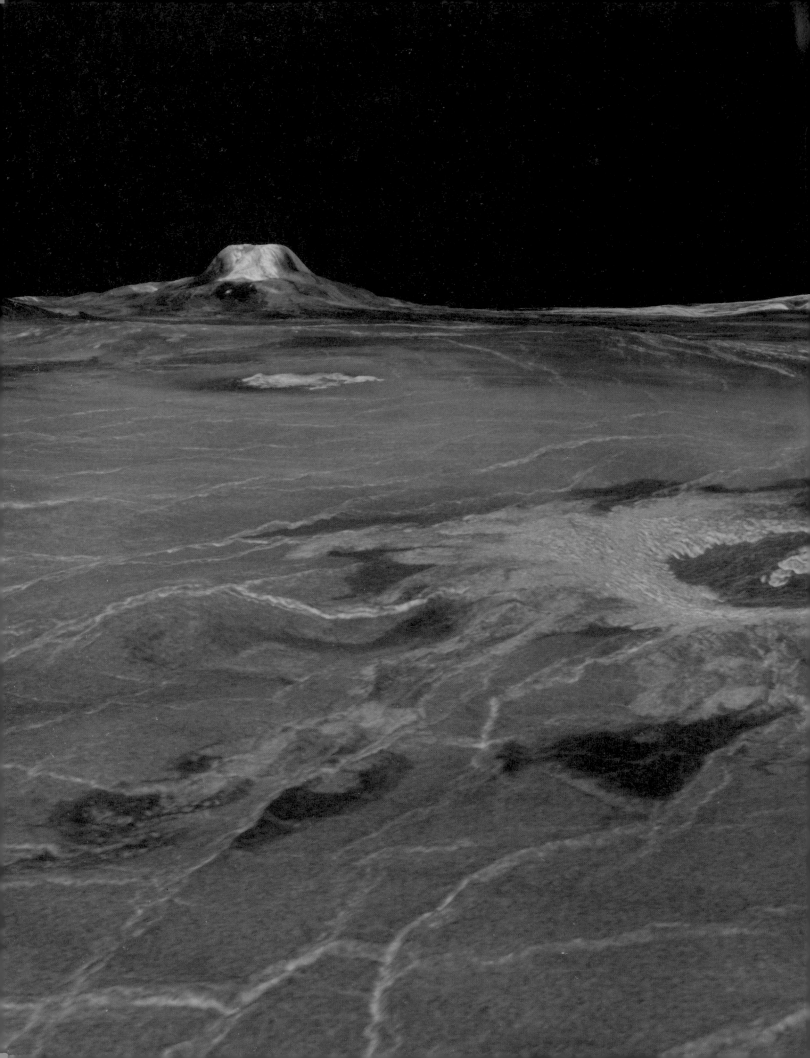